CRITICAL PERSPECTIVES ON 21ST CENTURY FRIENDSHIP

Polyamory, Polygamy, and Platonic Affinity

EDITED BY REBECCA BROMWICH, OLIVIA UNGAR, AND NOÉMIE RICHARD

DEMETER

Critical Perspectives on 21st Century Friendship
Polyamory, Polygamy, and Platonic Affinity
Edited by Rebecca Bromwich, Olivia Ungar, Noémie Richard

Demeter Press
140 Holland Street West
P. O. Box 13022
Bradford, ON L3Z 2Y5
Tel: (905) 775-9089
Email: info@demeterpress.org
Website: www.demeterpress.org

Demeter Press logo based on the sculpture "Demeter" by Maria-Luise Bodirsky www.keramik-atelier.bodirsky.de

Printed and Bound in Canada

Front cover design: Michelle Pirovich
Typesetting: Michelle Pirovich

Library and Archives Canada Cataloguing in Publication
Title: Critical perspectives on 21st century friendship : polyamory, polygamy, and platonic affinity / edited by Rebecca Bromwich, Olivia Ungar, Noémie Richard.
Other titles: Critical perspectives on twenty-first century friendship
Names: Bromwich, Rebecca, editor. | Ungar, Olivia, 1997- editor. | Richard, Noémie, 1999- editor.
Description: Includes bibliographical references.
Identifiers: Canadiana 20190144742 | ISBN 9781772582079 (softcover)
Subjects: LCSH: Friendship. | LCSH: Friendship—Sociological aspects. | LCSH: Female friendship. |
LCSH: Non-monogamous relationships. | LCSH: Polygamy. | LCSH: Platonic love.
Classification: LCC HM1161.C75 2019 | DDC 302.34—dc23

MIX
Paper from
responsible sources
FSC FSC® C004071
www.fsc.org

Acknowledgments

The editors of this anthology wish to acknowledge the support of the Department of Law and Legal Studies at Carleton University and to give a nod to the amazing Dr. Andrea O'Reilly; without her remarkable insight and impressive energy, Demeter Press would not be possible. Also, we would be remiss if we did not acknowledge the ongoing support of our families, and, last but not least, the backing of our friends, without whom we would never be able to reach as far and achieve as much.

Contents

Introduction

Rebecca Bromwich and Olivia Ungar

"Friendship marks a life even more deeply than love.
Love risks degenerating into obsession,
friendship is never anything but sharing"—Elie Wiesel

Human beings have friendships. Through our lives, we are socially situated not just in formal networks of kinship, or familial relationships, but also in informal webs of friendship, which locate us in relationship to one another—but voluntarily and not necessarily through any type of filial ties, legal or biological. Indeed, as Ray Pahl has argued, friendship is an increasingly important relationship across contemporary societies, where people are more mobile and empowered to choose with whom they associate in a wider range of circumstances than in the past. Yet what constitutes a friendship and how to clearly define who is or is not a friend are matters subject to disagreement and debate: sociology does not offer a single, uniformly accepted definition of friendship (Allen). However, as sociologist Graham Allen further notes, friendships do not occur in splendid isolation from the friends' social location: friendships are circumscribed by class, race, age, and socioeconomic status. Furthermore, not all friendships are necessarily based in pleasure or affection: professional friendships may be predicated on mutual interests and business networks.

Our intention in curating this collection of chapters is to take an international and cross-cultural approach to discussions about friendship by curating a set of diverse contributions situated in a transnational

context that takes friendship seriously as a subject of feminist study. It is important to look at the diverse range of friendships that exist cross-culturally in order to tease out the commonalities between experiences of affinity that are enmeshed with the differences between social, national, legal, and cultural frameworks surrounding thee relationships of affinity and affect.

This is far from the first text that studies friendship from a range of academic perspectives. Indeed, the concept of friendship has received attention in Western moral philosophy; in the *Nicomachean Ethics*, Aristotle theorizes that friendship is a path to knowledge of the self (qtd. in Biss), whereas Cicero links friendship to virtue by postulating that true friendship is only possible between good men. Ferdinand Tönnies, David Hume, and even Adam Smith (Shearmur and Klein) have opined and theorized about how friendship has developed new forms under capitalism (Hill and McCarthy). Anthropologists, too, have studied friendship, although it has not received as much attention or study as kinship (Bell). Across a variety of fields in the social sciences friendship is studied, although it is dramatically understudied relative to other human relationships (Pahl). What is fundamentally new about this contribution is its interdisciplinary approach and its breadth; it employs a feminist theoretical lens along with a cross-cultural, transnational scope. Moreover, this volume offers a synthesis between the critical academic study of friendship and feminism, specifically matricentric feminism. This volume has been crafted as a space for discussion—as well as the production of new imaginaries within critical feminist scholarship, analysis, and politics—about what it means to be a friend. This is intersectional feminist scholarship; therefore, this text considers how the categories of women and gender intersect with other dimensions of social identity, such as race, sexual identity, and class. Cross-gender and same gender friendships are also critically considered.

This volume seeks to bring together diverse perspectives through creative contributions, social science research, scholarly work, and critical theorizing about the roles, representations, identities, and work associated with being a friend. This is an interdisciplinary anthology. Contributions hail from a wide range of disciplines and fields, including psychology, sociology, anthropology, women's and gender studies, cultural studies, literary studies, and legal studies. Creative contributions are also included, including fiction, poetry, and art.

In her book *All About Love: New Visions*, bell hooks writes the following: "All the great social movements for freedom and justice in our society have promoted a love ethic....Were a love ethic informing all public policy in cities and towns, individuals would come together and map out programmes that would affect the good of everyone (hooks 6). The notion of friendship critically explored in this volume can take place within the context of marriage, as Mary Wollstonecraft espoused when she advocated marriage as friendship (qtd. in Abbey), but it is a concept not limited particular forms of kinship or status-based relations. When writing about love, hooks is not only contemplating a romantic or sexual concept but also "love as a verb," (6), which includes relationships between parents and children and between people in platonic relationships. She defines love as "the will to extend one's self for the purpose of nurturing one's own or another's spiritual growth" (6). Here, love is an enduring sense of warmth towards a person that shows a deep concern for them. It is related to kindness, munificence, and commitment as well as closely connected to what Sara Ruddick has called "maternal thinking." The care-based, other-centred themes of hooks's politics of love are resonant with Ruddick's maternal thinking. This resonance connects the concept of friendship explored in this volume with Andrea O'Reilly's "matricentric feminism." O'Reilly explains this as a feminism that positions mothers' concerns as the starting point for a politics and theories of empowerment. The love and care for an embodied, willful other that defines maternal thinking is closely connected to the relations of affinity that forge friendship, making matricentric feminism highly relevant to this work.

This book draws on the theoretical foundations of hooks's work and the theoretical lens offered by matricentric feminist scholarship; it also explores the potential of friendship, as Aristotle conceived of it, as a path to virtue—but a collective virtue not just an individual one. The contributions within this volume all resonate with the notion hooks proposes: how might we centre a politics of love when engaging in government of human relationships? And in doing so, how might we talk about friendship as a relationship based entirely on affinity, and not status, property, or filiation? The primary focus of this work is the feminist study of friendships between women, but it takes a constructivist approach to the definition of the project; thus any relationship based on affect rather than romance or filiation falls within the scope of this book.

Friendship is a fluid and not generally fixed relationship, which is based entirely on affinity, as opposed to status, although there can be status-based friendships. Whereas actual friendships often involve some level of inequality, the notion of friendship is a fundamentally egalitarian concept—a relationship of affinity without domination, which is precisely what hooks advocates we centre in contemplating a politics of love.

A liberating politics of love starts by centring friendship as a relationship for analysis, for fostering, and for protection. Following the maternal thinking espoused by Ruddick, moreover, a politics of friendship is an emancipatory politics of peace. This book critically assesses the emancipatory potential of friendship.

The contributions in this anthology are as follows. Sally Param's chapter, "Responding and Adjusting: Exploring the Friendship Dilemma through the Qualitative Lens of Educated Indian Women in Malaysia," examines the experiences of Indian women and Southeast Asian women with regards to nonkin friendships. Param interviewed eighteen Southeast Asian women with various middle-class careers and of varying ages, and she seeks to uncover exactly what these women are spending their leisure time on, the importance of nonkin relationships, and the adherence to the traditional view of kinship as the most valued relationship.

Rebecca Bromwich advocates for the decriminalization of polygamy in Canada in her chapter "Blurred Lines and Spaces for Renewal: Reconsidering Polygamy under Canadian Law." She uses trends in contemporary family law and empirical evidence to explore section 293 of the Canadian Criminal Code and whether it has any parallel to Canada's current views on family and friendship.

Josephine L. Savarese's chapter "Research Project Reality Show: Three Poems" explores her experiences working on a research project over three years with a colleague. The poems use various styles and topics, but all center on the friendship found between colleagues.

Meredith Stephens, an Australian woman and mother, recounts her experiences as a bilingual, Japanese-speaking woman living in Japan and the concept of friendship in her chapter "Friendships in the Japanese Language: Intersubjectivity through Mothering." She compares and contrasts these specific relationships from her life at home to her life abroad by comparing the Western concept of friendship against the

Japanese concept of friendship, specifically the special bond she has created with other Japanese women as mothers.

In "The Ibeji Model: Friendship Bonds as Soul's Salvation in the Scholarly Writing Process," S. Alease Ferguson and Toni C. King explore the unfortunate reality that they, as African American women, faced when entering the world of academia—the pressure to publish and the need to form a dyadic-relationship, classified as the Ibeji Model, to survive the patriarchal environment of academia.

Elieen Doherty and Kari Wilson's chapter, "Women 'Playing House': An In-Depth Examination of Adult Female Friendship on Television," uses the television show *Playing House* to examine the media portrayal of female friendship. The study uses multiple episodes to categorize the portrayal of female friendship and how it mimics, or rejects, the trends of female friendships in reality.

In "Protecting the Public in the Twilight of Trials: Towards Access to Justice in Relational Conflict via the Regulation of Mediator," Rebecca Bromwich and Thomas Harrison explore connections between affinity, friendships, collegiality, and the benefits and risks of alternative dispute resolution, specifically mediation, and how it can be more effectively integrated into the current legal environment in The study was conducted using a small survey of fifty-one people of various legal backgrounds in order to gauge the general public's attitude towards mediation and the desire for it to be a regulated legal practice.

In Myrina Bromwich's essay "Friendship," the ten year-old author describes her personal feelings towards, and experiences of, friendships and the value they hold. She explains her positive and negative experiences but ultimately concludes that friendship is an inherent and important part of life.

Finally, Jens Urban's essay "Polygamy and Human Rights in Canada and France" critically assesses how the legal treatment of polygamy in Canada and in France not only fails to appreciate the nature of human friendships and relationships but also violates human rights law.

It is our hope that this diverse, interdisciplinary collection sparks contemplation and conversations about what bell hooks enjoins us to consider: how politics, law, and theory may be reimagined if we foreground the human bonds of love and friendship.

Works Cited

Abbey, Ruth. "Back to the Future: Marriage as Friendship in the Thought of Mary Wollstonecraft." *Hypatia,* vol. 14, no. 3, 1999, pp. 78-95.

Allan, Graham. *Friendship: Developing a sociological perspective.* Hemel Hempstead, Harvester Wheatsheaf, 1989.

Bell, S. and S. Coleman, editors. *The Anthropology of Friendship.* Berg Publishers, 1999.

Biss, Mavis. "Aristotle on Friendship and Self-Knowledge: The Friend Beyond the Mirror." *History of Philosophy Quarterly,* vol. 28, no. 2, 2011, pp. 125-40.

"Elie Wiesel Quotes." *BrainyQuote.* BrainyMedia Inc, 2019. www. brainyquote.com/quotes/elie_wiesel_393174. Accessed 30 Aug. 2019.

Hill, L., and P. McCarthy. "Hume, Smith and Ferguson: Friendship in CommercialSociety." *Critical Review of International Social and Political Philosophy.* vol. 2, no. 4, 1999, pp, 125-40.

hooks, bell. *All About Love: New Visions.* Harper, 2000.

O'Reilly, Andrea. *Matricentric Feminism: Theory, Activism, Practice.* Demeter Press, 2016.

Pahl, R. *On Friendship.* Polity, 2000.

Ruddick, Sara. *Maternal Thinking: Toward a Politics of Peace.* Beacon Press, 1989.

Shearmur, J. and Klein, D. B. 'Good Conduct in a Great Society: Adam Smith and the Role of Reputation' in J. D. Klein *Assurance and Trust in a Great Society,* edited by J.D. Klein, Occasional Paper Number Two, Foundation for Economic Education, lsb.scu.edu/~dklein/ papers/goodConduct.html. Accessed 31 Aug. 2019.

Chapter One

Responding and Adjusting: Exploring the Friendship Dilemma through the Qualitative Lens of Educated Indian Women in Malaysia

Sally Param

Many have argued that Asian society prioritizes the strength of kin relationships over those of friendships. Noriko Tsuya and Larry Bumpass, as well as Nelson Chow, have shown how familial ties have acted as sources of emotional support, providing kin members' material and nonmaterial needs. However, processes due to postindustrialization have caused even Asian societal structures to adapt and reorient towards change. Intan Hashim et. al show how the effects of overwork, the decentralization of offices, and the inclusion of nonwork space within employment structures in Malaysia have created a new need for leisure hubs as well as friendship circles. Through the globalization of technological advancements, friendships across borders and continents have been made possible. John Helliwel and Haifang Huang explain that with the click of a button, the definition of social networks takes on a heightened meaning, and the addition of one word, "online," creates a whole new dimension of friendship. This online phenomenon can be seen as weakening family bonds and strengthening friendship circles. Commenting on urban lifestyles within an Asian context, Wendy Samter et al. discuss how friendship networks rely on

the physical environment, the situation, and nonverbal cues as added elements of friendship. The Malaysian context is similar, as evidenced by Hashim et al. Their statistics show that friendship circles not only reduce stress levels faced at the workplace, but seem to be the preventive tool of numerous social and psychological ailments.

This social context seems ideal to explore the lives of the women represented in this chapter, and to what extent they enjoy friendships. And yet, taking a closer look at racial and socio-economic boundaries is a necessary step as understanding the context of these women's motivations and aspirations will give insight to their preoccupations (of lack of it) about friendships.

Current Local Narratives

Globalization and the push for economic growth have propelled Asian governments to highlight the inclusion of women in their national labour force statistics (Douglass; Kabeer). Narratives in Southeast Asia evidence this as well (Quah), and as with the women of this research, their roles are now claimed as instrumental in moving their national economies forwards. In Malaysia, five-year socioeconomic plans support its gendered employment agenda. The Eleventh Malaysia Plan (2016–2020), the most current, continues to carry normative assumptions that most women get married, become mothers, and contribute to the participation rate of women in the labour force. Dual-income households that contribute to the growth of middle-class families are the current target group, as this category is seen as bringing stability to the country.

From the plethora of these politicized narratives, what emerges is the *type* of Malaysian women that the modernizing nation desires as part of their feminine national identity. Middle-class women who straddle motherhood and employment are projected as the gendered epitome of the nation's socioeconomic transformation. These women are not only able to feed the global market economy but also to keep their homes in order (Douglass). The women referred to in this chapter fit this desired prescription perfectly. They are educated, employed, mothers, and wives living in urban Malaysia. Together with their husbands, they make up the middle-class, dual-income household, which constitutes the sought-after category in national economic policies. Ideally, these

women's societal position spells success from every angle. This category of women is the perfect match for the study of urban friendships globalizing, modernizing Asia. As the study by Hashim et al shows, friendship groups are seen as the new norm for urban Malaysia. And yet, what should seem like a natural progression of these urban women engaging with friendship groups is thwarted by unseen obstacles.

The Shadow of History

Peter Robb's work highlights how the Indian community entered Malaya (as the nation was then called) in the late 1800s; as a diasporic minority under British colonial rule. Although almost ninety-five per cent of the total population came in as manual workers (rubber tree tappers and railway track labourers), the British did want workers educated in English to form the civil service and administration. From a gendered perspective, Kernial Sandhu's work depicts clearly that the Indian migration of both manual worker and educated white-collared worker "was essentially a movement of male adults" (Sandhu 154). Both these historical aspects shed light on the lives of the Indian women in this research. Although their grandmothers also came to Malaya as a diasporic entity, their entry into their new homeland was silenced by history books. Only records of 'male adults' exist. The women of this research are defined as educated, as their grandparents are part of the white collar worker recruitment by the British. Since then, although more than a hundred years have passed, and the Indian women population has grown, there are still very few public narratives that prioritize Indian women. Writers within the country continue to discuss dominant discourses that focus on 'bigger' issues pertaining the Indian community: poverty, patriarchy and (their lack of) political presence (Tate; Sandhu and Mani; Manickam).

Writing about the Chinese minority community in Indonesia, Chang-Yau Hoon explains how the Indonesian government promotes "decorative aspects" of the Chinese minority as part of "their ideal version of minority cultures" (Hoon 155). This is an excellent parallel to the representation of Indian women in Malaysia. Indian women are portrayed within the traditional stereotype of wearing long braided hair and dressed in colourful *sarees* or *salwar kameez*. These elements are "celebrated as evidence" that the minority culture lives "happily ever

after" with the dominant cultures (Hoon 155). This image intentionally conveys the idea that only the 'decorative' elements of Indian femininity are celebrated within Malaysia; real-life representations of Indian women in social media or popular narratives continue to be few and sparse.

This backdrop explains the silence that educated Indian women face in Malaysia. These women fulfill the current feminine national identity, but only on paper. Borrowing Benedict Anderson's concept of an "imagined community," these women enjoy an imagined national identity that denotes success. In reality, they still attempt to emerge from the shadows of a recent history that has eclipsed their identity along gendered and ethnic lines. This perspective will help explain the friendship dilemma in their lives.

Methodology

Twenty Indian women were interviewed for this research, and all of the women live in the heart of Kuala Lumpur (referred to as KL from now on), the capital of Malaysia. The methodological framework for this research is qualitative, and although I am researching on women, I am careful to not call this a feminist lens. To do so would be erroneous, as decades earlier, Shulamit Reinharz exposed how "malestream" methodologists had claimed that quantitative methods were more scientific and, therefore, more masculine. Therefore, although this research studies the lives of women, the framework itself should be gender-free. I have used an interviewing technique that does not follow a strict format of structured questions. My questions are been open-ended and I find that this is the best approach, as it allows the participants to express themselves freely. These women were interviewed one-to-one in the privacy and the comfort of their homes.

My approach is also reflexive and combines the "multi-perspective practise" and the "positioning practise" (Alvesson et al. 483). Both these approaches allow me to complement the women's perspectives with mine and to contextualize the women's views against "broader institutionalized norms" (Alvesson et al. 485). These methodological approaches enable the women's views on friendship to be analyzed not just as a separate entity but as interdependent and interconnected data within the larger context of their lived experiences.

The women's responses are recorded and transcribed, which are then interpreted, operationalized and analyzed. These women have signed informed consent papers prior to the research, which enables me to use their actual names in this chapter. Each participant mentioned in this chapter had been given a choice to use a pseudonym in spite of their consent, but no one wanted to do so.

Forming Friendships

This section looks at the evolution of how these women manage leisure spaces with friends. The meaning of nonkin friendship that I will be using as a reference point is best defined by Daniel Hruschka: a "long-term relationship of mutual affection and support" (Hruschka 2). I explore how these women form and maintain face-to-face friendships within the context of leisured space. Self-care is also delineated under leisure and will be referred to later, but the main focus of this chapter is how these women attempt to form meaningful friendships. The historic neglect and current policies discussed earlier shed light on these women's positionality in society.

The topic of friendships can be likened to a conceptual leverage in the lives of Malaysian Indian educated women. This is because, as Helliwel and Huang show, having friendships in urban Malaysia is not so much about avoiding loneliness or boredom; rather, for these women, friendships allows them to articulate a feminism that speaks to their ability to be successful in life. This reality echoes older research by Dominic Strinati, which claims that by having time for friendship circles, these women are taking their nonwork lifestyle more seriously. Below are snippets of the conversations I had with these women as they discussed how they negotiate space for meaningful friendships.

Thirty-nine-year-old Shamala is a businesswoman, who decided to resign from an established international computer company and start a retail cake-making shop. Although she is busy with raising her two young sons, she still finds time to be with friends: "Yes, we do make it a point to meet up—not as often as we like, but yes, we do meet up. We have in a way grown up together from college days, and we have fun just going out and being together."

Thirty-eight-year-old Gauri has two young children, and she stresses her need for her girlfriend time: "Catching up makes a big

difference. We look forward to it, us girls. It's quite therapeutic for us."

Both Shamala and Gauri express the closeness they feel with their girlfriends, a connection they have developed over the years. Both these women demonstrate the element of mutual affection that is consciously protected through frequent meet ups. For other women, their friendship circles are measured more in terms of time-based convenience.

Forty-nine-year-old Sudha has two adolescent daughters and teaches in a primary school. She talks about the group of friends she connects with: "The year-end holidays are the best time to travel together, as the kids are off school. My friends and I are busy with work, but we enjoy planning for an overseas trip, and saving up for it throughout the year. It's something we look forward to. We have gone to India and Cambodia, and are now thinking of where next."

Forty-two-year-old Priti is a home designer and restaurant owner, and because she runs her own business, her time for friendships is fluid: "If I am not with my [three] kids, I am busy with my business, but if friends want to pop by, they are most welcome. As long as they are ok when I get random calls on the phone about this or that, or if they are ok to dine at my restaurant, then catching up becomes much easier. My friends have to accept my crazy life."

For these two women, friendship circles are important, but only if it can be dove-tailed into their work-life. While these women also enjoy friendships, the disposition is affected by their work schedules. These women are more flexible in their approach to friendships, where adjusting to work patterns take precedence. While these women enjoy their same-sex friendships, other women joined their husbands in sharing friendships with other couples.

Thirty-nine-year-old Jigna is a department head in an educational institution with two children under fourteen. Her administrative and domestic duties often overlap, but friendship is one thing she does not compromise. In Jigna's case, her friends are the wives of her husband's friends. This means that the children of these couples are also involved, and their time together becomes more a combined family outing: "We try our best to meet every weekend. The kids play badminton or some sport, while we get together and chat. I wait for the weekends to come, like a ritual. Friendships like these are important, you know, even for the children, as we can grow together."

Forty-year-old Yasodha is a mother of two boys and shares a good

group of friends with her husband: "We don't meet face-to-face so often, as we are busy with life. But once a year, we try to go for a holiday together as a group ... although we make it short, as the kids are here with their grandparents. Last year we went skiing to Melbourne."

Forty-seven-year-old Sara is a bank manager who also shares a friendship circle with her husband: "Actually, the men are my husband's friends, but we wives decided to be part of the group, too. A few years ago, we decided to spice up our occasional meet ups by organizing trips out of town. When we travel out, we stay in a nice recreational site, about six to eight of us."

For these mothers, their feelings and behaviours towards friends can be seen as a psychological extension for the need of kinship (Hruschka). Because their husbands are also involved, the sharing of common friendship circles creates a kin-like bond which these women prefer. The commitment to these types of friendships are more dependent on features of commonality, rather than preference and comfort.

The three types of friendships discussed thus far validate the women's needs for social support and subjective wellbeing (Helliwell and Huang). These women attach significance to their friendships, and receive emotional support that contributes to their subjective wellbeing (Samter et al.). The case is different for the other mothers.

The Gap—Children

Despite the small group of Indian women enjoying friendships, some of the other mothers hardly mention anything about friendship groups. In their responses, they were more preoccupied with quotidian time-management issues. Being part of dual-income households in a fast-paced urban environment, Stella Quah sheds light on how these women are caught "in the exigencies of a modern economy" (110).

Some of the mothers talk about how their work experiences tire them. Fifty-year-old Mary is a medical doctor with two adolescent daughters, and although she has some free afternoons, she has to clock-in from 9:00 a.m. to 5:00 p.m. three nights a week: "I drive a lot, and I don't sit at the clinic. My medical team is a panel for many major companies, and they have clinics in their factories, where I have to go with my nurses. So, apart from actual work, there is also a lot of driving her and there."

Forty-nine-year-old Navisha is a securities commissioner, and most of her hours are at work: "If I'm home by 8:00 p.m., everyone feels I'm home early. If it's late, it can be midnight. Otherwise, it's between 9:00 and 9:30 p.m. I can come back earlier, like before 8:00 p.m., but that would mean really leaving things behind, and it will load up my work the following day."

Brenda Yeoh and Shirlena Huang discuss how the majority of urban-dwelling employed mothers hire domestic help or rely on the help of their own parents to supervise their children's after-school hours. Although a few women do have husbands who perform childcare duties, gendered conjugal roles is more the norm (Douglass; Baker).

However, what is more interesting—beyond the levels and types of support these women receive or don't receive—is that most of these modern-day working mothers in Malaysia do not prioritize domestic roles like women used to in previous generations (Param). Rather, the main preoccupation of these women is their children's educational engagements. Middle-class mothering has taken on new levels of expectation in modernizing Asia; Southeast Asian urban mothers now see their roles as educational agents to their children's performance at school. Instead of domestic chores, the "key project of mothering practices" has become helping the children improve their grades at school (Yeoh and Huang 33). A practice peculiar to Malaysia and some other Asian countries is that school children continue to go for classes after school hours. During these after-school classes, tutors are paid to give extra coaching tips in the subjects the students are weak at, or want to improve in. These extra classes are called 'tuition' classes in this region, and has become a regular practise in most urban homes that have school-going children.

Forty-four-year-old Annie has two adolescent children and says the following: "My children have some tuition between 3.30 and 7:00 p.m. after school, so I drive them to and fro," whereas fifty-year old Mary says, "when the tuition teacher changes the timing of their lessons, we are all in a fix. I have to take leave to send the kids for these classes. Tuition rates are so expensive nowadays."

Forty-five-year-old Shanthi says the following: "my husband and I both studied in local schools, but we received government aid to have our tertiary education overseas. I don't foresee my children getting such scholarships, and so we have put them in international schools. The

tuition fees are exorbitant, but we feel we want the best for the children." Thirty-nine-year-old Prema says, "my friends and I have the typical middle-class upbringing, where going to private school is the norm. Naturally, I want this for my kids as well."

These examples show the shifting trend of these working mothers' priorities. Moving away from a preoccupation with the domesticity of household chores and meals, these women's focus is now heavily related to their children' education. Chris Rojek had talked about how feminist theories had "problematized the relationship between ideology, gender and choice" (Rojek 34). Those older feminist theories had rightfully addressed how patriarchy and gender role ideology had inhibited women from enjoying friendships and leisure according to their own preferences. Comparing a previously common underlying structure to this current context of intensive mothering, it is perhaps inaccurate to blame patriarchy as the reason for women's inability to appreciate leisure or friendship patterns. These mothers have made the conscious choice to extend mothering to another level altogether, at the expense of their own need for friends. While evidencing a typical Asian middle-class cultural trait in their 'mothering practices', are these Indian women creating an urban lifestyle that excludes meaningful friendship for themselves?

The Gap—Kin

Each of the women in this research enjoys paid employment at the middle-class level, and, typically, this is where "the traditional sociology of leisure" can be most practiced (Rojek 34). As Christia Wichterich shows, these women are in systems that allow them the decision-making space to take leave or even be awarded allowances for leisure pursuits.

Shalini Singh talks about how "Malaysia's urban professionals" are part of the middle-class population who enjoy "recreation" as part of "a comfortable lifestyle" (287). So why is it that these women don't consider friendship circles as part of their recreational needs? During my conversations with these women, the topic of friendships did arise from an initial conversation about leisure. And although only a few women talked about friendship circles, the majority of them did opine on leisure. The women spoke about how their families enjoyed leisure

collectively (either at home, or away).

In conversations about out-of-town trips, especially during the school holidays, a common feature was identified: almost all of these nuclear families would visit and stay over in a relative's home. Forty-four-year-old Annie, a manager, has a brother-in-law in Sabah (a two-hour plane ride from KL), and his house was the meeting point. Forty-four-year-old Uma, an airline officer, spends all her school holidays at her mother's place in Raub (a journey of 75 km from KL). Thirty-seven-year-old Anna spends her children's school holidays in Pahang a 200 km car ride from KL.

Fifty-two-year-old Navina shares the following: "Since my father wanted all his children and their families to go for one combined holiday, we don't stay at any one sibling's home. We go away to a nice resort or hotel and have our annual family holiday there."

These narratives show the value of family to the average Indian, middle-class household. Leisure, for these women, is connected to catching up with relatives and kin members rather than with nonkin friends (Armstrong; Hashim et al.). Making or keeping friendships was not a common necessity for the majority of them; rather, filial piety to kin members of the family seemed to dominate their leisure trends. While a postmodern, twenty-first century context would see leisure being celebrated in multiple, personalized ways, these women's engagement with leisure is far from adherence to a contemporary trend. What dominates these women's lives is the traditional norm of cultural and ethnic priorities, like kin-based support.

As Hruschka's detailed study of friendships reveal, it is kin support that meets the definitions of social acceptance and emotional support for these women. More than engagements in friendship circles, these women rely on kin to provide mutual affection and support. Why do these Indian women seemingly hesitate in finding support through meaningful nonkin friendships? Why do they maintain "kinscripts" over personal fulfillment? Why do they still affirm traditional theorizations of leisure, which highlight familial cohesion and community renewal over individual wellness and personalized social networks?

First Steps

The use of reflexivity as a research tool helps bridge the gap between what these women ought to progress into and where they are at. The years of remaining eclipsed and silenced in both popular and national narratives have caused these women to merely conform to existing patterns. The clash in values these women had to contend with—oscillating "between the need to be productive and to be reproductive" (Thambiah 57)—is still ongoing, where conformity to ethnic and national scripts has been the biggest definition of their identity. These women want to be good mothers and successful women in employment. Together with public narratives that have silenced them, while focusing only on the "decorative aspects" of their ethnic identity, these women have merely conformed to existing stereotypes. Although friendship circles have become synonymous with a universal middle-class lifestyle, these women still respond to older scripts that have told them what to do and how to behave.

Perhaps first steps need to be acknowledged. If friendships with other women are not yet celebrated, attempts at personalized leisure are. During the interview process, there was one research question that gave me, the researcher, an immediate connection with the mothers—"How do you find time for yourself?" If there were existing inhibitions between me and the mothers during the research process, this one question seemed to be the proverbial elixir that brought down all forms of resistance and that the mothers used as a pivot to express themselves more fully. This one question seemed to say that they need not impress me with stories of glorified motherhood or successful career paths, and that they could be free of such a researcher bias. Their stories of their downtime revealed that they *did* want to explore leisure and friendship circles.

Forty-four-year-old Annie loves a good pamper: "Yes, with all the hard work I do, I must try to pamper myself. I go do my hair and nails ... I do massages and all." Forty-year-old Yasodha, meanwhile, shares the following: "The kids go to bed by 9.30 p.m., and I like to plan everything while I am home. So my facial lady comes around 9.30 p.m., or a therapist for reflexology. My kids don't like me going out, so that's how I manage my me time."

Forty-one-year-old Selvam finds the day filled with too much of activity and, therefore, seeks time for herself: "I love this time as

nobody bugs me. I get up very early, like at 5:00 a.m. It's just me myself, and I don't have to talk to anyone. That one hour is enough."

Fifty-two-year-old Navina also has a hectic life, as she handles her three sons' schooling experience which can be exhausting: "Sometimes at 9.30 or 10:00 p.m., I'll be watering my plants. It's nice, you know? Just being out there in the garden, watering your plants, nothing to think or worry about ... it's my time."

These "me times" were the tiny spaces of time where the mothers gave themselves the permission to not dabble with mothering responsibilities or carry out a national project that would move the economy forward. It was these seemingly insignificant spaces that actually empowered the women.

What then, of friendships and this ethnic minority group of educated, middle-class Indian women in Malaysia? Perhaps the key social processes involved in the creative workings of friendship are still new for these women who still cling on to cultural roots of kin support. All is not lost. Fifty-year-old Sujata, a mother of three, says the following: "Yes, I do keep in touch with my friends. We have been friends since secondary school, so you see it has been a long time. Recently, when we all turned fifty, we spent a night together in a hotel. That's how we painted the town red."

Eight of the women in this research have shown that "finding support in the form of friendships" is a serious adaption for Indian women in "urban Malaysia" (Armstrong 623). These few women have crossed the bridge to find such needful support.

Friendships provide elements of mutual affection and support, and can decrease individuals' stress levels (Hruschka; Hashim et al). For most of the women in this research, their intensive mothering strategies and kin-based priorities have caused them to miss out on "the happiness effects" that nonkin friendships bring (Helliwell and Huang 16). Despite this, there is an element of positivity in these women's lives. The tiny, negotiated space for "me time" could be a precursor for these women giving themselves the permission to consider friendship circles that they personally prefer and want. It can be said that eight of these women already have a postmodern identity, denoted by the gradual disappearance of culture, ethnicity, and the nation-state, as defined in the narrative provided by Strinati. Together with the other women who enjoy the small spaces of "me time," perhaps the stage is set where old

impasses can be broken, and new trajectories can be created, through which these women can reinvent themselves. By responding and adjusting, perhaps educated Indian women of Malaysia will finally be able to engage in meaningful nonkin friendships.

Works Cited

Alvesson, M., et al. "Reflecting on Reflexivity: Reflexive Textual Practices in Organization and Management Theory." *Journal of Management Studies,* vol. 45 no. 3, 2008, pp. 480-501.

Anderson, B. *Imagined Communities: Reflections on the Origin and Spread of Nationalism.* Anvil Publishing Inc, 2003.

Armstrong, M. Jocelyn. "Womens' Friendships under Urbanization: A Malaysian Study." *Women's Studies International Forum,* vol. 10, no. 6, 1987, pp. 623-33.

Baker, J. "Young Women and Housework: Awkward Relics of Modernity and Post-feminist Empowerment". *Australian Feminist Studies,* vol. 27, no.74, 2012, pp. 339-54.

Chow, Nelson. *Untapped Resources. Women in Ageing Societies across Asia.* Marshall Cavendish International, 2005.

Hruschka, Daniel J. *Friendship: Development, Ecology, and Evolution of a Relationship.* University of California Press, 2010.

Douglass, M. "Global Householding and Social Reproduction: Migration Research, Dynamics and Public Policy in East and Southeast Asia." *Asian Research Institute Working Paper Series No. 188.* National University of Singapore, 2012, PDF document. www.ari.nus.edu.sg/wps/wpsl2_188.pdf. Accessed 23 Aug. 2019.

Government of Malaysia. "The Eleventh Malaysia Plan 2016–2020." Asia Pacific, policy.asiapacificenergy.org/node/2508. Accessed 23 Aug. 2019.

Hashim, Intan, et al. "Factors Predicting Inter-Ethnic Friendships at the Workplace." *Interpersona,* vol. 6, no. 2, 2012, pp. 191-99.

Helliwell, John, and Haifang Huang. "Comparing the Happiness Effects of Real and On-Line Friends." *PLoS ONE,* vol. 8, no. 9, 2013, pp. 1-17.

Hoon, Chang-Yau. "Assimilation, Multiculturalism, Hybridity: The Dilemmas of the Ethnic Chinese in Post-Suharto Indonesia." *Asian Ethnicity*, vol. 7, no. 2, 2006, pp. 149-66.

Kabeer, N. *Reversed Realities: Gender Hierarchies in Development Thought.* Verso, 1994.

Manickam, J.R. *The Malaysian Indian Dilemma: The Struggles and Agony of the Indian Community in Malaysia.* Nationwide Human Development and Research Centre, 2010.

Param, Sally Anne. "Battling with Ourselves: Exploring How Far Indian Middle-Class Working Mothers in Malaysia Are Able to Negotiate Gendered Spaces." *Asian Women*, vol. 31, no. 2, 2015, pp. 29-52.

Quah, Stella R. *Families in Asia, Home and Kin.* Routledge Taylors and Francis Group, 2009.

Rojek, C. *Decentring Leisure: Rethinking Leisure Theory.* SAGE Publications, 1995.

Reinharz, Shulamit. *Feminist Methods in Social Research.* Oxford University Press, 1992.

Robb, Peter. *A History of India.* Palgrave, 2002.

Samter, Wendy, et al. "Ethnicity and Emotional Support in Same-Sex Friendships: A Comparison of Asian-Americans, African-Americans, and Euro-Americans." *Personal Relationships*, vol. 4, 1997, pp. 413-30.

Sandhu, Kernial. "The Coming of the Indians to Malaysia." *Indian Communities in Southeast Asia*, edited by K.S. Sandhu and A. Mani, The Institute of Southeast Asian Studies, 2006, pp. 151-89.

Singh, Shalini. *Domestic Tourism in Asia.* Institute of Southeast Asian Studies, 2011.

Strinati, Dominic. *An Introduction to Theories of Popular Culture.* Routledge, 1995.

Tate, M. *The Malaysian Indians: History, Problems and Future.* Strategic Information and Research Development Centre, 2008.

Thambiah, S. "The Productive and Non-(re)productive Women: Sites of Economic Growth in Malaysia." *Asian Women*, vol. 26, no. 2, 2010, pp. 49-76.

Tsuya, N., and L. Bumpass. *Marriage, Work & Family Life in Comparative Perspective, Japan, South Korea & the United States.* University of Hawaii Press, 2004.

Wichterich, Christia. *The Globalized Woman: Reports from a Future of Inequality.* Zed Books, 2002.

Yeoh, Brenda. S., and S. Huang. "Mothers on the Move: Children's Education and Transnational Mobility in Global-City Singapore." *The Globalization of Motherhood: Deconstructions and Reconstructions of Biology and Care*, edited by W. Chavkins and J. M. Maher, Routledge, 2010, pp. 31-54.

Chapter Two

Blurred Lines and Spaces for Renewal: Reconsidering Polygamy under Canadian Law

Rebecca Jaremko Bromwich

Introduction

> "Love is friendship that has caught fire."
> —Ann Landers

My purpose in writing this chapter is to investigate, engage with, and deepen conversations about the theorizations of love, friends, and family underpinning Canadian law's treatment of friendship. The specific focus of this chapter is around criminal prohibition against polygamy in Canada and how this connects with theorizations of friendship. I look at the regulation of polygamy in the context of how friendship is regulated under the law, how Canadians organize their lives around ties of affect and friendship, and what boundaries are drawn around those relationships. I argue that Canada's current criminalization of polygamy should be reconsidered in view of friendship as a liberating expression of what bell hooks has called a "politics of love."

Traditional conceptions of the family under the law focus on the

statuses into which people have entered; the more contemporary trend in the family law context is to look at the connections of affect that grow in the spaces created in private lives. Although people who consider themselves to be friends can enter into contracts with one another, for the most part, "friendship" is not a legal status. The status of "friend" has historically conferred no automatic or agreed upon rights or obligations. At the same time, the bonds of affinity that forge friendship have long been understood to be significant in people's lives. Furthermore, in our current era, new bonds of affection are being legally recognized, and "family" is becoming legally and socially to be understood as more than biological procreation—a kinds of friendship, which is often but not always conjugal, whereby the parties to the friendship seek to render their friendship as a legal entity, a status with lasting effect.

This chapter seeks to trouble the binary construction of friendship as opposed to family. I seek to explore the ways in which current social circumstances and changes to family law challenge the widely held assumption that friendship and family are necessarily distinct and separate things, thereby critiquing the notion that they should be legally understood as different from each other. This chapter explores which laws may logically follow if policymakers started from an understanding that marriages and families are variants of legally recognized friendships and that friendships are spaces of respite. If consensual ties of affect, whether conjugal or not, as opposed to particular family and statuses, underpin contemporary notions and practices of family as they are understood and enacted in the social world of mainstream Canada, this suggests law should support adults who choose to love unconventionally.

In July 2017, in *R. v Blackmore*, a Canadian court rendered the country's first polygamy convictions in over a century. There can be little doubt that convictions rendered against breakaway FLDS (Fundamentalist Church of Jesus Christ of Latter Day Saints) Mormon polygamists Winston Blackmore and James Oler were a correct application of the current law, as elucidated in the Reference re: Section 293 of the Criminal Code of Canada, But a larger, and more timely, question is whether that law should be changed. Whether criminal justice policymakers should reform the provision before a likely Charter challenge makes its way through the courts is a live question. In contemplating whether law reform is appropriate in this area, criminal lawyers, policymakers, and the public in general should bear in mind the knowledge and experience

of family law researchers and lawyers. The growing numbers of clients in a diverse variety of polyamorous relationships encountered by family law lawyers are relevant to any social policy discussion about whether consensual conjugal relations between adults should be criminalized.

Canada's Criminal Prohibition of Polygamy

The Provision

Polygamy is prohibited by section 293 of the Criminal Code of Canada. The section sets out as follows:

293 (1) Every one who
(a) practises or enters into or in any manner agrees or consents to practise or enter into
(i) any form of polygamy, or
(ii) any kind of conjugal union with more than one person at the same time, whether or not it is by law recognized as a binding form of marriage, or
(b) celebrates, assists or is a party to a rite, ceremony, contract or consent that purports to sanction a relationship mentioned in subparagraph (a)(i) or (ii), is guilty of an indictable offence and liable to imprisonment for a term not exceeding five years.

In its current form, as has been noted by Angela Campbell, the provision criminalizing polygamy in Canada is extremely broad. The language of section 293 gives the state sweeping powers against people living in polyamorous relationships. It carries the potential to criminalize women as well as men. It hangs over the heads of immigrant families, who hail from jurisdictions where they entered into polygamous relationships legally, and it does not recognize or exempt Indigenous families, which also, in many instances, have traditions of polygamy (Campbell, "Beautiful Voices"). As Campbell writes in a 2017 *Globe and Mail* opinion piece, "The scope of authority that the ban [on polygamy] gives the state to investigate, arrest, prosecute and punish individuals for their private, intimate choices is both broad and alarming" (Campbell, "Polygamy Ban").

The statutory language criminalizes a broad range of intimate, and even social, conduct between consenting adults. Section 293 creates an indictable (or serious) offence for which accused persons can be

sentenced to five years in prison if they enter into a polygamous marriage and even if they attend a polygamous marriage ceremony.

Polygamy has been prohibited in Canada since the Criminal Code was first introduced in 1892. As discussed below, the origin of this provision was in protecting then-commonly held Judeo-Christian family ideals against a perceived threat from the growth of Mormon populations, who were polygamous, in the North American west. The polygamy prohibition has not been amended since it first came into force, although comparable provisions that dealt with sexual and moral issues and family forms, such as the prohibition on same same-sex sexual contact and the criminal prohibition of adultery, have been struck down.

Although the Criminal Code has been amended since its adoption in 1892, section 293 has remained the same. The polygamy prohibition as enacted was situated in the context of provisions criminalizing adultery, suicide, and same-sex marriage. It has been included in the Criminal Code since it was first adopted in Canada. When enacted, the provision aimed at the protection of the specifically Judeo-Christian institution of monogamy against the growth of Mormon polygamy, perceived as a threat. Yet among the provisions regulating family forms that were specifically grounded in a nineteenth-century formulation of Christian values, the polygamy provision remains on the books, whereas adultery and same-sex consensual sexual contact are no longer illegal.

Prohibition of polygamy has been maintained for the stated purposes of protecting monogamy, preserving the ideology of romantic love, and defending mainstream Judeo-Christian norms against a perceived threat from Mormon evangelism. Polygamy has been expressly forbidden in Christian doctrine since at least the sixteen century Council of Trent (Percival 327). In the nineteenth century, American laws were enacted to prohibit polygamy largely in response to challenges posed to widely-accepted Christian norms of monogamy by Mormon doctrines allowing, and even encouraging, polygamy (Barringer Gordon 22-23; Quinn; Embry). The Canadian prohibition on polygamy was an outgrowth of the same cultural conflicts at the same time: it was similarly based on an attempt to legislate family forms in opposition to Mormon polygamy, and it grew directly out of U.S. efforts to quell the growth of Mormonism through deployment of law (Drummond 29). All of these things are problematic in a liberal democratic society in the

twenty-first-century and call into question the constitutionality of continued criminalization of polygamy pursuant to section 2(a) of the Canadian Charter of Rights and Freedoms, which assures freedom of conscience and religion to all.

Constitutional Scrutiny

Whether the prohibition on polygamy under section 293 continues to be enforceable now that the Canadian Charter of Rights and Freedoms provides, under section 2(a), for freedom of conscience and religion, was a matter recently considered by the British Columbia Supreme Court. The British Columbia provincial government brought a reference proceeding under Section 1 of British Columbia's Constitutional Questions Act. In 2009, the province referred two questions concerning the constitutionality of section 293 of the *Criminal Code* to its Supreme Court. The hearing of the reference case went on for several months; it lasted from November 2010 to April 2011. *Viva voce* and affidavit testimony were adduced by over ninety witlessness. A decision on the reference was rendered in 2011 in *Reference* re: Section 293 of the Criminal Code of Canada (Constitutional Questions Act), authored by Chief Justice Bauman of the British Columbia Supreme Court (BCSC).

The questions referred to the Court were as follows:

a) Is section 293 of the Criminal Code of Canada consistent with the Canadian Charter of Rights and Freedoms? If not, in what particular or particulars and to what extent?
b) What are the necessary elements of the offence in section 293 of the Criminal Code of Canada? Without limiting this question, does section 293 require that the polygamy or conjugal union in question involved a minor, or occurred in a context of dependence, exploitation, abuse of authority, a gross imbalance of power, or undue influence?

In answer to these constitutional questions, Chief Justice Bauman answered in the affirmative to a). He upheld section 293 of the Criminal Code and found that section 293 violated section 2(a) of the Charter but that harms he ruled to be associated with polygamy justified the limitation imposed on freedom of religion under section 1 of the Charter (Constitutional Questions Act para 1352). On the second question, the

Court held that section 293 applied to the practice of marriage between more than two people at a time. Justice Bauman did, however, limit the applicability of section 293 to be enforceable against adult accused only—and not against minors who are alleged to have entered into polygamous marriages.

The case was an unusual one in many respects. It was, foremost, unusual as a case without parties, since references are less common than prosecutions under criminal law. Perhaps ironically, given the nostalgic vaunting of history in the decision, the case was an unusually innovative legal process. It marked a movement of Canadian legal procedures towards the electronic age: it was the first British Columbia Supreme Court case for which the legal arguments were webcast live (Constitutional Questions Act para 33-34). The case also offered an unprecedented level of engagement for a wide range of scholars, advocates—such as the Canadian Civil Liberties Association and the Canadian Polyamory Association—and community members, such as people from the predominantly polygamous community of Bountiful, British Columbia, who appeared as *amicus curiae* interveners and participated actively in the proceedings. It was also the first BC reference case in which interveners were permitted to adduce evidence and cross examine witnesses.

Significantly, it was noted repeatedly by scholars and interveners in the case that social science data presented was not based on studies conducted in Canada but in other global jurisdictions. Queen's University law professor Nicholas Bala's report was quoted as follows:

> All of the empirical social science research comparing outcomes for polygamous and monogamous families is based on populations in Africa and the Middle East, where polygamy is relatively common and legal. Thus, *there is a lack of empirically sound research to irrefutably establish the harmful effects of polygamy in Canada*; this reflects the difficulty of doing research with polygamous families, who tend to be highly secretive. However, the research literature from Africa and Asia establishes that polygamy is generally harmful for women and children, which is broadly consistent with the first person, media and ethnographic reports about polygamy in Canada. (my emphasis, Constitutional Questions Act para 605)

Chief Justice Bauman elected not to "read down" Section 293 to refer only to what has been termed "exploitative polygamy," as the West Coast branch of Women's Legal Action Fund (LEAF), acting as an intervener in the case, had submitted should be done. LEAF requested that polygamy for criminal purposes be considered to extend only to "exploitative polygamy" and not consensual polyamorous relationships were no parties were being abused or exploited.

Those whose arguments were unsuccessful in the reference case chose not to appeal it. No reasons were given for this decision, although it is reasonable to speculate that they elected to save their limited resources to challenge the enforcement of the polygamy provision against an actual accused. The fact that the case was not appealed means that a higher court will likely have a particular set of facts to explore when undertaking an analysis of what limitations on freedoms are reasonable under section 1 of the Charter. It also means that a challenge is very likely pending now that the *Blackmore* conviction has been rendered.

The reference case decision rested primarily on detailed consideration of the history of monogamy in the West; however, it also discussed social science research around the question of harm. Although the decision did consider social science research—including scholarship that correlates polygamy with increases in warfare as well as work that contends that polygamy is economically disadvantageous—it largely uncritically accepted a Judeo-Christian foundation for contemporary Canadian criminal law.

The decision of Chief Justice Bauman set forth that the purpose of section 293 is to suppress the harms viewed as arising from polygamy: harms to women, children, society, and the institution of monogamous marriage (Constitutional Questions Act para 881). But these were characterized as "largely secular concerns" (Constitutional Questions Act para 904). Although the text of the reference case decision is complex and nuanced, its theoretical basis is simple: it rests on a theorization of families as something different from other types of affiliations and associations— different indeed from friendship. Justice Bauman concluded with an absolute statement: "there is no such thing as good polygamy" (Constitutional Questions Act para 1343).

The Blackmore and Oler Convictions

In the case of *R v Blackmore* (2017), the British Columbia Supreme Court rendered convictions against Winston Blackmore and James Oler for polygamy pursuant to section 293 of the *Code*. The Court confirmed that Winstone Blackmore's marriage, entered into by religious means, with at least twenty-four women and James Oler's simultaneous marriage to at least nine women constituted polygamy within the meaning of section 293.

It is notable that Winston Blackmore's impugned conduct not only consisted of plural marriage but also marriage to minors and allegations of sexual interference, offences for which he was also charged separately. Notably, several of Winston Blackmore's twenty-four wives were teenagers when they married; three were only fifteen years old and were still teenagers when they had their first children with him. Moreover, Blackmore and Oler, along with one of Blackmore's wives, had been convicted earlier in 2017 of removing a thirteen-year-old daughter of Blackmore and a fifteen-year-old daughter of Oler from Canada to be married to infamous U.S.-based FLDS leader Warren Jeffs.

In the *Blackmore* case, Justice Sheri Ann Donegan, writing for the British Columbia Supreme Court, found the accused guilty of polygamy largely without adding additional reasons for the constitutionality of section 293 to those specified in the previously mentioned reference case. The application of the provision to the facts of the case adopted the ruling that the prohibition was constitutional and focused its reasoning around what it means to practice polygamy—being an ongoing state of being married to more than one other person at the same time.

Certainly, aspects of Winston Blackmore's and James Oler's romantic lives are troubling. Notably, both are linked to sexual exploitation of minors, conduct that is in itself criminal, and for which they have been convicted quite apart from their polygamy convictions. It is abundantly clear that Winston Blackmore is not a popular individual in mainstream circles: there are well-founded concerns about the FLDS engaging in child marriage and effectively sex trafficking underage girls. It is an open question whether Canadians are or should be worried about the fact of Blackmore's and Oler's plural marriages or whether the real issue is with the allegations of child exploitation and abuse. Furthermore, it is also questionable whether the disturbing aspects of Blackmore's and Oler's polygamous marriages involving minors are inevitably results

that follow from polygynous relationships. Indeed, is Canadians' moral outrage in relation to the Blackmore case really about polygamy? Quantitative and qualitative social research discussed below suggest the answer to that question is no.

Social Research: The Canadian Context

Qualitative and quantitative social research dealing with the Canadian context suggest that Canadians are, on the whole, increasingly acceptant of unconventional family forms entered into by consenting adults, including same-sex marriage, common-law partnerships, polyamorous unions, as well as polygamy. I would suggest that a productive way to theorize this social change is to understand that social expectations and norms in the pluralistic Canada of the twenty-first century are evolving into a context in which the historical distinctions between families and friendships are becoming blurred. Social research also suggests that the harms speculatively associated with polygamy in the reference based on ideological assumptions and data from abroad may not be applicable in this country.

As has been noted by Campbell, the received assumption that wives living in FLDS polygamous unions in Bountiful, British Columbia, are always inevitably living in conditions of oppression is not evident when actually talking to them. Campbell interviewed twenty wives from polygamous families in Bountiful, and they articulated a diversity of views and experiences even within the context of breakaway Mormon polygamy (Campbell "Bountiful Voices"). From her research, Campbell argues that oppression and sexual inequality do not appear to flow automatically from polygamy.

Furthermore, the sweeping prohibition on polygamy under Canadian Criminal law does not just affect FLDS members in Bountiful. Many immigrants and refugees hail from jurisdictions in the Middle East and Africa where polygamy is legal, and they may live in family units where polygamous unions are a practical reality and cultures where polyamory is a social ideal. There is a growing disconnect between the emphasis placed on monogamy in the reasoning of the polygamy reference and the centrality of monogamy to mainstream Canadian's notions of family as well as the place of monogamy in a growing number of people's lived realities. This point was made in

testimony during the hearing of the polygamy referenced by Campbell and later in writing by the legal scholars who contributed to Gillian Calder and Lori G. Beaman's 2014 book, *Polygamy's Rights and Wrongs: Perspectives on Harm, Family, and Law* (Calder and Beaman).

As is well known to family lawyers, families are complex, and people's lives are complicated. Consensual, nonmarital polyamorous relationships proliferate in Canada, and they are not limited to the context of breakaway FLDS Mormons in Bountiful. They are also not limited to the paradigm of one man and several women (polygyny) but also extend to one woman and several men (polyandry). They are as plausibly bohemian as they are fundamentalist.

Some empirical data about polyamory in Canada has started to emerge, which were not available when the reference case decision was rendered, a gap that was indicated by expert testimony and interventions in the case. A just-released report from the Canadian Research Institute for Law and the Family (CRILF), "Polyamorous Relationships and Family Law in Canada," reports on a survey in which the majority of polyamorous respondents were more educated than average members of the general public, had better levels of employment, and reported egalitarian relationship. The CRILF report details the legal distinction between relationships that are polyamorous and marriages that are bigamous and polygamous. It further addresses how polyamorous relationships are (and are not) accommodated by the domestic relations legislation of Canada's common law provinces. Most significantly, the report provides statistical confirmation of what many family law lawyers already anecdotally knew: in Canada, as in the U.S, there are a growing number of polyamorous relationships. Indeed, the report recommends that focusing in on polyamorous relationships can prove a growing niche practice for family law practitioners (Boyd).

Thus, the centrality of monogamy to Western society seems discordant with people's stated practices and perceptions. The CRILF research findings reveal the following about the concept of family in Canada:

Family is now thoroughly unmoored from presumptions about marriage, gender, sexual orientation, reproduction and child-rearing; the notion that romantic relationships, whether casual, cohabiting or connubial, must be limited to two persons at one time may be the next focal point of change. The scant data

currently available on polyamorous relationships suggest that the number of people involved in such families is not insignificant and may be increasing. (Boyd 20)

Empirical data about monogamy are also relevant to claims and fears about polygamy causing harm. Quantitative and qualitative data suggest that monogamous marriage is not a particularly stable or utopian institution, especially for women and children. Different sources provide differing data about rates of domestic violence, and Statistics Canada's most recent figures indicate the trend is towards a decline in violence, but on the whole, it is clear that the amount of abuse, particularly of women and children by men in the context of marriages and conjugal unions, is significant. Fewer people are getting married in any event, and those who do often dissolve their monogamous unions in divorce. Census data provided by Statistics Canada demonstrate that over time, the percentage share of the population across Canada that is getting married is decreasing. As of 2011, less than half (46.5 per cent) of Canada's population aged fifteen and over was married—a figure down significantly from 60 per cent in 1982. Fewer people are getting married than in the past, and those who do get married are waiting until they are older to do so. The divorce rate for the last year it was kept by Statistics Canada (2011), or the percentage of marriages likely to end in divorce before thirty years of marriage, was 43.6 per cent. Statistics Canada has not collected data on marriage and divorce rates since 2011. In sum, empirical data indicate that monogamous unions are less stable, less prevalent, and less egalitarian than is culturally celebrated or assumed in the reference case decision.

In considering whether to maintain the criminal prohibition on polygamy, criminal policymakers should look to emerging social research, including the CRILF report as well as Campbell's work, about how people now organize the intimate and mundane detail of their private lives. Additionally, the ways in which family law has changed and is changing to become more inclusive of a variety of unconventional family forms, as discussed below, are relevant to changes that should be made to the criminal law.

Twenty-First-Century Family Law: Redefining Family and Friendship

Historically, under English common law, family law regulated status and property in accordance with rigid rules of primogeniture and coverture, which disenfranchised and disinherited married women (Backhouse). The late twentieth century witnessed a shift in Canadian family law away from regulation based on status, property inheritance, and religious ideology to a freer social order (Bradbury). Canadian family has been reformed significantly since the late twentieth century in a direction towards recognizing a broader range of family forms on the basis of adults' consensual private ordering of their relationships and towards a more inclusive vision of what properly constitutes a legal family. In 1968, a new federal Divorce Act was passed that altered Canada's approach to divorce from being based in accusations of fault, where judges were considered to be gatekeepers and protectors of marriages, to a more liberal-based approach consistent with then-Prime Minister Pierre Trudeau's famous statement in support of the 1968 reforms to the Criminal Code: "there is no place for the state in the bedrooms of the nation." This shift in approach was confirmed by the 1968 and then the 1985 Divorce Act (Backhouse).

Family law regimes in jurisdictions across Canada are being reformed to accept and include a wide range of family forms and configurations as spaces for free expression of affection and affinity along the lines people choose. These family forms are not invariably dyadic: plural parenting arrangements are recognized in many jurisdictions. The bonds of affinity legally recognized as forming families overlap more and more with the bonds of affinity of chosen families understood as friendship.

Canadian provincial and territorial family laws have mechanisms that permit multiple people—even folks who are simply collaborating friends and co-parenting outside of a conjugal relationship—to be recognized as the legal co-parents of a child or children. By 2016, Ontario, Alberta, and British Columbia had all enacted birth registration legislation that permitted same-sex parents to be registered as birth parents. In Ontario, the relevant law is the All Parents Are Equal Act, passed in November 2016, in which the term "parent" is used in lieu of mother or father, and same-sex parents no longer have to adopt their own children (All Families Are Equal Act). Furthermore, the Act

expressly contemplates that children may have more than two legal parents; it codifies and expands upon the rule from the "three parent case," a decision of the Ontario Court of Appeal in *A.A. v. B.B.* In this case, for which leave to appeal to the Supreme Court of Canada was denied, it was held that a child's biological male and female parents, and the same sex female partner of the biological mother, could all be declared parents to the child.

In the family law context, persons who entered into plural marriages in other jurisdictions, where they were legal, can receive some protection and benefit from family law. Moreover, reproductive technologies now allow more than two people's DNA to be brought into one fetus (as is the case using mitochondrial replacement therapy, currently prohibited in Canada). It is significant that although polygamy is criminalized under the Criminal Code, under family law provisions, Canadian jurisdictions also recognize, for some purposes, polygamous marriages concluded in other jurisdictions for some purposes, such as spousal support. Furthermore, when entered into in Canada, polyamorous unions or romances are legal; it is only when a polyamorous grouping seeks to formalize their union by entering into a marriage that the parties will run afoul of the criminal law.

In Canada, family law has shifted from being theoretically grounded in status to being centred on inclusive protection for ties of affect that are entered into consensually between adults and through which the vulnerability of children is protected. The movement towards formal legal recognition of friendships in a variety of forms has gone farther in jurisdictions outside of Canada. Friendships now have some legal recognition in the Netherlands, where Article 3:40 of the Dutch Civil Code enables people to register their friendship contracts in much the same manner that people can register domestic partnerships if they are conjugal partners (*Burgerlijk Wetboek*). This is a very recent development, and the first such contract was registered in 2015.

Although the Dutch innovation towards formal legal recognition for friendship contracts is a unique innovation, it can be understood as related to a larger, transnational movement towards legal recognition of family forms and relationships of interdependency that are more inclusive and supportive of alternative intimate and personal arrangements than approaches taken in the past. In several countries, a widening group of legal academics has advocated for the legal recognition of bonds

of friendship. In the U.S., legal scholars Laura Rosenbury and Rachel Moran have promoted "friendship law," whereby the law should permit people to voluntarily take on legal obligations to one another out of friendship. They also suggest that the legal recognition of friendship in lieu of insistence on traditional family forms carries potential to alleviate patriarchal inequalities in gender roles (Rosenbury). American legal scholar David Chambers has also suggested a status additional to marriage should be opened up where "designated friends" can share in each other's estates and be entitled to medical leave to care for one another. Amid the campaign to legalize same-sex marriage in the U.S. and Canada that was a central preoccupation of family law reform for the early part of the twenty-first century, reforms towards legal recognition for friendships were overshadowed by advocacy for marriage equality. Now that marriage equality between same and opposite sex monogamous couples has, at least formally, been achieved in Canada as well as in the U.S., the time is ripe for refocusing on other ways in which family and criminal law have been exclusionary, and the next logical step is to look critically at the laws on friendship and polygamy.

Towards an Ethic of Love—Time for Criminal Law Reform

"A family is a unit of toilet-cleaning energy" — Student response in family law class to question of how to define family

As noted above, emerging empirical data about polyandry in Canada suggest that polygamy is not necessarily coincident with the oppression of women and abuse of children, and it is not inevitably always bad. At the same time, empirical data about marriage and divorce in Canada and caseloads from the family court belie stated assumptions about monogamy from the reference case that dyadic marriages are necessarily, or even generally, harmonious and egalitarian. Additionally, it is problematic to conflate sexuality and conjugality with family formation. Families are economic and social spaces, as is evident from the Netherland example, and the Ontario "co-mammas" case; relationships that are foundational to co-parenting do not have to be coterminous with sexual expression.

As Gillian Calder and Lori Beaman have argued, assumptions about

monogamous marriage underlying the reasoning of the reference case seem unduly idealistic. In drawing lines around the family form of monogamy as an underpinning of the egalitarian West, and defending monogamy as in women's interests, the reference case decision may be overly romantic. The romantic narrative about monogamy being an ideal space for women and family life is not evident from the practice of family law or from research into polyandry as a practice in Canada. Social research now emerging about the Canadian context does not support the conclusion that monogamy is always good or polygamy is always bad. Furthermore, conjugality and sexuality are not always essential or central elements to what constitutes a family as Canadians now understand it. Focusing on conjugal relations may be the wrong place to look for the bonds that Canadians now generally perceive to constitute a family. The types of shared endeavour and ties of affect that are foundational to the spaces Canadians inhabit and in which they find respite and support may not be romantic at all (Calder and Beaman).

It is not clear that the Blackmore case is representative of polygamy in Canada. First, it represents only one variant on polyamorous relationships covered by the criminal prohibition, and there may be a conflation in the analysis in the reference case and in public opinion of underage marriage and child exploitation with polygamy as consensual marriage between adults. Second, there are other things wrong in the Blackmore case in addition to polygamy (if we even accept polygamy as something wrong). There were allegations of sexual exploitation and sex with minors. Other laws against these things actually exist in addition to the polygamy prohibition: if a desired social end is to see Winston Blackmore stopped and to stop young girls from being moved across the U.S.-Canadian border to be exploited by FLDS men, the polygamy prohibition is not actually the most direct way to criminally address the harm about which the public and authorities are concerned.

Undoubtedly, polygamy is controversial in Canada. Legal experts and social scientists disagree about what should be done about the prohibition of it. Just by way of example, a 2006 study commissioned by Canada's Federal Department of Justice concluded that some polygamous marriages entered into elsewhere should be legally recognized in Canada and that the blanket prohibition on polygamy set forth in section 293 of the Code should be repealed (Bailey), whereas another study commissioned through the Department of Justice the same year

by Rebecca Cook and Lisa Kelly came to a different conclusion and suggested the continued criminalization of polygamy.

Fifty years ago, Pierre Elliott Trudeau declared publicly that "there's no place for the state in the bedrooms of the nation." As minister of justice, Trudeau introduced The Criminal Law Amendment Act or C-195 on December 21, 1967. The omnibus bill proposed controversial reforms to the Criminal Code including the decriminalization of homosexuality and the legalization of abortion under certain conditions. Yet, in 2017, the criminal prohibition on polygamy in section 293 of the *Criminal Case* most certainly does bring the state and the full force of the criminal law in the form of an indictable offence into the bedrooms of the nation. Furthermore, it brings the criminal law not just into the bedrooms of the nation but also its kitchens, bathrooms, and minivans; criminal law regulates both the sexual and social lives of consenting adults.

In the context of shifting family forms, and increasingly legal recognition in the family law sphere for unconventional relationships, the criminal prohibition on polygamy is anomalous. Increasingly, the assumption that all relationships are monogamous, and even that monogamous conjugal relations are the only proper way to produce children, has become questionable.

Conclusion

"I think we can't go around measuring our goodness by what we don't do. By what we deny ourselves, by what we resist, and who we exclude. I think we've got to measure ourselves by what we embrace, what we create, and who we include."—from the film *Chocolate* (2000)

Making polygamy illegal initially can be understood as a means to prevent the blurring of social lines of authority and relationship: the blurring of lines between statuses in a family—between sister, brother, wife, husband, father, mother, and child; the blurring of lines between a marriage and promiscuity; the blurring of lines between affect and authority; and the blurring of lines between what was endorsed as legitimate Christianity in the nineteenth century against the growth of Mormonism. However, in the twenty-first century context, empirical data about family forms and shifts in family law confirm that

mainstream Canadians now reject many of the rigid hierarchical lines that were long protected by the law. Patriarchal hierarchies that forced women in particular to remain in marriages and the lines that created "coverture" between man and wife, overwriting a woman's legal existence with her husband's identity, are not to be vaunted but rather blurred, if not erased. In the contemporary context where law and policymakers seek to ensure equality for all, we should be clear about which lines we want to retain and why. Rather than being inspired by Hollywood-style romantic visions of monogamy when we contemplate the continued criminalization of polygamy, criminal policymakers would be wiser to look to the messy realities of monogamy, polyamory, and families' lives, as revealed by the CRILF report and in family courts.

Increasingly, a diversity of family forms openly exist—some of which are not necessarily centred on sex or conjugality, but all of which are linked by consensual affinity. Ontario's family law, as well as family law across Canada, is slowly aligning with what bell hooks theorizes as an "ethic of love." She advocates the fostering of "life-sustaining political communities that ... provide ... a space for the renewal of the spirit" (248). Families linked by relations of affect can be such spaces for renewal of the spirit. Such an "ethic of love" is consistent not with laws that focus on the forms that families take but the spaces they provide. When the notion of love as the practice of freedom is considered, indeed, it may be in the messy and amorphous realities of friendship in its many forms where ties of affect become not mundane but actually inspiring. Perhaps it is not so much that the law should be unromantic but that it should look with a different lens at what to value in romance. Maybe the core value to be protected in families is not in the shape they take but the space they can offer. bell hooks has posited that an ethic of love can be a powerful theoretical space from which to counter violence and domination, an ethic that can underpin the "practice of freedom":

> The absence of a sustained focus on love in progressive circles arises from a collective failure to acknowledge the needs of the spirit and an overdetermined emphasis on material concerns. Without love, our efforts to liberate ourselves and our world community from oppression and exploitation are doomed. As long as we refuse to address fully the place of love in struggles for liberation we will not be able to create a culture of conversion where there is a mass turning away from an ethic of domination. (243)

As discussed in this chapter, the polygamy prohibition set forth under the criminal law in section 293 of the Criminal Code criminalizes a wide swatch of consensual conduct that amounts to loving one another unconventionally. I have argued that our current criminalization of polygamy should be reconsidered in view of friendship as a liberating expression of what bell hooks has called a "politics of love." Criminal law should be reconfigured to support unconventional family forms, engaging with the intimate and social lives of Canadian adults in inclusive ways that support consensual bonds of affinity. Laws that impose rigid structures on households or that facilitate the surveillance of family relationships between consenting adults to ensure those relationships conform to a particular religious or cultural ideal are not consistent with love as the practice of freedom, as proposed by hooks. Rather, an emancipatory "ethic of love" would be more consistent with laws that focus not on lines separating and defining people but on the connections between people—laws that focus on the vulnerabilities, strengths, collaborations, and dependencies that connect people rather than on the lines of status or hierarchy that set us apart.

Works Cited

A.A. v. B.B. ONCA 2. Ontario Court of Appeal, 2007.

All Families Are Equal Act (Parentage and Related Registrations Statute Law Amendment). *Statutes of Ontario, c. 23—Bill 28.* Ontario 2016.

Backhouse, Constance. "'Pure Patriarchy': Nineteenth-Century Canadian Marriage." *McGill Law Journal*, vol. 31 no. 2, 1986, pp. 264-312.

Bailey, M. "Dossier: Should Polygamy be Recognized in Canada? Ethical and Legal Considerations." *Les Ateiers de L'Éthique* vol. 2 no. 1, 2007, pp. 1-5.

Barringer Gordon, Sarah. *The Mormon Question: Polygamy and Constitutional Conflict in Ninteenth Century America.* University of North Carolina Press, 2002.

Boyd, J.P. "Polyamorous Relationships and Family Law in Canada." *CRILF,* April 2017, www.crilf.ca/Documents/Polyamorous %20 Relationships%20and%20Family%20aw%20-%20Apr%202017.pdf. Accessed 26 Aug. 2019.

Bradbury, Bettina. "Book Review: Married Women and Property Law in Victorian Ontario, by Lori Chambers." *Osgoode Hall Law Journal,* vol. 37, no. 4, 1999, pp. 877-84.

Calder, Gillian, and Lori Beaman. *Polygamy's Rights and Wrongs: Perspectives on Harm, Family, and Law.* University of British Columbia Press, 2014.

Campbell, Angela. "Bountiful Voices." *Osgoode Hall Law Journal,* vol. 47, no. 2, 2009, 183-234.

Campbell, Angela, "Polygamy Ban Fails to Protect Women and Children." *The Globe and Mail,* 25 July 2017, www.theglobeandmail.com/opinion/polygamy-ban-fails-to-protect-women-and-children/article35790131/. Accessed 26 Aug. 2019.

Canada. Statistics Canada. *Census Data, 2011, Statistics Canada,* 2011, www.statcan.gc.ca/pub/91-209-x/2013001/article/11788-eng.htm. Accessed 26 Aug. 2019.

Canada. Statistics Canada. *Family Violence in Canada, a Statistical Profile, 2014, Statistics Canada—The Daily,* 2016. www.statcan.gc.ca/daily quotidien/160121/dq160121b-eng.htm. Accessed 26 Aug. 2019.

Chambers, David L. "For the Best of Friends and for Lovers of all Sorts, a Status Other than Marriage (Symposium: Unmarried Partners and the Legacy of Marvin v. Marvin)." *Notre Dame Law Review,* vol. 76, no. 5, 2001, pp. 1347-64.

Constitutional Questions Act. *Revised Statutes of British Columbia, c. 68.* British Columbia, 1996.

Cook, Rebecca J., and Lisa M. Kelly. "Polygyny and Canada's Obligations under International Human Rights Law." Department of Justice Canada, 2006.

Criminal Code. *Revised Statutes of Canada, C. 46.* Canada, 1985.

Criminal Code. *Statutes of Canada, c. 29.* Canada, 1892.

Drummond, Susan. "Polygamy's Inscrutable Criminal Mischief." *Osgoode Hall Law Journal,* vol. 47, no. 317, 2009.

Embry, Jessie. "Two Legal Wives: Mormon Polygamy in Canada, The United States and Mexico." *The Mormon Presence in Canada,* edited by Y. Brigham, University of Alberta Press, 1990, pp. 108-116.

hooks, bell. "Love as the Practice of Freedom." *Outlaw Culture: Resisting Representations*. Routledge, 2006.

"Ann Landers Quotes." *BrainyQuote*. BrainyMedia Inc, www.brainy-quote.com/quotes/ann_landers_143025. Accessed 31 Aug. 2019.

Percival, A.P. *Roman Schism Illustrated from the record of the Catholic Church*. Gilbert and Rivington Printers, 1836.

Quinn, D Micheal. "Mormon Women Have Had the Priesthood since 1843." *Women and Authority: Re-Emerging Mormon Feminism*, edited by Maxine Hanks, Signature Books, 1992, pp. 45-60.

R. v. Blackmore. BCSC 1288. British Columbia Supreme Court, 2017.

Reference re: Section 293 of the Criminal Code of Canada. BCSC 1588. British Columbia Supreme Court, 2011.

Rosenbury, Laura. "Friends with Benefits." *Michigan Law Review,* vol. 106, no. 189, 2007, pp. 189-242.

West Coast Leaf. "Memorandum for Leave to Intervene of the Proposed Intervener West Coast LEAF." *West Coast Leaf,* 2017, www.westcoast-leaf.org/wp-content/uploads/2017/02/Part-2-Motion-Record-West Coast-LEAF-Filed.pdf. Accessed 26 Aug. 2019.

Chapter Three

Research Project Reality Show: Three Poems

Josephine L. Savarese

T he following three poems are about a friendship made over a research project. For three years, I worked on a project with a colleague. There were challenging moments as well as a few terse emails. In the end, we stayed clumsy friends united by our mutual generosity, our love of dogs, and our interest in weightlifting.

1. Postcard Story: "And I in My Dream?"

Two years working on a film with a researcher. Traveled around in a rented car interviewing Elders. We think about her people, the Innu from northern Québec. We say how GREAT it must have been to live outside, on the open land. Imagine women under the night stars, peering across water. I wonder about appropriation. I say: I would like to collect message Sticks. Start a FIRE/READ Joséphine Bacon. I tell her My FATHER visited Once. OUR NEW home was, to him, a tundra. Flew to the largest city near the remote village. It was blizzarding when his plane landed. He travelled by bus to the village. On our new home: HE Said: There is nothing here but MILES AND MILES OF TUNDRA. Saskatchewan is NOT tundra: A vast, flat, treeless Arctic region/subsoil is permanently frozen. EASTER 2018. Q: Overseas Friend: What is a potluck? (Is he teasing?) A: All guests bring a dish and create a collective meal & two women found my wallet LOST. GREAT. *people (most) are wonderful.*

2. What I Thought

We would remain friends, afterwards
Go salmon fishing on the Miramichi
Kayaking on the bloated Saint John
Cook up a camp breakfast on shore
Scramble eggs with fiddleheads
 Grown in knee high flood waters
 Tasting of tin.

Thought we would remain friends
Mostly we didn't—once it ended.
Yet I remember: a summer road
Trip along the Acadian Peninsula

Parade of Blue Red White flags
Marching along the road in
Front of small houses,
Well maintained and tidy.

Banners waving gleefully
Saluting, bowing—gold star
On brilliant display.
Rental car handling like a Cadillac.

Windows down, cool refreshing breezes
On the radio:
Joel Plaskett crooning *I'm broke,*
I know I'm broke,
 But I'm not broken

3. Reality Television Research Project

We are the last contestants
On the Research Project
Bake Off.

She is yelling at me from across the stage.
I keep my cool. Bake the BEST chocolate
Chip cookies Ever. The chips are Melty. I
Offer her one. It is crispy, baked Just Right.

A fight must have broken
out in the audience. Crash.

We join hands and

 Run.

Chapter Four

Friendships in the Japanese Language: Intersubjectivity through Mothering

Meredith Stephens

Introduction

My closest and most lasting friendships in the Japanese language have been with other mothers. The dramatic life event of raising a newborn in a different culture catapulted me into friendships that would have otherwise been unlikely. The intersubjectivity I shared with other mothers—of responding to a baby's needs—transcended the enormous cross-cultural differences in childrearing. It provided me with an opportunity of interacting with people whom I would not otherwise have met. As an expatriate in Japan, I naturally gravitated to the company of other English-speaking expatriates, but the shared experience of mothering enabled me to form friendships with Japanese mothers too. My use of Japanese in these friendships concentrated on topics related to childrearing and was therefore distinct from friendships formed in the workplace. The friendships formed with Japanese mothers during the early years of mothering have outlasted many other friendships in Japanese, and they have permitted me to understand the lives of people in the wider society outside the confines of the university. Over twenty years later, I no longer need their advice about childrearing in Japan, but our friendship has lived on.

I begin with a discussion of the assumptions behind the English word "friend" and contrast it with the many equivalent words for "friend" in Japanese. The meaning of a "friend" in English is not identical in other languages, even in other European languages. I discuss how my Anglo notion of friendship intersected with my Japanese friends' notions of friendship and how overlapping features in our respective notions of friendship helped us develop bonds that have transcended the narrower definitions of friendship in each culture. I came to learn what it means to be a friend in Japanese culture, and my Japanese friends might have come to understand what a friend is for an English speaker.

Next, I discuss the role of intersubjectivity in friendship. Jerome Bruner explains intersubjectivity to be "how humans developed the capacity to read the thoughts, intentions, beliefs, and mental states of their conspecifics in a culture" (174). Clearly, these qualities characterize the expectations of friendship. My Japanese friends shared their childrearing practices with me, and I came to understand their beliefs about mothering and to adjust my beliefs so that I could participate as a mother in their culture. I also discuss the importance of speaking a foreign language, Japanese, with other mothers, how Anglophones may be positioned as non-Japanese speakers in Japanese society, and how friendships with Japanese mothers enabled me to participate in the society in the local language.

Finally I provide an autobiographic narrative of the trajectory of my friendships with Japanese mothers mediated through the Japanese language. In the field of second language acquisition, Andrea Simon-Maeda argues that narrative inquiry can reveal the "unquantifiable, personal and socially interactive aspects of language experiences" (22). This observation could be generalized to include not just language experiences but also the topics of this discussion: friendship and motherhood.

Narratives of immigrants feature in Mary Besemeres and Anna Wierzbicka's edited volume, in which they introduce the narratives of twelve immigrants to Australia. Explaining the rationale of these autobiographies, they explain: "Until recently, it was widely assumed in both scholarly literature and popular wisdom that valid knowledge can come only from objective study of external reality. Because of this assumption, some subjects of profound human interest and of great social importance could not be explored in depth and discussed in

wide-reaching societal conversation" (xv). Narrative is a means of exploring experiences that remain closed to the tools of scientific analysis—whether it be immigrant experiences or how the shared experience of motherhood fosters intercultural friendships. Aneta Pavlenko explains the strengths of autobiographic narratives in terms of the object of the study becoming the subject and the subject being granted agency. She warns that such narratives are not the sole property of the protagonist but are co-constructed according to the subject's interlocutors, the time and the place, as well as the language choices of the narrator. Accordingly, in the following narrative, I, the subject, reflect on the object: my friendships with Japanese mothers.

What Is Friendship in English?

The linguist Anna Wierzbicka (1997) argues that the English word "friendship" is an Anglo cultural construct and not a language universal: "This reliance on the word *friendship*, as if it were a label for a pre-existing fact, betrays an absolutization of this Anglo concept" (34). She warns that other languages may not have the lexical equivalents of "friend" and "friendship." Even the lexical equivalents of "friend" in European languages are not identical to the English word. Furthermore, the meaning of "friendship" has varied across the history of its usage in the English language According to Wierzbicka, the classical meaning of a "friend ship" in English referred to a slowly developing and lasting relationship, and collocations with the word "friend" included "faithful friend," "steadfast friend," and "old friend" (38). In the former usage, a friend was someone who was considered beloved, for whom one performed good deeds; other collocations included "sweet friends," "loving friends," and "dearest friends." In contrast, in modern English, friends expect to be liked rather than loved, and they are companions when doing fun activities (39).

Wierzbicka continues to contrast the lexical semantics of "friend" in classical and modern English, and she suggests that the classical meaning implied that one could confide in the friend, as is expressed in the collocation in older English "bosom friend." In modern usage, one may have fifty friends, but it would be unlikely that one would share confidences with fifty people. Wierzbicka explains that the older concept of friend implied an exclusive relationship. In contemporary usage, the

expression "circle of friends" implies that one is in the centre of a circle of people with whom one shares unilateral relations in "a multiplicity of people related in an analogous way to a central figure" (45). Furthermore, Wierzbicka identifies the expression "to make friends," which refers to the practice of actively seeking multiple such relationships. This expression only emerged in modern English and reflects human relationships in the contemporary Anglosphere. Formerly the collocations "finding a friend" and "choosing a friend" were common and implied a selective and discriminating process, whereas the current collocation "making friends: implies less exclusivity and a focus on having many friends. Wierzbicka explains that the older usage of "friends: is still present for those who are familiar with English literature and the culture of times past.

A recent volume by Deborah Tannen provides a nuanced view of women's friendships, and begins with the following opening sentence: "Best friend, good friend, close friend, good strong friend, bestie bestie, to-to core friend, close close friend, very very very very close friend, bff, my sweet angel from heaven" (ix). Tannen interviewed over eighty women for her study and indicates that the range of words they used to describe the friends they cherish to be without limit. She describes one of the benefits of friendship as to be given entrance into a different world, when the family backgrounds of the friends differ. This is especially the case with intercultural friendship; my Japanese friends have been my gateway to Japanese culture.

What Is Friendship in Japanese?

Next, I explore the understanding of friendship in Japanese, and compare and contrast it with its modern English equivalent. Wierzbicka explains the range of words for "friend" in Japanese: *shinyu* approximates "close friends"; *tomodachi* is close to "friend"; *yujin* is a formal equivalent of *tomodachi*; *nakama* refers to the crowd one hangs out with; *nominakama* are the friends one drinks with; *asobinakama* are those one plays with; and *shigotonakama* are those one works with (35). Wierzbicka argues that "each such word reflects assumptions and values characteristic of Japanese culture and absent from the less differentiated English concept of friend" (35).

A recent addition to this list is the word *mamatomo*. This is a special

word describing the phenomenon of women who become friends through the shared experience of mothering. The first part of the word *mama* means "mother," and the second, *tomo*, means "friend." There is no English equivalent of *mamatomo*, although the phenomenon will be familiar to English-speaking mothers too. The fact that this experience has a label is indicative of its salience in Japanese. The bonding through the shared experience of mothering can be so powerful that I argue it can be extended to intercultural friendships between mothers. The word *mamatomo* came to my attention in an authentic setting as I was writing this chapter. I was introducing an American friend to a Japanese professor and explaining that she had been my first friend in this city. I told her that despite our age differences our children were the same ages: twenty and twenty-three. The Japanese professor summed this up in one word: *mamatomo*. *Mamatomo* can transcend age differences because different women have children at different ages and develop bonds with one another when their children are in the same class. Similarly, *Japan Today* explains the word *Mamatomo* as referring to groups of women who bond when their preschoolers are in the same class. It describes the pressures of conformity these groups may impose on their members, such as purchasing the same handbag or ordering a drink at a restaurant. Clearly, the pressure of conformity is not confined to Japan and has also been identified in the U.S.: "Decisions about what to wear, like decisions about what to say, are reflections of who you are, so sameness with another can be deeply reassuring" (Tannen 82). Nevertheless, the degree of the pressure to conform is greater for *mamatomo* than for English-speaking friends; the latter does not extend to the pressure to conform in such detailed ways, such as the choice of handbags or drink.

In the following narrative, I cannot pretend to have participated as a Japanese member of a *mamatomo* group. I have always been well aware of my position as an outsider, a foreigner. One of the benefits of being perceived as foreign is that sometimes (but not always) one is exempt from the expectation of conforming to group norms, and this is known as the "*gaijin* card" (Simon-Maeda). It was a novel experience to participate in a group of *mamatomo* and attend the round of organized gatherings at restaurants, the homes of the members, or different excursions, but my foreigner status generally exempted me from an unwelcome pressure to conform, as I explain.

Similarly to Wierzbicka, the scholar of Japanese culture Jiri Neustupny highlights the informal nature of friendship in the Anglosphere and warns English-speakers not to extend the English language definition of friendship to the Japanese context. Neustupny identifies the casual nature of friendship for English speakers and notes that interlocutors may use first names at a party. In Japanese, even the most superficial friendship develops after more extended contact than this, and deeper friendships arise from growing up or working together over a long time. In English, people of varying ages or status can be friends but cannot qualify as *tomodachi* in Japanese. However Neustupny explains that the strict conventions of friendship may be suspended in relationships with foreigners. For example, the duration for forming a friendship may be shortened, and the age difference may be disregarded. However Neustupny cautions foreigners against being too hasty in forming a friendship if the Japanese person appears uncomfortable.

Speakers do not carry on a conversation unaware of the listener. The presence of a foreigner is an example of language contact, and speakers adjust themselves according to their perception of the listener. Lisa Fairbrother explains "many Japanese native speakers seem to expect non-native speakers to be *more* different and *more* foreign than they actually are" (130). She indicates that contact norms for communication with English speakers are more lenient than with foreigners from other countries. Some intercultural contact may involve the Japanese interlocutor approximating the English concept of a "friend" when relating to English speakers. Intercultural contact may be a two-way process in which both parties converge to form a friendship that suits their particular relationship.

Intersubjectivity and Friendship

Bruner provides a simple and elegant explanation of intersubjectivity: "how people come to know what others have in mind and how they adjust accordingly" (161). He argues that a common language and traditions foster the mutual expectations that underlie intersubjectivity. If this notion is extended to the experience of foreign mothers living in Japan, it implies that knowledge of the Japanese language and culture by the foreign mother will facilitate intersubjectivity with Japanese mothers. One important source of intersubjectivity is linguistics.

Pavlenko describes the stages involved in achieving intersubjectivity in another language: "we have to internalize new interpretive frames and to readjust the salience of already existing ones, learning, once again, what frames to use, with whom, how, and when" (227). In contrast, she explains that differing social circles, genders, generations, social hierarchies, and epistemologies (for academics) may constitute reasons for intersubjectivity not being achieved (227).

Whether intersubjectivity can be achieved without friendship is beyond the scope of this discussion, but some degree of intersubjectivity is necessary for friendship to develop. As Daniel Stern explains "in most of our modern Western conceptions of love and friendship, inter-subjectivity is perhaps *the* indispensable element" (102). Stern contrasts this with other societies (which he does not specify), where intersubjec-tivity is achieved through belonging to the group rather than through dyadic conversations.

Intersubjectivity, Caring, and Motherhood

I suggest that the experience of motherhood can be a powerful source of intersubjectivity between mothers. Across a range of cultures, women share many common experiences through the practice of motherhood. When these experiences are shared and intersubjectivity arises, the result is often friendship, even when the mothers come from divergent cultures.

Another quality that supersedes cultural notions of friendship is caring. The act of caring is a universal instinct. Nel Noddings argues the following: "the impulse to act in behalf of the present other is itself innate. It lies latent in each of us, awaiting gradual development in a succession of caring relations" (83).

Neustupny explains that the expectation of a *tomodachi* is to help. The act of helping clearly arises out of the drive to care for another. Similarly, in old English, the notion of "friend" included the assump-tion of helping the other in times of adversity; one helps those whom one loves in such times. In modern usage, friends may be numerous and are liked rather than loved; it is those who love rather than those who like who will be counted on in times of adversity (Wierzbicka 40).

Why Is It hard to Speak Japanese in Japan?

Tannen advises the following: "It's natural—for people as well as parrots—to prefer the company of those who will understand us when we talk, and whose talk we can easily understand" (76). Arguably, the practice of speaking Japanese with someone perceived to be an English speaker is a novel experience for many Japanese, and there is a perception by many that Japanese people should address those they perceive to be English speakers in English, even those of long-term residence. An American scholar working in Japan, Simon-Maeda, describes how she imagines she is perceived by Japanese speakers when she speaks Japanese to them, who "in turn go through their own discombobulating mind shift when communicating with a red-haired, fair-skinned, definitely non-Japanese individual who speaks *Nagoyaben* (Nagoya dialect)" (23). Meryl Siegal also explains the low expectations that Japanese may hold of the Japanese language ability of Westerners, and Adam Komisarof argues that many of his Western interviewees, who are long-term residents of Japan, "are stymied when Japanese behave as if there is an unbridgeable cultural distance between them, as it carries the implication that they can never be fully accepted in Japanese society" (186). Accordingly, speaking Japanese in Japan has been a considerable barrier for me because I am readily perceived as an English speaker (Stephens).

My Japanese Friends

I use both the old and modern definitions of friendship in English, provided by Wierzbicka, to describe my friendships, although my Japanese friends will have brought their own cultural interpretation of friendship to our relationship. My individual friends remained steadfast during times of adversity, and our friendships stood the test of time. They are firstly Mieko and Yukie, who befriended me in one of the neediest times in my life, when I found myself in a foreign country with a newborn baby. The second individual friend is Professor Kutani, who has an office opposite me in the university and who continues to support me in my professional life, even though our research interests do not intersect.

After describing my individual friends, I describe my circle of friends, who conformed to Wierzbicka's definition of friendship in

modern English; they were a group of friends with whom it was fun to do shared activities, but we gradually lost contact with each other due to geographical mobility, distance, and time. We achieved intersubjectivity as members of a *mamatomo* group, and our bond may be explained in terms of Stern's comment of how intersubjectivity in other cultures may be achieved by being members of a group.

Mieko

I made my acquaintance with Mieko when my elder daughter Eloise was a newborn and I had newly arrived in the city of Takasago, where I had no acquaintances. Seven weeks after giving birth to Eloise, I flew to the newly opened Kansai Airport near Osaka to start my life as a first-time mother in a foreign land. After the long drive to our apartment, I discovered that we had to ascend the external staircase with no handrails. The excitement of relocation was short lived. Within days, I had adjusted to the rhythm of caring for a baby in a foreign land with no friends or relatives on hand. My husband Roland departed for work every morning, and I had no incentive to change out of my dressing-gown; I spent days in the apartment wondering what lay beyond the apartment walls. Gazing outside the window, I looked beyond the station and noticed what appeared to be a miniature town. Cars encircled the square along neat little roads from dawn till dusk. I longed to be part of a community, and wondered how to safely descend the stairs without the handrails with my baby. Finally, I decided to take the pram downstairs first and then to retrieve Eloise, and I gingerly carried her downstairs. I was free from the confines of the concrete apartment and ventured around the station to the town I have been longing to discover. Only it was not a town; it was a driving school. Japanese driving schools were designed to resemble a neat little village, and the community I had imagined did not exist.

Suddenly stripped of a car, and being reliant on walking and public transport, was daunting, especially with the additional responsibility of caring for a newborn. I pondered on my journey into this new life with no car, no permission to work, to a town where I had no family other than my spouse or friends. I was too proud to admit failure and was stoic by nature, so I resolved to put up with these deprivations as long as I could. Thankfully, I was saved by kind neighbours, who recognized my plight and anticipated my needs. Mieko was the sister-in-law of my

hairdresser. She had three primary school children and intuitively anticipated the practical difficulties I was facing. Even though she did not speak English, she lacked the reluctance to engage with foreigners that other people sometimes exhibited. This provided me with an entrance into the local community and an opportunity to gain relief from perceiving myself as the "other."

Fairbrother explains that in Japan, foreigners from different countries of origin display different degrees of foreignness and that English speakers are perceived to be the most foreign (147). Clearly, the perception of a newcomer as the "other: is experienced by migrants all over the world. Eva Hoffmann details the trials of migration from Poland to Canada in her classic memoir *Lost in Translation*. She continues on this theme in *The New Nomads* (1999), in which she describes the trial of being positioned as the "other," referring to "certain hazardous syndromes of the exiled stance: that this posture, if maintained too long, allows people to conceive of themselves as perpetually Other" (55). I found resonance in Hoffmann's observations to my situation as an English speaker in Japan, but finally I had found a friend who was tolerant of my accented and slow Japanese, was patient enough to recast expressions I did not understand, and was not deterred speaking in Japanese to me despite my improbable appearance.

Citing Haru Yamada's work, Tannen contrasts displays of friendships by American and Japanese women; Haru's American friend showed caring by listening to Haru's feelings, whereas her Japanese friend showed caring by her practical efforts to solve difficulties. In the beginning of our friendship, Mieko demonstrated caring when she helped me. First, she noticed that I would have trouble going shopping without a car and having a newborn baby. She would regularly pick me up in her car for shopping trips. Second, she stepped in to provide the babysitting I needed when venturing out to teach English, albeit without a work permit, to make ends meet. Furthermore, I was a fussy eater and did not wish to cook rice daily as our staple. Mieko had a bread machine and would bake loaves of bread and the send her son to our apartment to hang them on the outside door handle for us.

Not only did Mieko provide me with practical help, she also confided her troubles in me. Because it was easier for me to listen than to speak Japanese, I spent many hours listening to these family sagas. Finally, Mieko wrote a blog in Japanese of her extraordinary story and

attracted a range of readers in distant cities in Japan. In my experience, Japanese friends do not restrict acts of caring to practical help but include discussion of personal problems in the same way that English-speaking friends do.

Yukie

The second friend to come to my rescue was Yukie. We had caught each other's attention one day when we happened to be in the same carriage in the local train and admired each other's toddlers. One day at the end of December, she appeared on my doorstep with a citrus fruit called *yuzu* in hand and told me of the custom of adding *yuzu* to the bathwater at the time of the winter solstice. She exhibited the generosity common to many Japanese people. She would often arrive at my doorstep with clothes for Eloise that she had managed to find at bargain prices. Her son was a year older than Eloise and we would take our toddlers out to children's playgrounds in shopping centres, which provided me with some relief from the monotony of being trapped in my apartment. When I returned to Australia, she would send me boxes of clothes for Eloise and my newborn daughter Annika. After relocating to another city in Japan, she kept sending me boxes of the kinds of unique Japanese foodstuffs I showed interest in, such as spinach-flavoured potato chips, soybean chips, and individually wrapped tiny dried fish. When my great-nephews were born she would send me children's toys featuring pictures of Pokémon for them. I have been receiving such parcels from Yukie for twenty years. Yukie works hard at her night shift at the supermarket, and I did not take for granted the many boxes of delicacies that I received from her over the years.

Mothers of Kindergarteners

Stern describes how participation in joint activities can result in intersubjectivity: "the participation in rituals, artistic performances, spectacles, and communal activities like dancing and singing together all can result in transient (real or imagined) intersubjective contact" (109). In my experience as the mother of kindergartners, I regularly participated in a wide range of rituals and events for parents. The kindergarten year began with an entrance ceremony. Parents and children dressed formally and assembled with their children to pose for the group

photograph. Other annual events were excursions, children's perfor-
mances, and Sports Day. Parents, usually mothers, were assigned roles
during these events.

I found myself befriended by a group of mothers of girls and boys in
the same class as my younger daughter, Annika. This was my entrance
into a group of *mamatomo*. We went out to lunch together during the day
when our children were at kindergarten, visited each other's homes,
and sang karaoke some evenings. We shared the experience of being
mothers of children in the same class and being taught by the same
teacher. No one ever tried to address me in English or frame me as a
foreign visitor. I became a member of the in-group, and it was so satisfy-
ing not to be positioned as an outsider. All of the other mothers were
housewives, some of them working part time, and I was the only one
teaching at a university. None of them expressed more than a passing
interest in my status as a university teacher. Rather, our discussion
centred on our children's lives at kindergarten. We exchanged gossip
about the kindergarten staff and other mothers, reinforcing our group
solidarity. In contrast to my positioning as an English-speaker in my
professional life, in my friendship with other mothers of children at
Annika's kindergarten, I was not excluded on the grounds of being an
English speaker. We shared the experience of sending our children off
to kindergarten in the mornings, preparing a daily *obento* packed lunch,
and participating in school events. My role as a mother was similar to
theirs, and the issue of my foreignness and speaking Japanese with an
accent was inconsequential.

I did resist the pressure to conform on some occasions. There was a
gathering at a local restaurant one evening, by which time our children
had graduated from kindergarten and I had moved to another city. I
visited other friends in the city one weekend, and on a chance meeting
with one of the mothers, I was strongly advised to attend the restaurant
gathering. Circumstances did not permit me to attend, but it continued
to puzzle me for years later why my attendance was deemed so import-
ant. The expectations of allegiance to the group of mothers appeared to
be stronger than groups that with groups of friends in my own country
who had drifted apart over different life stages.

Another area where my foreign background did cause me difficulties
was my struggle to provide an aesthetically pleasing *obento* each day
(Stephens). One of the mothers encouraged me and suggested I make an

obento in the form of a Japanese flag—that is, a bed of rice with an *umeboshi* pickled plum in the centre. I knew that many women rose at 5:00 a.m. to make elaborate *obentos* for their family members, and I was glad to be accepted despite my resistance to conform to local norms to that degree. Despite being challenged in the culinary domain, I derived a secret pleasure that my profession as a university teacher and my foreignness were no obstacle to my becoming a group member.

Professor Kutani

Finally, even as our children have become independent, my friendships forged through the shared experience of motherhood remain strong. My closest friend in academia is historian Professor Kutani, mother of two sons. Professor Kutani singlehandedly relieved me of the isolation imposed at the workplace where I was positioned as an English-speaking foreigner. Not only am I foreign, I am also a long-term resident of Japan, a mother, and a writer. Being positioned as an English-speaking foreigner was oppressive because I was often cast as an outsider. Ingrid Piller explains the importance people attach to national identity, despite other aspects of identity being performed simultaneously and also at different times in our life trajectory. She critiques the practice of banal nationalism, in which national identity is deemed to be of such importance that other aspects of identity become invisible (59). The friendship with Professor Kutani enabled the otherwise invisible aspects of my identity to come to the fore.

English is considered an important and desirable ability in Japan, and being an English speaker gave me many privileges. Nevertheless, being addressed in Japanese gave me an opportunity to feel a sense of belonging to the local community. Because of my Western appearance, students and staff often addressed me in English, and it was tiring for me to constantly challenge the assumption that I was a monolingual English speaker. The one member of staff in an institution of thousands who took the trouble to include me in the Japanese speaking community by addressing me in the local language was Professor Kutani.

Because she was a senior figure in a hierarchical institution and society, I was reluctant to impose on her. Nevertheless, she would knock on my door to introduce me to the delights of Japanese culture and history, and invite me to events at the museum. She bathed me in a sea of

language, which provided a springboard for me to respond freely in Japanese. She had the generosity to share her language and culture with me as well as the belief that this was a treasure worth sharing. After indulging in this wave of Japanese, I recovered from my sense of being an English-speaking commodity and was able to summon the inner resources to be generous to others with my native English linguistic skills.

Professor Kutani's specialization is the Edo period, but this has not stopped her from supporting me in writing grant submissions to pursue research in my subject area, applied linguistics. My weakness in Japanese literacy deters me from applying for research grants. Similarly, Simon-Maeda complains of "not being able to function at a level of literacy comparable to one's professional status" (108). The most helpful and willing colleague to assist me overcome my battles with Japanese literacy is Professor Kutani. Despite applied linguistics being outside her area of specialization, she has organized a committee for me of academics from other specializations who can contribute to a common research goal. She has even provided the impetus for us to begin a research group in applied linguistics. She is confident that our application for a grant will be successful. After a recent meeting, she shared her real research interest with the research group. She produced an original manuscript from the Edo period—a story which had been written with a brush on a scroll—and informed us that her greatest excitement was the times when she was free to read these manuscripts. Although this was her real passion, she made the time to create a research group based on my interests, to enlist the support of other scholars, and to draft and submit my grant application in Japanese.

Lack of Friendship

These friends stand out in my memory because they overcame the obstacles posed by my otherness. There were other mothers I met through kindergartens and schools who suddenly excluded me from a circle of mothers after using me as an opportunity to make other friends or viewed me as an opportunity to practice their English. Even solid friendships may be characterized by ruptures. All relationships are ambivalent, and sometimes being hurt is likely in all friendships (Tannen). The friendships with Mieko, Yukie, the kindergarten moth-

ers, and Professor Kutani, sometimes suffered friction due to misunder-standings, but the reason their stories are recounted here is that they reached out to befriend me because of my plight as a mother without an extended family in a foreign country. For us, the intersubjectivity arising from the shared experience of motherhood was stronger than the lack of intersubjectivity deriving from our dissimilar cultural back-grounds.

Conclusions

These friends reached beyond the boundaries of Japanese notions of friendship. None of them was the same age or status as me; they ranged from ten years younger to five years older, and their jobs ranged from a supermarket shift worker to a university professor. There was even more variation in ages and status than in my English-language friend-ships. The shared experiences of bearing and raising children were powerful enough to overcome cultural differences in these matters.

Not having the knowledge of the different notions of friendship in different cultures at the time, I behaved according to my Anglo concept of friendship by initiating conversations about problems (Tannen). In the beginning of our friendship, my Japanese friends behaved according to their own concepts of friendship, which involve physical and practi-cal acts of kindness and generosity, and I was surprised to receive so many presents even when there was no particular occasion. As we spent more time together, we began to disclose personal problems and share confidences in a similar way to English-language friendships. The shared experience of motherhood became the impetus for participating in the wider society outside of the university. This enabled me to forge close friendships with Japanese mothers who helped me in times of adversity.

Works Cited

Besemeres, Mary and Anna Wierzbicka. *Translating Lives: Living with Two Languages and Cultures*. University of Queensland Press. 2007.

Bruner, Jerome. *The Culture of Education*. Harvard University Press.

Fairbrother, Lisa. "Native Speakers' Application of Contact Norms in Inter-cultural Contact Situations with English-speaking, Chinese-speaking

and Portuguese Speaking Non-native Speakers of Japanese." *Language Management in Contact Situations: Perspectives from Three Continents*, edited by J. Nekvapil and T. Sherman, Peter Lang, 2009, pp. 123-150

Hoffmann, Eva. *Lost in Ttranslation: A Life in a New Language*. Penguin Books. 1989.

Hoffman, Eva. "The New Nomads." *Letters of Transit*, edited by A. Aciman, The New Press, 1999, pp. 35-63.

Komisarof, Adam. *At Home Abroad: The Contemporary Western Experience in Japan*. Reitaku University Press, 2012.

"Mama-Friendships Can Be Deceptive." *Japan Today*, 15 Apr. 2013. japantoday.com/category/features/kuchikomi/mama-friendships-can-be-deceptive. Accessed 24 Aug. 2019.

Neustupny, Jiri, *Communicating with the Japanese*. The Japan Times, Ltd, 1987.

Noddings, Nel. Caring: *A Relational Approach to Ethics and Moral Education*. University of California Press. 2013.

Pavlenko, Aneta. *The Bilingual Mind and Shat It Tells Us about Language and Thought*. Cambridge University Press. 2014.

Piller, Ingrid. *Intercultural Communication: A Critical Introduction*. Edinburgh University Press. 2011.

Siegal, Meryl. "The Role of Learner Subjectivity in Second Language Sociolinguistic Competency: Western Women Learning Japanese." *Applied Linguistics*, vol. 17, no. 3, 1996, pp. 356-82.

Simon-Maeda, Andrea. *Being and Becoming a Speaker of Japanese: An Autoethnographic Account*. Multilingual Matters. 2011.

Stephens, Meredith. "Speaking Japanese in Japan: Issues for English Speakers." *Babel*, vol. 44, no. 2, 2010, pp. 32-38.

Stephens, Meredith. "The Rebellious Bento Box: Slapdash Western Mothering in Perfectionist Japan." *What's Cooking, Mom? Narratives about Food and Family*, edited by Tanya Cassidy and Florence Pasche Guignard, Demeter Press, 2015, pp. 162-72.

Stern, Daniel. *The Present Moment in Psychotherapy and Everyday Life*. W.W. Norton & Company. 2004.

Tannen, Deborah. *You're the Only One I Can Tell: Inside the Language of Women's Friendships*. Virago, 2017.

Wierzbicka, Anna. *Understanding Cultures through Their Key Words: English, Russian, Polish, German, and Japanese*. Oxford University Press, 1997.

Chapter Five

The Ibeji Model: Friendship Bonds as Soul's Salvation in the Scholarly Writing Process

S. Alease Ferguson and Toni C. King

Introduction

"Where there are experts there will be no lack of learners."
—Swahili proverb

"He, who learns, teaches."
—Ethiopian proverb

Minority and women junior faculty represent one segment of the higher education workforce that requires uplift and support in the process of tenure attainment. Particular assistance is needed in developing strategies for self-agency in the writing and publication process. As a group, many do well in the implementation of the face-work dimensions of the assistant faculty job description relative to teaching, student support, and committee participation. These aspects of the work are often fulfilled in a highly skillful and personable manner, whereas the writing and publication go lacking. This backstage function of mounting a full-scale writing and publication task agenda from start to finish can flummox even the best of newly

minted assistant professors. In response, we, as organizational behav-
iourists, examine the use of the dyadic relational model of co-authorship
as one positive and time tested method of combating the early career
stage phenomenon of writer's block and forestalled publication among
junior minority and women faculty at risk of tenure declination.

We contend that a series of complex environmental, experiential,
and intra-psychic barriers can obscure an assistant professor's ability to
write and publish within the allotted timelines for progression towards
the coveted role of tenured associate professor. Currently, the problem of
publication failure is so dire that the already low numbers of minority
and women assistant professors are not being granted tenure. In addi-
tion, the denial of tenure to those at the lower rung of assistant faculty
status rests on two salient factors: the absence of a proven publication
track record at the third- and fifth-year reviews as well as discrediting
student evaluations (Harvey; Strauss; Treitler). These factors stymie
more rapid progress in tenuring for African American and other women
of colour to a rate that *The Journal of Higher Education*'s news and views
column (May 31, 2018) describes as "snail-like." The result is that while
thirty-three thousand African Americans teach fulltime in the acad-
emy, for more than a quarter of a century, African American females
have comprised only 5.3 per cent of the professoriate. This statistic has
vast implications for the young scholars themselves and those they are
charged to educate. Sadly, this group's high rate of attrition from the
field comes at a time when senior African American women and other
scholars of color are retiring and where the coming higher education
thrust is to strengthen the pre-K to college pipeline with a diverse appli-
cant pool. As the pipeline is being strengthened to increase the numbers
of entering and matriculating student's classified as diverse, who will
meet these students at the higher education cross-roads if scholars from
underrepresented groups are not retained by academe?

If not reversed, this trend heralds the extinction of the minority and
woman faculty across the U.S. To prevent such negative outcomes, the
research and literature recommend that institutions of higher learning
promote collaborative intellectual endeavours. They further urge a
culture change within institutions of higher learning that values
knowledge production and recognizes that in reality, it is a collaborative
and interdependent process (Whittaker et al.). One strategy aligned
with the cultural shift to embrace collaborative research and writing

involves the university's development of formalized mentoring programs that offer structure and the coalescence of people and technical resources. In turn, the junior faculty person is required to engage these resources via acceptance of the educational and mentoring supports provided. As the wheels of university bureaucracy grind slowly relative to budgetary and policy matters, there is slim likelihood of universal adoption of developmental junior faculty onboarding and retention processes. Furthermore, the matter of tradition and the meritocratic nature of the academy's rigorous gate-keeping structures demands that the burden of productivity will always be placed on the junior faculty person in pursuit of tenure. Thus, junior faculty must be prepared to take the reins of destiny into their own hands to fulfill the writing and publication requirements of tenuring. They must do so by cultivating the necessary personal organization disciplines and self-advocacy behaviours that can maximize their writing outputs and related tenuring outcomes.

To move minority and women junior faculty from a place of inaction to action with regards to writing and publishing requires interventions that promote a decisive shift from individualism to dyadic partnership and collectivism. Movement towards collectivism in authorship is a pathway to self-actualization and reconnection with one's sense of purpose regarding their original aim to earn a PhD. It also stimulates a reevaluation of those cultural templates of collectivism that are a part of the strivings of all disenfranchised groups' efforts to enter into the mainstream to contribute and place their unique signature on their respective fields and society. We have observed that young scholars born as generation Xers, and millennials arise from a societal template that is at once individualistic and technologically based. Many have moved through life as isolated and as solo contributors in architecting their scholarship and careers. Relationships are subsequently construed as secondary to individualized functioning and, committee work notwithstanding, the requisite modus operandi for a productive scholarly work life. When members of these cohorts struggle to get their writing on point, they become, as the old folks would call "a lost ball in high weeds." As such, little consideration is given to either the formation of or engagement in dyadic and small group writing collectives as mechanisms for prevailing as the published and not the perished.

Here, we discuss the use of dyadic relational co-authorship method

as one sustainable and culturally enriching avenue for African Ameri-
can and other diverse scholars to emerge as literary contributors. To
date, we have engaged in a twenty-five-year dyadic relational co-author-
ship collaboration. Toni C. King is a tenured associate professor and
former associate provost for faculty diversity, and S. Alease Ferguson is
a veteran adjunct professor and director of mental health services and a
child welfare clinician. We share backgrounds as both organizational
behaviourists and licensed professional clinical counsellors. Philosoph-
ically, we are scholars-at-large in the DuBoisian tradition. Thus, our life
work has been dedicated to teaching, writing, and acting upon situa-
tions that widen the opportunity structure for disenfranchised groups.
Through these interdisciplinary and action prisms and the dyadic rela-
tional model of co-authorship, We have penned numerous solo articles
and many more collaborative articles, essays, and book chapters, as well
as a co-edited book in the feminist and social sciences press.

For almost fifteen years, we have operated the Third Shift Writers
Cooperative as a portal for the engagement, mentorship, and mutual
support of minority and women of colour faculty in the actualization of
authorship and co-authorship productions. Now at the quarter-century
mark, we reflect on the momentous nature of a collaborative writing
enterprise that has endured and remained viable, enjoyable, and
productive. As exemplars of the dyadic relational co-authorship
method, we offer a series of unique insights concerning: 1) the purpo-
sive nature of scholarly co-authorship and publication; 2) unlocking the
psychological resistance to writing publishable works; and 3) strategies
for building individual and collective resilience and virtuosity in
authorship and the long term attainment of a scholarly publication track
record. These cumulative insights offer junior faculty a window into the
process and hallmarks of collaborative co-authorship.

The Challenge

For some, the start of a writing and publication agenda is a matter of
course. Others, however, may have more difficulty getting started
in the production of publishable works due to the following reasons:
the timing of faculty entry; orientation to a new campus and faculty
role; the demand to prepare course materials and syllabi for multiple
classes each consecutive semester; and the rigours of getting on with

one's departmental chair, colleagues, administrators, fellow committee members, and the students they are charged to teach. For many women, and minority faculty, entry may be a tumultuous and psychologically perilous experience that is often managed without mentor-coaching supports. According to Donald Beaver, the absence of consultative and task mastery supports around the focused development of a research and writing agenda can place junior faculty at risk of continued stressors, career derailment, and ultimately denied tenure.

Diagnostically, we suggest that writer's block and forestalled publication among entry-level minority faculty is a secondary trauma response to racism and sexism in educational systems, graduate school, and entry-level university career environments. Problems such as prior maltreatment, intellectual discrediting, and expressed disbelief in potential, as well as denied access to the doctoral program opportunity structure, are examples of epistemic violence that minority and women scholars must work through in order to write. In addition, social isolation and marginalization at the doctoral stage of development can become an undue emotional baggage carried into the academic career life. Then as junior faculty, the trauma of marginalization is restimulated by the lack of departmental and interdepartmental inclusion; subtle and overt expressions of student racism and discrediting; and the sheer lack of advocacy and mentoring supports. Intermittent and chronic exposures to such environments become mine fields of marginalization, anomie, and social isolation; physical and psychic energy drain; and immobility on specified task requirements.

Tangentially, the experience of writer's and publication block can be expressed as flight, fight, or freeze relative to the daunting task demands of the academy. From both a physiological and psychological vantage point, many newbies are stressed to the point of adrenal exhaustion. Essentially, the problem can become further exacerbated by the minority and women junior faculty's perception of themselves as strangers in a strange land due to their lack of connections; limited knowledge concerning campus and departmental history and politics as well as student diversity concerns; and their own communal and cultural disconnection. The cumulative toll of discrimination, social isolation, and other situational adjustment challenges can forestall the formulation and implementation of a writing agenda that results in publication. Managing the energetic demands of the workload and

public face can take more than the one year to resolve. Thus, it is possible for that eighteen to twenty-fourth month gestational window for publishable work creation, submission, publication confirmation, and final edits can slip away without notice. Over time, the ticking clock proceeding the years and months of the first tenure review without published products or the confirmation thereof can unleash a cascade of stress, pandemonium, and psychic paralysis.

The subject's recovery and the production of outputs are dependent upon receipt of a variety of stress inoculation procedures and relational antidotes. Remedy can be obtained through education, coaching, mentorship supports, and the selection of authorship methodologies that facilitate increased social support, creativity, and outputs. As veteran scholars, we recommend the use of the dyadic relational co-authorship approach as one method of writing and publication that promotes collegiality, collaboration, individual and collective writing proficiencies, task and resource sharing, and outputs that enable minority and women scholars to actuate their potentials for publication and career success long term. Application of this methodology is best supported by mentors and coaches willing to tell their stories and show others the ropes. It begins with understanding the merits and practical utility of co-authorship.

Inspiration for the Third Shift Writers Collaborative: The Literature

Francisco José Acedo et al. define co-authorship as the formal manifestation of intellectual collaboration in scientific research. It represents the participation of two or more authors in the production of a publishable study. This approach to authorship and publication can be considered a mid-twentieth-century to twenty-first-century phenomena. Acedo et al.'s review of the literature demonstrates that in the first half of the twentieth century, it was rare to have scientific papers written by more than one author. However, in recent decades, there has been growing trend for co-authorship in scientific publication. This trend has attracted much attention from researchers interested in exploring the incidence and key elements of the phenomenon.

Today, more than ever, scholars are capitalizing on the benefits of co-authorship in order to obtain status and higher salaries linked to the

number and the quality of articles produced. There is a growing body of research that establishes the commonality of the co-authorship strategy among contemporary researchers (Biagoli and Galison; Braun, et al.; Cronin; Cronin et al.; Glanzel and De Lange; Moody; Cronin; Cronin et al; Glanzel; Laband and Tollison; Moody; Wagner et al). Another notable trend surfacing in the literature is the increase in the proportion of co-authored papers, the total number of publications, and the number of authors per co-authored publication (Cronin; Glanzel and De Lange; Smith; Wuchty et al.). From a utilitarian perspective, co-authorship can further increase the number of studies that can be undertaken due to efficiency arising from the division of labour (Barnett et al; Rigby and Edler). This approach also provides an opportunity for rigorous peer review on the front end, which serves to improve article quality and increase the probability that an author's work will be accepted for publication in a journal. It is also likely that the collaborators will tend to publish more (Cronin; Hamermesh et al.; Sauer).

Individual Growth

Others have written that co-authorship helps individualized growth in the craft of writing and publication. In her study of co-authorship networks, Anne Rumsey-Wairepo tested the extent to which co-authorship leads to the research productivity of individual authors measured in terms of number of publications. She found that most authors preferred to write alone and then next in pairs, or in cohesive groups to meet their writing and publication aims. The findings also show that the dyadic relational model appears to offer the most accessible mode of collaboration, expedites the work detail, and moves the publication phase rapidly forward. Aliya Kuzhabekova's research also supports the idea that co-authorship increases research productivity. Thus, co-authorship has been found to be beneficial for the researcher's prestige and visibility in the environments that regard co-authorship as a value added.

Relative to the primacy of the relational properties in co-authorships, Calvin Streeter and David Gillespie's work focuses on the content and the form of the relationship between network members. The two most studied aspects of relational properties include transaction content and the nature of relationships (Streeter and Gillespie). Transaction

content refers to what is exchanged in networks: resources, information, influence, and social support. More specifically, transaction content covers the following factors:

- Resources: physical goods, personnel, and services;
- Information: descriptions, opinions, ideas, and facts;
- Influence: power, prestige, legitimation, and advice; and
- Social support: comfort, encouragement, and inspiration.

Nature of the relationship examines the following:

- Importance: the importance and significance of the relationship;

- Frequency: rate of recurrence of social interactions surrounding authorships;

- Formalization: official recognition; and

- Standardization: defined procedures and units of exchange.

These factors can be considered an amalgam for making the dyadic relational co-authorship function as a productive entity.

The relational dimensions of co-authorship refer to the qualities of the relationship between members of the network. Social network analysis of co-authorship has been also been widely used in social sciences with the goal to understand co-authorship as a social phenomenon. Key examples include Marcel Fafchamps et al.'s exploration into the co-authorship network in economics to reveal insights into the production of knowledge externalities via collaboration in the field of growth economics as well as James Moody's exploration into co-authorship networks in sociology with the intent to understand co-authorship itself as a type of research collaboration.

Our implementation and observations of the dyadic relationship co-authorship methodology suggests that the approach renders a series of opportunities and perks for the participants. Namely, the members of the dyad receive intellectual community, cooperative work relations born of collaborative intent, a defined tandem division of labour, and the unfoldment of a demonstrated peer supported writing and publication agenda. The value-added dimensions of the work include the fun of co-inquiry and creativity and the pragmatic use of time, talent, energy, and material resources in service of the research and writing agenda.

Why Write: The Publish or Perish Imperative

The development of a writing life is indivisible from the academic life. One does not exist without the other. The challenge of creating publishable works is a role-based, functional, and existential dilemma for anyone pursuing a career in the academy. At entry, junior faculty members are confronted with the challenges to develop a writing and publication agenda. The rigours of completing that first writing and publishing endeavour from start to finish are a major production. The publication of one's first scholarly peer refereed article is always a momentous occasion marked by joy, pride, and elation. It is both a rite of passage and a "meat and potatoes" requirement for the entry level faculty careerist and those beyond. At the most basic level, one's livelihood depends on writing and publishing. In addition, these accomplishments offer junior faculty opportunities for personal growth, self-satisfaction, and mastery of a craft that can not only garner tenure but also acclaim and important professional affiliations that raise self-esteem and stature. Choosing to go the distance offers junior scholars advanced writing skills and the self-satisfaction from demonstrated mastery of the craft of writing, a necessary step towards achieving tenure.

As representatives of the Black motherline tradition, we stress that succumbing to writer's and publication block without seeking remedy and applied action is tantamount to a refusal to wage battle against one's own inner demons and the ugly spectre of raced and gendered discrimination (King and Ferguson). Inaction on the press to write with the intent to publish places junior faculty in a position of vulnerability vis-à-vis tenure and promotion success and the opportunity for longevity within the exclusive sphere of higher education. Personally and career wise, it means a breach in fulfilling the terms of one's employment contract. Yet in the broader university and societal contexts, it alters the visible diversity of the higher educational landscape and jeopardizes the university sector's retention and matriculation of generations of college-going female and minority students. In addition, both case-by-case and trend-based data on this group's inability to publish can further corrupt the hiring process and bar entry and tenure appointments for successive minority and women faculty.

The Co-Authorship Case of King and Ferguson

"Helped are those who create anything at all, for they shall relive the thrill of their own conception and realize a partnership in the creation of the Universe that keeps them responsible and cheerful."—Alice Walker (287)

We began our friendship as doctoral students at the Case Western Reserve University Albert J. Weatherhead School of Management in 1988. Looking back, there was something fortuitous about our meeting. We met at the urging of our shared mentor and chief faculty advisory Dr. Donald M. Wolfe. From the outset, Wolfe believed that we would become fast and forever friends known to one another's family and friends. Our bond is reflective of the Yoruba tradition's Ibeji, twin spirits of the cosmos, as we are so closely tied in our thinking and awareness. Shortly after becoming friends, King completed her research on African American female bonding relationships and prepared to graduate and enter her first professorship at the Norfolk State University School of Business. Ferguson conducted her dissertation research on the career path development of African American rhythm and blues Artists, managers, and entrepreneurs; she travelled to Cleveland, New York, Philadelphia, Detroit, and Chicago to meet R&B industry greats. During this interval, King was developing a solo research and publishing career while doing collaborative work with graduate school friends Ella Bell and Stella Nkomo. We tended the friendship long distance with phone calls emails and periodic visits. Despite the geographical distance, it was agreed that upon Ferguson's graduation, we would develop a line of research and related practitioner activities in the fields of African American womanist studies and leadership. We adhered to our original intent to forge a line of sustainable research and practitioner activity that would aid in the advancement of knowledge. We concentrated on the African American female experience, resistance to oppression, and the praxis of leadership and social action. This ongoing dialogue and work agenda kept us connected and working.

We do believe that our years of doctoral study prepared us for the writing life and the implementation of the dyadic relational model of co-authorship. During our years of doctoral training, the emphasis was not on writing for publication but rather on experiencing and completing our studies and the progressive phases of integrative seminar,

candidacy, dissertation research and writing, and oral defense. In many ways, our class assignments, written papers, and the dissertation itself were all considered preparatory for the writing to come.

We attribute some of our arrival at the preferred style of dyadic relational co-authorship to two factors: our doctoral training in collaboration and our roots as African American girl children born in segregated mid-century America. During the era of the late 1980s and early 1990s, "collaboration" was the hot organizational behaviour buzz word. Conceptually, it was promoted as a tool, a vehicle for transforming human interaction and organizational life proven to create change and make things happen. We were taught that collaboration was a form of concrete experience to be lived, examined, practiced, mastered, and analyzed in order to improve the effectiveness of our interventions aimed at humanizing management and the workplace, small groups, family, and community life. In short, collaboration was an energy and a commodity to be harnessed, bridled, and used to enable positive results. It was also considered a way of being in the world and a pathway to action, discovery, and productivity. From the mouths of our professors, collaboration was a tool to be readily applied to the practice of organizational development practice, inquiry, writing, and publication. Thus, the validation of these various modes of collaboration seemed quite natural to us.

Doctoral training aside, the notion of collaboration was not new to us as African Americans coming from U.S. Black community with its history of disenfranchisement. We already had our own theory concerning the application of collaborative action. As small children, we watched the unfoldment of the U.S. civil rights movement, attended freedom school, and saw our parents send money and shoes to the Montgomery bus boycott. In everyday life, we saw members of our parents' friendship circles and church accomplish an array of goals: organizing church garden party fundraisers and college send offs for the children of widows; cooking rib dinners to buy a new roof for the church; and forming studying groups to get through GEDs, nursing school, degree programs, and the like. We saw our elders stand in the gap for one another by serving as relative caregivers for children whose parents were deceased and provide loans to one another to buy a first home or sponsor a child's travel to a musical competition in a faraway state. We also saw them work together earnestly and unselfishly to

make both personal wins and collective wins by working together. Early on we were taught the African adage that "we are all as strong as our weakest link." Meaning that by working together and supporting one another, we strengthen the self as well as the collective.

Our doctoral program must also be credited with offering the necessary creative and conceptual stimulation. The doctoral experience framed our literary and critical thinking abilities. As a prestigious school of management, the Department of Organizational Behaviour had a faculty of famed scholars with lengthy book publication rosters. We also were also inspired by visits with such famed theorists as Mary Catherine Bateson, Peter Drucker, Chris Argyris, Warren Bennis, and other notables. At that stage of our development, critical thinking and processing theory took precedence.

Naturally, we were taught the cautionary adage "publish or perish" should we choose careers in either academe or the world of business. Essentially, writing was viewed as a bread and butter craft needed to represent oneself as a scholarly thinker in the academic, business, and technical domains. Concerning the task of writing, our faculty armed us with the following guide points: believe that you can be the author of your own thoughts; create new knowledge; write to captivate, inspire, and educate; organically map out your strategy for producing your writing contributions; and stop walking around like a paper-trained puppy trying to figure out where to go and just start writing. In short, there was no formulaic other than to remain curious, interested, and inspired in the conduct of research and writing and then do it. Further inspiration came on the day of our graduations and the conferring of the degree of doctor of philosophy. We each remember that day at Case Western Reserve's Amassa Stone Chapel and multiracial faculty in the full regalia representing their disciplines. They were so luminous and ethereal that it seemed that they had materialized out of the Mists of Avalon. The one who appeared as Merlin imparted a message that it is the covenant of the PhD to go forth and generate new knowledge in service of the uplift of humanity.

Going forth, we kept to the commitment to study Black women's mental health and social support networks as resistance to oppression. We wanted to lend voice to an underresearched and a highly pathologized segment of society. And so, we took off: we conducted action research, studied the literature, and wrote. Out first co-authored work

targeted to very popular womanist scholarly journal received a highly negative review. Although it was a miserable flop, we were not deterred. It gave us the fire to keep going—to teach ourselves how to progressively improve our writing, conform to the literary conventions of the academy, and form a signature style and voice. From that first published refereed scholarly journal article we gained confidence and momentum. With this green light, we have never stopped researching, writing, and publishing. Although the majority of our works are co-authored, we have worked both as solo contributors and dyad co-authors, and occasionally we have introduced others into the process to create a small collaborative writer's group for specific projects. During the initial formation of our process, we dubbed ourselves the Third Shift Writers Collaborative, as we customarily left our day jobs to write late into the night. Somewhere around our tenth year of collaboration, others remarked upon our collaborative success. There were others who began to ask how do you do it. They asked to be taught the Ibeji method and to enter the circle as an author in training. The sharing of our process grew into tutorials, workshops, and collaborative writing demonstrations.

When we share our story with groups of aspiring writers or other scholars, they always ask a mixture of questions, besides wanting to know what makes the activity functional. There are more concerns about potential risks and relational failures.

Q. What is the real glue that binds the two of you as co-authors?

Q. What are the operational elements of your work process?

Q. Has trust ever come up as an issue between the two of you?

Q. Has either one of your egos gotten in the way of doing the work?

Q. Do you all ever vehemently disagree about the direction the writing should be taking, about the division of your labour, or who should be first author?

Q. When your lives go through changes or one of you encounters a difficulty that impedes writing, what happens if one of you cannot come through and contribute their share of the work? How do you negotiate flexibility?

Q. Has there ever been a time when it seemed like the co-authorship process was not working? Has either one of you ever considered disbanding the co-authorship process?

Mounting a Dyadic Relational Collaboration?

"Joke: A pedestrian on 57th street sees a musician get out of a cab and asks how do you get to Carnegie Hall? Without pause the artist should say: practice, practice, practice!"— Unknown Author (qtd. in Tyler)

Most junior faculty beset with the task of publication view it as a solo activity. Many have grown up in a society that has become more and more individualistic and have no conception of dyadic co-authorship. Others question why they should share the glory with someone else. Those who have been betrayed fear that one partner will at some point become untrustworthy and steal all the credit to leverage their individual status. Seldom do they consider the benefits of what it could be like to write with another person or a small group of individuals. However, the larger question is how does one create a sustained process of research, writing, and publication that is both a contribution to the presentation of new knowledge and that meets academia's demands to publish or perish? In other, words, how does one embody the age-old joke reflected in our epigraph—admonishing the would-be artisan to "practice, practice, practice." Embedded in this question is a series of pragmatic concerns. Junior faculty will often query their own ability to duplicate the effort over and again. They may also be challenged in their ability to marshal the necessary resources associated with the costs of conducting research. The bigger question becomes is it practical to work as solo researcher or in a dyadic or larger network collaborative contributor in order to build a body of work and a publication track record that will span the breadth of an academic career? The practical wisdom in a collaborative approach can be used to jump start the writing and publication capacities of newly minted minority and women PhD at the career entry stage of tenure track junior faculty.

As a matter of manpower conservancy, we argue that it is pragmatic to intentionally coalesce for the sake of conducting research and the production of publishable works. Banding together holds the potential for increased proficiency at the craft of writing and the formation of a life-long collegial and friendship bond. This analysis focuses on the relational properties of a dyadic co-author social network.

Examining a Readiness for the Co-authored Writing Path

When offering junior faculty mentoring supports to improve their writing and publication outputs, it is critical to assess progress to date as well as the self-perceptions, values, and attitudes concerning the pursuit of a scholarly writing path. The following survey aims to collect this data.

Collaborative Writing Readiness Assessment Survey

Name: _____

Date: _____

Discipline: _____

Years in Academia: _____

Projected date of your first tenure review: _____

Aside from your dissertation, do you have any refereed scholarly publications? If so, how many? Please list the tiles and names of all authors:

Do you currently have any writing project(s) in process? If so, please describe:

1. During graduate school, did you ever have the experience of someone assailing your talents as a writer? How did it make you feel? And how did you remedy the problem?

2. How many hours a day do you dedicate to writing? Or how many times a week do you engage in scholarly writing pursuits?

3. Do you believe that you have what it takes to construct a publishable scholarly refereed literary work?

4. Are you prepared to tackle a project nearing the intensity of writing a dissertation? Are you willing to commit to ongoing hard work linked to the detailed effort of gaining a track record in scholarly writing?

5. What other activities are you willing to reduce or forego in order to implement a writing life?

6. As research discoveries often arise when one looks at old facts in a new way, do you shine when solving problems creatively?

7. Describe the ways that you evidence curiosity. How do use your scholarly acumen to pursue your interests? Do you fulfill minimum requirements or explore further on your own?

8. On a scale of one to ten, with ten being highly adaptable, how would you rate yourself when it comes to seeking innovation?

9. Describe how you fund self-motivation. Can you set goals independently and work on a task without day-to-day encouragement?

10. What do you view as the perks of developing a publication track record? Articulate what you stand to gain both personally and professionally.

11. Do you prefer to engage in research and writing activities solo, dyadically, or in small groups? Please provide a rationale for your choice

12. What do you perceive as the benefits of writing solo?

13. What do you perceive as the benefits of writing in a dyad?

14. What do you perceive as the benefits of writing in a small group?

15. What do you perceive as the current barriers to fulfilling your research, writing, and publication goals?

16. Do you have any one person or multiple members of your collegial network with whom you would like to write?

17. What types of skills and contributions would you expect those individuals to bring to the table?

18. What types of mentoring or coaching supports do you need to bring your writing and publication agenda to fruition?

19. What is your current timeline for producing a publishable product?

Conclusions: Individual and Relational Benefits and Institutional Gains

Although publication is not the sole guarantor of retention, it makes a career in academe more likely. Helping aspiring writers assess personal readiness and perceived barriers is the first step to facing into the task at hand. Junior faculty women of colour must elect to make the dyadic-relational writing life an emotional and a career survival imperative as well as a well-deserved luxury. There is self-satisfaction and joy to be gained in building the communality needed to shatter the mesmerism of patriarchally imposed struggle couched in academic cultures, which can effectively banish scholars to work in isolation. In contrast, we promote the Ibeji model as a twenty-first-century adaptation to the failure of the academy to diversify its faculty at associate professor levels and beyond. Our model springboards from the organically generated bonds of friendship forged in the crucible of graduate studies. Beyond such organic origins, the platform of friendship connections is a springboard for intentional and strategic use of relatedness and community for purposes of political resistance to academe's continued failure to retain underrepresented faculty. Academia's embrace of such organic models may be a direction that could counter the stifling pace of faculty retention of Black women and other underrepresented faculty groups, ultimately transforming the academy to reflect the diversities both on our campuses and in the world beyond them.

Works Cited

Acedo, F.J., et al. "Co-authorship in Management and Organizational Studies: An Empirical and Network Analysis. *Journal of Management Studies*, vol. 43, no. 5, 2006, pp. 957-83.

Barnett, A.H., et al. "The Rising Incidence of Co-authorship in Economics: Further Evidence." *Rev Econ Stat.*, vol. 70, no. 3, 1988, pp. 539-43.

Beaver, D. "Reflections on Scientific Collaboration (and Its Study): Past, Present, and Future." *Scientometrics*, vol. 52, no. 3, 2001, pp. 365-77.

Biagoli, M., and P. Galison, editors. *Scientific Co-authorship: Credit and Intellectual Property in Science*. Routledge, 2002.

Braun, T., et al. "Publication and Cooperation Patterns of the Authors of Neuroscience Journals." *Scientometrics*, vol. 51, no. 3, 2001, pp. 499-510.

Cronin, B. *The Scholar's Courtesy: The Role of Acknowledgement in the Primary Communication Process*. Taylor Graham, 1996.

Cronin, B. "Hyperauthorship: A Postmodern Perversion or Evidence of a Structural Shift in Scholarly Communication Practices?" *Journal of the American Society for Information Science and Technology*, vol. 52, no. 7, 2001, pp. 558- 69.

Cronin, B., et al. A Cast of Thousands: Co-authorship and Subauthorship Collaboration in the Twentieth Century Chemistry." *Journal of the American Society for Information Science and Technology*, vol. 54, no. 9, 2003, pp. 855-71.

Cronin, B., et al. "Visible, Less Visible, and Invisible Work: Patterns of Collaboration in Twentieth Century Chemistry. *Journal of the American Society for Information Science and Technology*, vol. 55, no. 2, 2004, pp. 160-68.

Fafchamps, M., et al. "Scientific Networks and Co-authorship." University of Oxford Department of Economics Discussion Paper Series no. 256, 2006.

Glanzel, W. "National Characteristics in International Scientific Co-authorship." *Scientometrics*, vol. 51, no. 1, 2001, pp. 69-115.

Glanzel, W., and C. De Lange. "A Distributional Approach to Multinationality Measures of International Scientific Collaboration." *Scientometrics*, vol. 54, no. 1, 2002, pp. 75-89.

Glanzel, W., and C. De Lange. "Modelling and Measuring Multilateral Co-authorship in International Scientific Collaboration Links." *Scientometrics*, vol. 40, no. 3, 1997, pp. 605-26.

Hamermesh, D.S., et al. "Scholarship, Citation and Salaries: Economic Reward in Economic." *Southern Economic Journal*, vol. 49, no. 2, 1982, pp. 472-81.

Harvey, A. "The Plight of the Black Academic." *The Atlantic*, 15 Dec. 2012, www.theatlantic.com/business/archive/2015/12/the-plight -of-the-blackacademic/420237/. Accessed 25 Aug. 2019.

King, T.C., and S.A. Ferguson. *Black Womanist Leadership: Tracing the Motherline*. SUNY Press, 2011.

Kuzhabekova, A. *Impact of Co-authorship Strategies on Research Productivity: A Social-Network Analysis of Publications in Russian Cardiology.* University of Minnesota, 2011. /hdl.handle.net/11299/108109. Accessed 31 Aug. 2019.

Laband, D. and R. Tollison. "Intellectual Collaboration." *Journal of Political Economy*, vol. 108, no. 3, 2000, pp. 632-62.

Moody, J. "The Structure of a Social Science Collaboration Network: Disciplinary Cohesion from 1963 to 1999." *American Sociological Review*, vol. 69, no. 2, 2004, pp. 213-38.

Rigby, J., and J. Edler. "Peering Inside Research Networks: Some Observations on the Effect of the Intensity of Collaboration on the Variability of Research Quality." *Research Policy*, vol. 34, no. 6, 2005, pp. 784-94.

Rumsey-Wairepo, A. *The Associationg between Co-authorship Network Structures and Successful Academic Publishing Among Higher Education Scholars.* Dissertation. Department of Educational Leadership and Foundations, Brigham oung University, 2006.

Sauer, R. D. "Estimates of the Return to Quality and Co-authorship in Economic Academy." *Journal of Political Economy*, vol. 96, no. 4, 1988, pp. 855-66. Smith, M. "The Trend toward Multiple Authorship in Psychology." *American Psychologist*, vol. 13, no. 10, 1958, pp. 596-99.

Strauss, V. "It's 2015. Where Are All the Black College Faculty?" *Washington Post*, 12 Nov. 2015, www.washingtonpost.com/news/answer-sheet/wp/2015/11/12/its-2015-where-are-all-the-black-college-faculty/. Accessed 25 Aug. 2019.

Streeter, C.L., and D.F. Gillespie. "Social Network Analysis." *Journal of Social Service Research*, 1993, vol. 16, no. 1, 1993, pp. 201-22.

Tyler, A. "How Do You get to Carnegie Hall? Practice, Practice, Practice." *On Stage Magazine*, 10 Nov. 2016, onstagemagazine.com/carnegie-hall/. Accessed 28 August 2019.

Wagner, C., et al. *Science and Technology Collaboration: Building Capacity in Developing Countries?* Report prepared for the World Bank by RAND Science and Technology, 2001.

Walker, A. *The Temple of My Familiar.* Harcourt, 1989.

Whittaker, J.A., et al. "Retention of Underrepresented Minority Faculty: Strategic Initiatives for Institutional Value Proposition



Based on Perspectives from a Range of Academic Institutions." *Journal of Undergraduate Neuroscience Education*, vol. 13, no. 3, 2015, A136-A145.

Wuchty, S., et al. "The Increasing Dominance of Teams in Production of Science." *Science*, vol. 316, no. 5827, 2007, pp. 1036-39.

Chapter Six

Women "Playing House": An In-Depth Examination of Adult Female Friendship on Television

Eileen Doherty and Kari Wilson

In a March 2017 article published in the *Boston Globe* titled "Women without Men (Are Doing Just Fine, Thank You)," author Alysia Abbott highlights recent statistics regarding the changing roles of marriage and friendship in American women's lives. Abbott notes that today, "fewer American women in their early 30s are married than at any other point since at least the 1950s," and the U.S. marriage rate overall "hit a record low in 2015, seeming to confirm an earlier study that found 55 percent of singles are not looking to get married." Abbott goes on to conclude that "with women increasingly marrying later or not at all, the supporting companionship once provided by husbands is now often being provided by friends." Abbott is not alone in noticing the shifting landscape of American women's relationships. Rebecca Traister, author of the best-selling *All the Single Ladies: Unmarried Women and the Rise of an Independent Nation*, has written about this topic as well. In her 2016 *New York Times* piece on the subject titled "What Women Find in Friends That They May Not Get from Love," Traister emphasizes the importance of friendship throughout women's lives: "For many women, friends are our primary partners through life; they are the ones who move us into new homes, out of bad relationships, through births and illnesses. Even for women who do marry, this is true at the beginning of

our adult lives, and at the end—after divorce or the death of a spouse."

With American women waiting longer to marry and increasingly relying on networks of female friends for companionship and support, it is reasonable to wonder if media depictions of women's social worlds reflect this new reality. Researchers from multiple traditions agree that media contributes to viewers' perceived reality (Gamson et al. 378; Livingstone 10; Shapiro and Lang 687; Shrum 71), and one particular area of importance in media's construction of reality is what it means to be part of interpersonal relationships. Relationships make up a large part of our identity and contribute to who we are. Distorted portrayals of relationships could influence distorted ideas about what it means to be a friend, lover, mother, son, etc.—leading to negative relational outcomes. Although some studies have examined the portrayal and impact of relationships in the media (Albada 5; Behm-Morawitz and Mastro 131; Ivory et al. 170; Leon and Angst; Moore), very few have examined female friendships, especially adult female friendships.

Studies examining media depictions of female friendships have been somewhat limited. Past studies have focused on understanding the teenage "frenemy" relationship (Behm-Morawitz and Mastro 131) or have examined the gendered nature (Boyle and Berridge 353; Ivory et al. 170) or historical development of the friendship within the media (Spangler 13). Many of these studies also focus on movies (Boyle and Berridge 353; Winch 69) rather than on television. As Michaela Meyer explains, "film is limited in its capacity to tell an on-going narrative, but television shows that continue for multiple seasons have the ability to create, maintain, and reform relationships between characters" (265). Although they are rather limited in their approaches, these previous studies underscore the need for further exploration of female friendships on television.

The purpose of this study was to examine the representation of adult female friendships currently on television. Utilizing the turning point perspective within relational dialectics theory (Baxter and Bullis 469), our goal was to identify how the television show *Playing House* represents adult female friendships. The following research questions guided our study:

1) How does Playing House define what it means to be in an adult female friendship?;

2) How does *Playing House* portray the negotiation of relational turning points and dialectical tensions in adult female friendship?

Adult Female Friendships

Friendships represent significant relationships in the lives of both children and adults (Rawlins 5), and intimacy is a fundamental, underlying component of friendship across the life course (Fehr 265). Friendship in adulthood is a particularly unique type of social and personal relationship—notable for both its flexibility and its fragility (Allan 3). As Graham Allan asserts: "Because friendships are based on notions of equality and reciprocal exchange, they are often more difficult to sustain when the material and social circumstances of those involved become dissimilar. As a result, there is an inherent tendency for change in friendship networks as people's commitments and lifestyles alter across the life course" (13). Due to the competing demands presented by work, marriage, family, neighbourhood, and community (Rawlins 153), contact with friends typically declines during the adult stage of the lifecycle. Research reveals, however, that friendships remain significant relationships in adulthood, even though they generally play less important roles and are less intense than other relationships and obligations (Bruess and Pearson 25).

A number of studies have explored how men and women's friendships differ. Women place higher value on their relationships than do men (Cross and Madson 5) and women's friendships are characterized by more intimacy, self-disclosure, and emotional support than men's (for a meta-analysis, see Reis 203 and Fehr 268). Studies also suggest that women may expect more of their friends than men do, particularly when it comes to rules governing support and disclosure (Argyle and Henderson 211). A meta-analysis by Jeffrey Hall (723) noted that studies find that friendship expectations are indeed higher for females than for males with regard to communion (e.g., intimacy), solidarity (e.g., mutual activities), symmetrical reciprocity (e.g., loyalty), and overall friendship expectations, but lower than those for males for expectations of agency (e.g., friend's wealth, status). According to Hall (730), these

findings are consistent with evolutionary theory, which suggests that females develop higher expectations regarding communication due to their relatively extensive investment in offspring and their need to maintain female coalitions to assist in rearing children.

Turning Points in Close Relationships

Originally, theories such as social penetration (Altman and Taylor 42) and Mark Knapp's (32) model of relational development conceptualized interpersonal relationship development as a serial process. Based on romantic relationships, these theories understand relationship development as occurring in a series of stages of deepening intimacy, with the stages ultimately leading to a final point, such as marriage (Baxter and Montgomery 42). These stage-based theories have been subject to a variety of criticisms (Baxter and Montgomery 20; Cate and Lloyd 32), largely because they "de-emphasize the possibility of multiple developmental trajectories" and are "predicated on the underlying assumption of linear progress" (Baxter et al. 293).

In contrast to serial theories of relationship development, Leslie Baxter and Barbara Montgomery's dialectics theory describes relational development as "fundamentally indeterminate, slippery, and fuzzy" (48). Rather than offering a view of relationship development as a process of serial growth, these authors view the process as one in which relationships are continually being modified. Indeed, Baxter and Montgomerycall for a redefinition of relationship development, referring to the process instead as "relational change process" (52). A turning point approach to relationship development focuses on events or occurrences associated with change within relationships, wherein a "turning point" is defined as a "transformative event that alters the relationship in some important way, either positively or negatively" (Baxter et al. 294).

Considerable research has examined turning points within a variety of relationship contexts, including romantic relationships (Baxter and Bullis 496; Bullis et al. 213), family relationships (Baxter et al. 291; Golish 79), and friendships (Becker et al. 347; Johnson et al., "The Process" 54); turning points have been identified in relation to a wide array of events within these relationship contexts. For example, turning points related to activities and special occasions (e.g., Baxter et al.), passion and romance (e.g., Metts), commitment and exclusivity,

changes in families and social networks (e.g., Golish), and crisis and conflict (e.g., Johnson et al., "The Process" 60) have been examined within the literature.

According to Baxter and Montgomery (22), turning points are indicative of the interplay of dialectical tensions within relationships, or as Jennifer Becker describes them, "the interdependent, yet mutually negated, contradictions that are native to all interpersonal relations" (352). Relational dialectics theory (RDT) suggests that all social relationships entail a constant balancing act between maintaining individual perspectives and merging them into a shared perspective. Relationship researchers have identified three central dialectical contradictions, or supra-dialectics, that occur with regularity in investigations of dyadic relationships: the dialectic of integration-separation, the dialectic of stability-change, and the dialectic of expression-privacy (Baxter and Simon 225; Baxter and Erbert 547). Both poles of each dialectical contradiction are important to relationship parties, as they represent important individual and relational needs.

Turning Points and Friendship

Whereas a number of studies have employed a turning points approach to the examination of romantic relationships, studies exploring turning points in the context of friendship are relatively scarce and focus almost exclusively on friendships among college students (Becker et al. 347; Johnson et al., "The Process" 54; Johnson et al., "Changes" 395; Johnson et al., "Relational Progression" 230). Friendships are ripe for study from a turning points perspective, as they encompass many relational changes and contradictions similar to those found within romantic or family relationship yet differ from those relationships in important ways. As Amy Johnson et al. assert, because most theories of relational development have been based on romantic relationships, friendships need to be examined to determine if existing conceptualizations of relational development accurately describe this relationship" ("Relational Progression" 234).

Findings are relatively consistent across studies regarding the content of friendship turning points. The turning points most commonly identified in these studies include engaging in activities together (either with purpose or due to circumstance), sharing living

quarters, general talking and hanging out, geographic distance, and shared interests (Becker et al. 347; Johnson et al., "The Process" 54; Johnson et al., "Changes" 395; Johnson et al., "Relational Progression" 230). In their examination of turning points and changes in friendship levels among college students, Johnson et al. note that the romantic relationship turning point types identified in previous studies—which included such turning points as exclusivity, serious commitment, external competition, and passion (Baxter and Bullis, 490, as cited in Johnson et al., "Relational Progression" 250)—were not identified as turning points within friendships. Certain turning point types do appear to be unique to romantic relationships, but there is also significant overlap between the two relationship categories. Indeed, results from Johnson et al. ("Relational Progression" 247) and subsequent studies of friendship turning points (Becker et al. 347; Johnson et al., "The Process" 54; Johnson et al., "Changes" 395) reveal similarities between friendship and romantic turning points, particularly when it comes to subcategories, such as greater geographic distance, engaging in activities together, self-disclosing, doing favours, and providing support.

It is important to reiterate that the studies of friendship turning points mentioned above have all focused solely on friendships among college students, largely due to the convenience of studying undergraduate samples. Although Johnson et al. ("Relational Progression" 230) have argued that this may be an advantage rather than a limitation—for example, college students have more frequent interactions with friends, and with fewer adult roles to fulfill, they have more time to focus on their friendships—the ability to generalize findings regarding friendship turning points among undergraduates to other age groups is uncertain. Indeed, Becker et al. note the following regarding their college student sample: "Individuals in more mature friendships would probably report different turning point content. For example, they may be unlikely to report living together as a turning point, but may report common interests (e.g., raising children) for fostering an upturn, or conflict (e.g., a perceived betrayal) as leading to a downturn in friendship level (366). Because the current literature on friendship turning points is so limited in scope—due to the fact that only college student samples have been examined—little is known regarding what the content of friendship turning points may look like for adults over the age of twenty-five.

Media Depictions of Female Friendship

Media scholars have also turned their attention to female friendship and have analyzed portrayals of these relationships in movies and television through a variety of lenses and theoretical frameworks. Lynn Spangler has provided an early, fairly straightforward historical overview of female friendships as presented on prime-time television, with a specific focus on how conversations were depicted between female friends. She concludes that depictions of female friendships evolved significantly from the 1950s through the 1980s:

> While female friendships and women in general have not been depicted favorably throughout television history, improvements have been steadily made. From the stereotyped, slapstick friendship of housewives Lucy and Ethel, to the emphasis on the characters of single women Mary and Rhoda, to the slapstick/ seriousness of Laverne and Shirley, we are now enjoying the realistic humor of divorcees Kate and Allie, the older "Golden Girls," and the socially significant drama of Cagney and Lacy. (21-22)

In more recent years, a number of scholars have interrogated the importance of intimate female friendships in movies and television from the 1990s through today (Boyle and Berridge 353; Hollinger 22; Stephens 886; Stillion Southard 149; Winch 69). Some of these scholars conclude that depictions of female friendship are moving in a positive direction by tackling socially significant themes and portraying women with fully complex identities, experiences, and relationships. For example, in a close reading of *Kate and Allie*, Vincent Stephens argues that the show's, "nuanced depiction of the struggles of divorced 'baby boomer' mothers and their ability to create a household" represents a benchmark redefinition of family in American television (887). In her examination of feminist meanings in *Sex and The City*, Belinda Stillion Southard concludes that the show "characterizes female agency as the power to choose friends and self over men," and despite the show's limited ability to portray diversity along race, class, sexuality, and nationality lines, "the characters' ongoing feminist struggles offer alternative meanings within a postfeminist climate" (166).

Other examinations (Brook 227; Winch 69) have sharply critiqued recent depictions of female friendship in "girlfriend flicks," such as *Bride Wars* and *The Women*. According to Karen Boyle and Susan Berridge, the dominant narrative in these films "is of the reconfiguration of female friendship groupings in the light of heterosexual romance and ritual" (365). For Alison Winch, rather than providing, "a cathartic space for female spectators to identify with the inevitable heartbreak and confusion involved in friendship," the girlfriend flick instead "reinstates conservative principles as each girlfriend slips into the seeming security of the middle class heterosexual matrix" (79). A review of the literature suggests that depictions of female friendship in the media vary widely, and although positive portrayals are increasingly common, negative stereotypes and representations of female friendship persist.

Turning Points in Media Depictions of Friendship

Dialectical approaches to media texts have been conducted but most have employed a deconstructive rather than relational approach (Downey 185; Frentz and Rushing 64). The few studies that have taken a relational approach indicate the usefulness of applying relational dialectics theory to media depictions of close relationships. Katherine Fields and Danette Johnson, for example, have examined the relational maintenance strategies used to negotiate autonomy and connectedness in father-child relationships portrayed in the adolescent television dramas *Everwood, Seventh Heaven,* and *Veronica Mars* (284). In another application of relational dialectics to a media text, Meyer (262) conducted a close narrative reading of *Dawson's Creek* for dialectical tensions in relationships that serve to construct the sexual identity of a gay character, Jack McPhee. These studies explore the negotiation of specific dialectical tensions among characters on television, but to our knowledge, no existing studies have examined the content of relational turning points in televised portrayals of close relationships. With the current study, we intend to fill this gap in the literature through an in-depth exploration of turning points in the depiction of adult female friendship on the television show *Playing House.*

Methods

This study employed a qualitative content analysis to examine the representation of adult female friendships on television. The goal of a qualitative content analysis is to explore "the relationship between the text and its likely audience meaning, recognizing that media texts are polysemic—i.e. open to multiple different meanings to different readers—and tries to determine the likely meaning of texts to audiences" (Macnamara 5). Unlike quantitative content analysis that categorizes and codifies data into numerical form, qualitative data analysis is interested in describing media content, understanding the meaning created through media messages, as well as verifying theoretical relationships (Altheide, 65). According to David Altheide, there are five stages in qualitative content analysis: (a) selecting the sample, (b) protocol development and data collection, (c) data coding and organization, (d) data analysis, and (e) the final report (68).

Sample Selection

Playing House, a television show airing on the USA network, was purposefully chosen as the focus of our study. The plot of the show centres on Maggie and Emma, two best friends who have recently been reunited after three years for Maggie's baby shower. After finding out at the baby shower that Maggie's husband has been cheating on her and she wants to divorce him, Emma decides to leave her high-powered career in China and move in with Maggie to help raise her baby.

The series *Playing House* was chosen as the focus of this study for several reasons. First, the series has received attention in the media for its novel representation of female friendships (e.g., Beck, "Playing House"). Second, although there are a variety of shows that focus on female friendships, *Playing House* focuses on the friendship between two adult women in their late thirties to early forties, unlike many shows that focus on teenage or young adult friendships. Also, the setting occurs in a suburb rather than in an urban environment in shows such as *Girls, Sex and the City,* and *Broad City.* As a result, much of the plot centres on more domestic concerns, such as raising a family, which may be more relatable to female viewers. In some ways, *Playing House* picks up where other shows like *Kate & Allie* left off over twenty-five years ago. But, in other ways, the show is completely unique in terms of what is on television concerning female friendship right now.

Protocol Development and Data Collection

The authors met to develop the coding protocol. Coding protocols within qualitative content analysis are meant to guide systematic analysis of the texts, without being rigid (Altheide 65). We used a directed content analysis approach (Hsieh and Shannon 1277) in which we started with relational dialectics theory and turning point literature as a guide. This helped to deductively develop different categories for observation. Drawing primarily from types of turning points initially identified by Leslie Baxter and Connie Bullis (12), we created an operational definition for a turning point as an event that changed the friendship in some way. We wanted to keep the specific types of turning points open ended during coding but considered the four different types of turning points identified by Catherine Surra—interpersonal/normative, dyadic, social network, circumstantial—as guides while viewing the content (17). Based on our research questions, we also wanted to make note of any instance in the series where it attempted to define what it meant to be in an adult female friendship.

All twenty-six episodes of the series (over three seasons) were obtained through purchasing or obtaining access to the episodes through free online websites. The unit of analysis was an individual scene. We defined a change of scene as a production cut to a new location or setting. In order to initially test our protocol, both researchers watched the first two episodes of the series together with the initial codes in mind as well as to determine how to break up each episode into scenes. After discussion of coding procedures and to reconcile any disagreement, we independently coded the next two episodes applying the coding protocol. There was 100 per cent agreement for these two episodes in terms of when each new scene occurred. We also discussed in depth application of the protocol to determine any discrepancies.

Data Coding and Analysis

Qualitative content analysis emphasizes analyzing narrative data with constant comparison in order to discover emerging patterns and themes within the messages (Altheide 24). There is constant interplay between data collection, data coding, data analysis, and interpretation. As a result, for the main data analysis, we watched all of the episodes in separate geographic locations and wrote down first impressions regarding what constituted turning points and female friendship.

After watching each episode once for general impressions, we went back and more carefully applied the coding protocol. For each episode, the general procedure included noting when in the episode the new scene began, who was in the scene, what the major plot occurrences were in the scene, and making any comments regarding the presence of turning points or information about female friendship. In general, the goal was to describe what was shown, who was shown, and what they were doing.

Although our research questions and coding protocol initially guided our interpretation, other themes were allowed (and expected) to emerge throughout the study. We wanted to be reflexive in order to include any emerging themes that were important for understanding interaction in adult female friendships (Altheide 65). Therefore, during the coding process, both researchers would talk periodically to review how reliably we were applying the codes in order to refine the coding protocol based on disagreements (Kim).

Results

Our analysis of turning points and female friendship in *Playing House* revealed four overarching themes: 1) female friendship defies easy categorization; 2) friendship involves sacrifice; 3) symbolic moments reinforce the family of choice; and 4) men as a source of conflict. In the following paragraphs, we provide descriptions and discussion of each of these themes.

Theme One: Female Friendship Defies Easy Categorization

A major theme that runs throughout much of *Playing House* is the notion that Emma and Maggie's relationship defies easy categorization. The show depicts a constant negotiation of their identity as a dyad, both publicly and privately. It is made clear throughout the show that Emma and Maggie perceive themselves as best friends, and they frequently make references to how friends should behave towards one another. Once Charlotte is born, Emma and Maggie also label themselves as a family. The two repeatedly convey to each other how important their family bond is throughout the show: with Maggie's decision to give Charlotte "Emma" as a middle name, with Maggie's insistence that their family portrait be on display at the portrait studio, and with

Emma's painting "The Charlotte" on their shared paddleboat. Although it is clear that Emma and Maggie think of themselves as friends who are also family, the people in their social networks seem to insist on categorizing Emma and Maggie as a romantic couple. This is a running theme throughout the show. For example, when Emma, Maggie, and Charlotte are having their first family portrait taken, they feel they must repeatedly correct the photographer, who mistakenly assumes that they are a lesbian couple:

PHOTOGRAPHER: That feels right, right moms?

EMMA: Actually, she's the mom. I'm the best friend, and this is the baby.

PHOTOGRAPHER: Friends, lovers—we don't need labels. All I need from you is do whatever you're going to do when you crawl into bed and start to snuggle with each other.

MAGGIE: I'm sorry, Dougie, but I think there's been a miscommunication because that's not what's happening here.

EMMA: Right, she got divorced. I moved home to help her with the baby so that's sort of what we're trying to capture here.

MAGGIE: Yeah, just kind of an alternative family situation but we're not married, but we're friends, and there's a baby.

PHOTOGRAPHER: Weird, but okay, let's move on. ("Hello, Old Friend")

Other characters on the show make more offhand—and often humorous—attempts to label Emma and Maggie as a romantic couple. Mark, a close friend to both Emma and Maggie, is frequently frustrated by the pair's hijinks and pleads with them to communicate with each other more effectively as if they were a romantic couple. On one occasion, Mark tells Emma, "Talk some sense into your woman, please!" in reference to Maggie. On another occasion, he tells Maggie, "Talk to your WIFE!" in reference to Emma. These moments are not treated as noteworthy on the show, nor are they treated as an implication that there is a sexual relationship between the pair; rather, they are simply depicted as offhand remarks. Still, they clearly indicate that, to Mark,

Emma and Maggie more closely resemble spouses than friends.

In another episode, Emma and Maggie eavesdrop on a conversation between Mark and his wife, Tina, in which Tina remarks that Emma and Maggie both looked tired the last time they saw them:

TINA: Didn't they both look tired?

MARK: Well we should probably cut 'em some slack, they just had a baby.

TINA: They just had a baby?! No, Maggie just had a baby. What's Emma's excuse for those extra ten pounds? ("Hello, Old Friend")

Here, it again becomes clear that members of Emma and Maggie's social circle view the pair as a traditional couple rather than just friends, playing off of the traditional idea of "sympathy weight," in which husbands gain weight during their wives' pregnancies. In this case, however, Emma is viewed as the husband in the pair.

In some cases, Emma and Maggie embrace the label of romantic partners—primarily when that label suits their needs. When Maggie goes into labour, her usual obstetrician is unavailable, so she is assigned a new doctor who happens to be a very charming and beautiful lesbian, Dr. J. When Dr. J meets the two friends and assumes they are a lesbian couple, they do not correct her: Emma and Maggie are simultaneously intimidated by and in awe of the doctor, and both feel that correcting her would create an awkward situation. Emma and Maggie become even less willing to correct Dr. J. after she invites the pair to join her and her wife for a "lovers and couples weekend" at their beach house on Block Island:

MAGGIE: So ... you have to be a couple or a lover, then, to attend?

DR. J: Right.

MAGGIE: I get it.

EMMA: Well ... we love each other, and we are a ... couple. So, why wouldn't we, right? ("Let's Have a Baby")

EILEEN DOHERTY AND KARI WILSON

Eventually, in the chaos of the impending delivery, Maggie feels that she must come clean with Dr. J, particularly to explain the presence of her ex-husband, Bruce, in the delivery room. After Maggie explains the true nature of the relationships between everyone, Dr. J is confused:

DR. J: Okay, I don't know what's going on here.

EMMA: Okay, Dr. J, we're really sorry. We let you believe we were lesbians because you're just such a good doctor and—

MAGGIE: We didn't want to make it weird, but we made it weird anyway.

EMMA: Yeah, and we just wanted you to like us. So, um, I am actually the best friend. I dropped everything, and I moved in to help her with the baby.

DR. J: Okay, for the record, this is a little lesbian-y. ("Let's Have a Baby")

When it comes time for Maggie to deliver the baby, Emma stays right by her side and delivers an emotionally powerful pep talk that helps Maggie through the final push. Although Bruce, the father of the baby, is in the room during the delivery, it is Emma who is in the most important position of support by Maggie's side—a position that, traditionally, is held by the mother's romantic partner.

The fact that Emma and Maggie's relationship defies easy categorization is very much in line with what Stephens (890) identifies as "kinship and family subversion" in his examination of *Kate & Allie*— another sitcom centred on female friends who make the conscious choice to cohabitate and raise their children together. As Stephens notes regarding *Kate & Allie*:

The dynamic of *Kate & Allie*'s two characters fosters an intimacy within the confines of their household that enables them to blend friend, sister, spouse, and mothering roles with seamless intensity.... Kate and Allie primarily relate as friends and household companions in parallel social situations. This feeds the dismantling and reorienting of platonic and familial roles. (890)

Because Emma and Maggie cohabitate and share a significant, common goal—to successfully raise a child together—their relationship similarly blends the roles of friend, sister, spouse, and mother. Although notion of "friends as family" has also been identified in examinations of shows such as *Sex and the City* (Stillion Southard 149), the family depicted in *Playing House* is a much more traditionally domestic one than the "urban tribe" depicted on *Sex and the City*. That is, although the female friends on *Sex and the City* are shown spending time together regularly and unconditionally supporting one another, they do not cohabitate or commit to raising children together.

Not only do *Playing House* and *Kate & Allie* share a similar premise, they also share a nearly identical episode plotline. Just as Emma and Maggie pose as lesbians in an effort to curry favour with Maggie's lesbian obstetrician, Kate and Allie pose as lesbians to justify the double occupancy of the apartment to their lesbian landlord who will permit the arrangement if it involves lesbians ("Landlady" aired October 15, 1984, as cited in Stephens 902). Furthermore, just as Emma and Maggie sheepishly come clean to their obstetrician regarding their status as best friends rather than lesbians, Kate and Allie eventually acknowledge their heterosexuality to their landlord but ask the landlord to be tolerant of their unusual family. Both plotlines suggest that a family that consists of two heterosexual female friends raising children together is far more unorthodox than a lesbian couple doing the same, and this may very well be a reflection of reality, then and now. *Playing House* and *Kate & Allie* portray unique, "alternative" family units while also depicting a society that isn't quite sure how to react to those family units. It is perhaps telling that *Playing House* is the first sitcom to portray this specific female friendship dynamic since *Kate & Allie*, which first aired in 1984, almost exactly 30 years before *Playing House* premiered.

Theme Two: Friendship Involves Sacrifice

A key theme that emerged several times throughout our analysis of *Playing House* is the notion that friendship involves sacrifice, and those sacrifices serve to bond friends together. An event that closely follows Emma's return to Pinebrook is the discovery that Maggie's husband, Bruce, has been cheating on her. This information actually comes to light during Maggie's baby shower and quickly throws Maggie into a state of panic regarding the state of her marriage—as well as her

impending motherhood. Emma comforts Maggie immediately after the discovery, and the next morning, she announces that she will quit her job and stay in Pinebrook in order to move in and help Maggie take care of the baby. Maggie reacts with mixed emotions:

EMMA: I'll move here. I will help you!

MAGGIE: That is not an option. You couldn't even drive down Main Street without having a nervous breakdown!

EMMA: Sometimes life doesn't work out as planned, and when that happens, you've gotta be brave and let your friend help you!

MAGGIE: When stuff gets hard, you're not going to be able to Skype in or call your assistant, and then you're gonna bail, and then I'll be all alone.

EMMA: You really think I would do that to you? ("Pilot")

This conflict leads to Emma angrily making the decision to go back to China after all; however, after Maggie realizes that Emma had done all the work to assemble the furniture in the baby's nursery as a favour to her, she changes her mind and insists that Emma stay after all:

MAGGIE: I love you. And I want you to stay here and help me raise this baby.

EMMA: Okay, what about all that stuff you said about how I can't handle it?

MAGGIE: I don't know if you can handle it. I honestly don't know if I can handle it. But I do know that you are the only one that I want with me. Okay? Will you stay with me and my stupid trash can?

EMMA: Yes. Yes I will stay with you and your stupid trash can. ("Pilot")

This sequence of events represents a number of important turning points between the friends. The most obvious turning point is that of sacrifice, as Emma gives up her very successful and lucrative career in China in order to stay in Pinebrook—a town she does not particularly

like—to help Maggie take care of her baby. It is clear that Emma is putting Maggie's interests above her own. Emma also does her best to help Maggie cope with a crisis, as her marriage to Bruce rapidly and unexpectedly falls apart. Maggie refers to her life as a "trash can" to emphasize its disastrous state. Lastly, these events represent a turning point of serious commitment, as both Maggie and Emma have increased their level of interdependence in a significant way, beyond the typical bounds of friendship and into the realm of co-parenting. It is a major commitment, particularly for Emma, as it will mean a great deal of additional responsibility in her friendship with Maggie.

The turning points of sacrifice and serious commitment reemerge again during the second season of *Playing House*, after Maggie has given birth to Charlotte, who is now several months old. Emma and Maggie are successfully raising Charlotte together, but Maggie starts to feel anxious about her job as a waitress and yearns for a more meaningful career. Maggie's anxiety builds throughout the episode until she finally confesses to Emma that she wants to go back to nursing school (which she had quit in her early twenties after her parents died suddenly):

MAGGIE: (crying) I have a question that I need to ask you that's very important, and I don't know how to ask it. I don't want to be a waitress forever ... if I'm gonna be away from Charlotte, it has to be for something that I really care about.

EMMA: Okay, what are you talking about? You're going to need to stop crying just a little bit so I can understand what you're saying.

MAGGIE: (crying) I wanna be a nurse! I want to go back to school, and I want to be a nurse. I don't know what kind of nurse. Do I have to decide right now?

EMMA: No, no!

MAGGIE: Okay, but it's gonna be really hard. I'm gonna be on rotations, and I'm never gonna be home, and you're gonna have to ferry milk back and forth, and I know how you hate touching those milk bags. You've told me many times how you hate touching those milk bags.

EMMA: Are you done?

MAGGIE: No, I don't think so. I have so much to say on the matter because I care about you a lot and you've given up a lot and it's a big question.

EMMA: Can I speak? If this is what you want, we are gonna make it happen, okay? Hey, you have spent your entire life taking care of other people. How about you let me take care of you while you learn how to take care of other people? Dammit! Why are you always taking care of other people?

MAGGIE: It's what I love to do.

EMMA: You're gonna be great at it. Hey, it's why I moved back here. Alright? And as it just so happens, I just love taking care of that little monkey upstairs. ("Sleepless in Pinebrook")

Here, Emma once again decides to sacrifice her time and make a more serious commitment to Maggie by agreeing to take on a greater share of co-parenting responsibilities. Maggie clearly acknowledges that Emma has already made a large sacrifice by helping her raise Charlotte in the first place, which creates anxiety for her when she feels compelled to ask Emma to sacrifice even more. Throughout the exchange, Emma is completely supportive and understanding, and Maggie is clearly relieved and grateful that Emma is willing to help.

In terms of sacrifice, the tables turn in season three of *Playing House*, when Emma is diagnosed with breast cancer and Maggie takes on the role of her primary caregiver. Maggie is by Emma's side—quite literally—throughout every stage of her illness: from discovering the lump in Emma's breast (Maggie is the first one to actually feel it, while assisting Emma's doctor with a breast exam during a physical), to helping Emma choose new, prosthetic breasts, to preparing Emma for her double mastectomy surgery, and to caregiving for Emma at home as she goes through multiple rounds of chemo following her surgery. When a friend comments on Maggie's sacrifice for Emma, she acknowledges the shared sacrifices they have made for each other: "If you knew the lengths she would go to for me." Interestingly, by the time Emma is diagnosed with cancer, she and Mark are in a firmly established romantic relationship, but it is Maggie who takes on the primary caregiving

role. This arrangement is treated as natural and expected within the show: clearly, Maggie and Emma are each other's primary partners.

Sacrifice and serious commitment are both identified in studies examining turning points in romantic relationships (Baxter and Bullis, 482; Baxter and Erbert, 564), but they have not been identified in studies examining friendship turning points. Indeed, in their examination of friendship turning points among college students, Johnson et al. note that doing favors and supporting a friend emerged as turning point types for their participants "but did not take on the tone of sacrifice, the category listed by Baxter and Bullis, perhaps reflecting David and Todd's (79) assessment that giving one's utmost is more relevant to romantic relationships" ("Relational Progression" 244). By agreeing to move in with her best friend in order to help her raise her child, it is obvious that Emma's actions go far beyond merely doing favours for or supporting her friend. Instead, the sacrifice turning points between Emma and Maggie clearly align with the "crisis help" romantic turning point category identified by Baxter and Bullis (482) as well as the "sacrifice events" category identified in Baxter and Erbert's, which the authors describe as "unforeseen events that often functioned to propel relationship partners towards greater relational commitment and disclosure of feelings" (564).

The sacrifices Emma and Maggie make for each other resemble those identified in the literature on turning points in romantic relationships because the stakes are much higher than they might be in a more typical friendship. That is, most friendships—particularly those among college students—do not entail shared responsibility for parenting a child or caregiving throughout a serious illness. Once again, the show blurs the lines between friendship, kinship, and romantic commitment.

Theme Three: Symbolic Moments Reinforce the Family of Choice

A number of events depicted in *Playing House* increase the closeness between Maggie and Emma symbolically, largely by reinforcing the notion that they are friends who also constitute a family unit. The first occasion occurs shortly after Charlotte is born and Maggie and Emma are preparing for her christening. In the days leading up to the christening, Emma deals with the loss of her friendship with Mark, her ex-fiancé, who is no longer allowed to spend time with Emma as per his

wife's orders. Emma is very upset by this and confesses to Maggie that she feels very alone because she does not have a romantic partner:

EMMA: I feel like everyone has someone.

MAGGIE: You have Charlotte and me, and you are a part of this family. ("Bugs in Your Eyes")

To provide her with more reassurance, Maggie then reveals Charlotte's birth certificate to Emma, which shows that Maggie has chosen "Emma" as Charlotte's middle name. Maggie tells Emma, "You are a part of who she is." This symbolic gesture is both a private and public one, making it clear to both Emma and their social circle that Emma holds a very important role in Charlotte's life.

In a later episode, Charlotte once again serves as a tie between the two friends that reinforces their bond. In the episode, Maggie and Emma have a huge fight when Emma's new boyfriend, Dan, crashes what was supposed to be a "Girls' Weekend" getaway at Emma's family lake house. As a symbolic gesture of apology, Emma and Dan paint the name "The Charlotte" on the paddleboat that she and Maggie have shared on the lake since childhood. The painting of the paddleboat not only serves as an apology but also demonstrates to Maggie what Emma truly values most: Charlotte, the child they are raising together. The gesture works as intended, and Maggie forgives Emma and becomes more accepting of Dan.

This family unit is further solidified symbolically in the first episode of season two, which begins by showing Emma, Maggie, and Charlotte having a family portrait taken in a portrait studio. The photographer assumes that Emma and Maggie are a lesbian couple; when they try to explain that they are, in fact, just friends raising a child together, he responds with, "That's weird, but okay." Maggie then makes it her mission to have their portrait displayed on the studio wall, alongside the other family portraits, and she proclaims, "I believe we belong up on that wall with all those other families—because we are a real family! And it is very important to me." At the end of the episode, Maggie and Emma learn that their family portrait has, indeed, made it up on the wall at the photography studio, alongside the other families. Maggie promptly begins to cry upon learning the good news: "Well, we're a family, we're up on the wall—that means we're a family. We're a real live human family" ("Hello, Old Friend").

Additional symbolic moments reinforce Maggie, Emma, and Charlotte as a family unit when Emma undergoes treatment for breast cancer. Soon after receiving her cancer diagnosis, Emma shares her fears with Maggie and reveals that the stakes are higher now that she's a co-parent to Charlotte:

> EMMA: If this was just me, it's like whatever, but then I think about Charlotte and who's gonna be there to hide her pot? Maggie, do you think I'm gonna be okay?

> MAGGIE: I have never met a stronger woman than you in my entire life. So cancer has picked the wrong duo to mess with. And I'm not gonna leave your side for one second. ("Paging Doctor Yes Please")

In the following episode, Emma and Maggie meet with Emma's oncologist, Dr. Rollins, for the first time, and Emma explains to the doctor that her cancer treatment needs to be effective for Charlotte's sake:

> EMMA: What's going to keep me alive, because I have a one-year-old daughter—well, she's not my daughter—

> MAGGIE: Yes, she is.

> EMMA: She's Maggie's baby, but I need to make sure that I'm here for her. Do you understand?

> DR. ROLLINS: You're gonna be there to dance at Charlotte's wedding—not that she has to get married. We're not gonna force those kinds of decisions on her. ("You Wanna Roll with This")

As an unorthodox family, Emma and Maggie confront the external relational dialectic of revelation-concealment (Baxter and Erbert 565), as they strive to negotiate both a family identity and the public affirmation of that identity. Elizabeth Suter et al. note in their examination of lesbian couples' management of public-private dialectical contradictions that "relational borders are where a dyad meets its networks, social norms, and laws. Dyads may be reaffirmed or disconfirmed by their interactions at relational borders" (350). Several studies have examined how symbols help construct a legitimate parental identity for the

nonbiological mother in lesbian couples; naming (e.g., giving the child a last name that uses or incorporates the nonbiological mother's last name) has been identified as a common strategy used to forge a parental identity (Bergen et al.; Reimann, as cited in Suter et al. 351). In her own twist on this strategy, Maggie gives Charlotte the middle name "Emma." For Emma, the nonbiological parent to Charlotte, seeing her name listed on Charlotte's birth certificate serves as a powerful affirmation of her parental role. Furthermore, Maggie is not satisfied to simply have their family portrait on display in their home; rather, she desperately hopes that it will also be displayed prominently on the wall of the portrait studio, alongside portraits of other, more traditional families. When this eventually happens, Maggie is overjoyed that her family unit has been granted legitimacy in a public setting, even if that legitimacy is only bestowed upon them by the portrait photographer. For Emma and Maggie, symbolic gestures serve to solidify their family identity, both publicly and privately.

Theme Four: Men as a Source of Conflict

Although the majority of interactions between Maggie and Emma on *Playing House* are positive ones, a number of major conflicts threaten the closeness between them, and most of these conflicts involve men who are potential romantic interests. The first of these conflicts occurs shortly after Emma moves in with Maggie and before Charlotte is born. Maggie is going through divorce proceedings, and she enlists the help of both Emma and her divorce attorney, Gary. Shortly after Emma and Gary meet for the first time, Gary asks her out on a date. Unaware that Maggie is secretly harbouring a crush on Gary—a crush that is made very obvious to the viewer throughout the episode—Emma goes on the date with Gary and, afterward, discloses to Maggie that she had sex with him in Maggie's car. This disclosure is too much for Maggie, and she finally blows up at Emma:

> MAGGIE: Yeah, I like him! Okay? And I know it's stupid, but I thought maybe he's the guy I could be with when everything calms down.

> EMMA: If you liked him, why didn't you just tell me?

> MAGGIE: You should have known! I made truffles for him!

EMMA: Maggie, I had no idea.

MAGGIE: You know why? Because you're so far stuffed up your own butthole that you don't know what anyone else needs or wants.

EMMA: Hey! That's not nice!

MAGGIE: You know what else isn't nice is hearing about you doing it on my car seat with the guy of my dreams!

EMMA: All right, you know what? I asked you if it was okay if I went out with him and you said, "It's totes kewl."

MAGGIE: Yeah, well, it wasn't kewl, okay? Whenever I say it's "totes kewl," FYI, it's not kewl.

EMMA: But, Maggie, kewl means cool! Kewl means cool! ("Totes Kewl")

Even though this is ostensibly a fight over Gary, it also illustrates Maggie's and Emma's conflicting expectations regarding how they should communicate with each other. Maggie expects Emma to know how she is feeling without having to communicate it explicitly, but this is an expectation that Emma finds unreasonable. At the end of the episode, Emma breaks up with Gar and then tells Maggie:

EMMA: You're the only thing that matters.

MAGGIE: I should have told you that I liked him, though.

EMMA: No, please, I should have known. And I know that I don't always pay attention 'cause I'm too busy talking, but please don't tell me something is totes kewl if it isn't totes kewl, 'cause I don't want to hurt your feelings. ("Totes Kewl")

Although the fight over Gary temporarily threatens the friendship between Maggie and Emma, it also prompts communication between the two friends that ultimately brings them closer together. It also makes it clear that Emma values her friendship with Maggie over any potential romantic relationship with Gary.

In their examination of female friendships in contemporary film, Boyle and Berridge assert that "there are few stories to tell about women's friendships that are not also, and centrally, stories about heterosexuality" (355). Although Playing House presents an over-whelmingly positive portrayal of female friendship, the conflicts that do arise between Emma and Maggie largely centre on men. These depictions of conflict could also be viewed as positive, however, as they largely avoid the stereotypes of "avaricious, envious, and competitive women," which Winch identifies as endemic to many contemporary women-centred comedies, or what she calls "girlfriend flicks" (77). Rather than overtly or even underhandedly competing with Emma for Gary's affections, for example, Maggie quietly seethes while Emma begins dating him. When Maggie's resentment eventually boils over and she makes it clear to Emma that she is romantically interested in Gary, Emma immediately ends the relationship. Furthermore, the confrontation over Gary is arguably a constructive portrayal of female conflict: rather than actually fighting over Gary, Emma and Maggie use the confrontation to acknowledge the flaws inherent in their own relating. Winch argues that this kind of constructive portrayal of female conflict in the media is useful, as it depicts "conflict, pain, and betrayal acted out between women and, in doing so, is invaluable in offering the female viewer a cathartic space to explore the complexities of women's relationships" (77).

An outside romantic interest once again threatens the friendship between Maggie and Emma several months after Charlotte is born, when Emma is in the "honeymoon phase" of a new relationship with her boyfriend, Dan. Maggie and Emma embark upon a girls' weekend at Emma's family lake house, but Dan repeatedly disrupts their time together—first by texting, calling, and Skyping with Emma, and then finally by showing up at the lake house to surprise Emma. Emma is excited to see Dan, but Maggie is obviously annoyed by his arrival, which throws a wrench into the numerous bonding activities she had planned for the weekend. After Dan completes a jigsaw puzzle that Maggie had been working on for several summers, her resentment boils over and she confronts Emma about Dan's unwelcome presence at the lake house:

MAGGIE: It was just supposed to be us! I didn't give up a weekend with Charlotte so you could hang out with your dumb boyfriend!

EMMA: What am I supposed to do, ask him to leave?

MAGGIE: Yeah, would you? I didn't think so!

EMMA: Ok, you don't like Dan. Why don't you just say it?

MAGGIE: It's you I don't like right now. ("Kimmewah Kup")

After this confrontation, Emma realizes how important the weekend is to Maggie as well as how difficult it is for Maggie to spend time away from Charlotte. With Dan's help, Emma paints "The Charlotte" on the paddleboat she and Maggie have shared since childhood. As noted above, this symbolic gesture serves as both an apology and a clear statement of what is truly important to Emma: her relationships with Maggie and Charlotte.

With the conflict over Dan's disruption of the girls' weekend, Emma and Maggie are not depicted as rivals for Dan's affection; rather, it is Maggie and Dan who are competing for Emma's time and attention. For this reason, the conflict aligns closely with a turning point commonly identified in the literature on romantic turning points—the "external competition" (Baxter and Bullis 481; Baxter and Erbert 565; Baxter and Pittman 11). As identified by romantic couples in these studies, this turning point "involved events in which at least one of the parties experienced a competing demand for time or other relational resources" (Baxter and Pittman 11). In the case of Emma and Maggie's conflict, the more specific categorization of this external competition turning point would be that of "new rival," which, according to Baxter and Bullis, refers to the appearance of a third-party rival for the affection of one of the parties (481).

Of course, Dan and Maggie compete for different kinds of affection from Emma: Dan seeks romantic and sexual affection from Emma, whereas Maggie seeks to reestablish friendship bonds and reenact the pair's longstanding rituals. For example, Maggie plans for the two of them to participate in a paddleboat race, the same one she and Emma had competed in together annually as children. Instead, after Dan's arrival, Emma and Dan take the paddleboat out for a romantic paddle

around the lake. Because there is only room for two people in the paddleboat, Maggie remains on the dock, watching dejectedly as Emma literally leaves her behind. Essentially, the newness of the romantic infatuation between Emma and Dan is pitted against the longstanding bonds of female friendship between Emma and Maggie, and the too-small paddleboat serves as an obvious metaphor—illustrating that Emma can only accommodate one primary partnership at a time. Although the romantic partnership between Emma and Dan temporarily threatens the friendship between Emma and Maggie, the conflict is neatly resolved by the end of the episode, when Emma clearly demonstrates that her partnership with Maggie—and their shared connection to Charlotte—is her top priority.

The resolution of this conflict stands in stark contrast to the way conflicts between female friends have been previously depicted, particularly in the "girlfriend flicks" that Winch has examined. Winch argues that in these girlfriend flicks, "the sentimentalised endings gloss the mutual abuse and betrayal that these women have inflicted," and "the primary intimate relationship between two women is rerouted as a heterosexual one between a man and a woman" (77). Although this particular episode of *Playing House* does indeed feature a sentimentalized ending, its depiction of conflict between Emma and Maggie lacks the negative elements that Winch identifies: there is no real mutual abuse or betrayal between the friends, and the intimate relationship between Emma and Maggie takes precedence over the heterosexual one between Emma and Dan. In this way, *Playing House* presents a refreshingly humane depiction of conflict between female friends while also privileging the bonds of friendship and kinship over the traditional heterosexual script.

Discussion

The purpose of this study was to use the concept of turning points to examine how adult female friendships are constructed on television. One of the most interesting findings from our analysis suggests that *Playing House* portrays adult female friendship as having characteristics associated with both heterosexual marriages and lesbian relationships. In this sense, the show sends the message that the female friendship should take priority over other relationships, in the way that marriages

are often the top priority for adult females in real life (Beck, "How Friendships Change in Adulthood"). For example, Emma usurps the position of primary co-parent from Bruce, Charlotte's biological father. As Maggie gives birth to Charlotte, Emma is by her side, whereas Bruce is relegated to the corner of the room, a juxtaposition demonstrating the centrality of the women's friendship. When Emma undergoes treatment for breast cancer, it is Maggie—not Emma's romantic partner, Mark—who is diligently caregiving every step of the way. This is often contrary to real-life experiences where friendships are sometimes perceived at the bottom in the hierarchy of relationships, as spouses, children, and even parents often take priority.

At the same time, the friendship appears to be situated not on its own but in terms of how the characters form connections with men. Even though the show tries to focus on the centrality of the friendship, conflicts arise as the two women develop and deal with outside relationships. These plot lines are similar to past shows focusing on female friendship (e.g., *Kate and Allie*, *The Golden Girls*) in that "these shows are about how taking on the role of spouse, boss, and employee upsets the balance of a rock-solid friendship" (Hess).

Thus, although *Playing House* has received attention for its accurate portrayal of female friendships (Beck, "Playing House"), there is still a distorted image being presented regarding female friendships. The persistent narrative throughout the show is that female friendships will weather any conceivable crisis. Turning points that would most likely cause serious upheaval in a real-life friendship are minimized on *Playing House*. Due to the format of the thirty-minute comedy, issues that would most likely take days, weeks, months, or even years to resolve are wrapped up by the end of the episode, suggesting optimistically that no matter what, their female friendship will endure.

This study is not without limitations. Previous research examining turning points has only been conducted with real-life, interpersonal relationships, utilizing the retrospective interview technique; therefore, whether or not a turning point has occurred is solely determined by the perceptions of the individual who (may or may not have) experienced it. This study was a first attempt to apply a turning point framework to an analysis of television content. Utilizing the literature and our own perspectives as researchers, we believe we were able to accurately assess whether or not characters experienced turning points. Future research

could apply these findings in order to create a codebook that could be quantitatively applied to other television programs.

Second, *Playing House* presents an unorthodox—and most likely unrealistic—configuration of female friendship in adulthood. That is, in actual adult female friendships, most women would not be able to drop everything in order to help a friend raise a child. This idealized version of the importance of female friendships is one of the reasons we chose to examine the show. However, this may distort expectations regarding appropriate levels of sacrifice between female friends. Future research should also examine how female friendship is defined and how turning points are represented in other media outlet in order to create a more holistic view of the media messages sent regarding female friendship.

Finally, future research should be concerned with how women utilize these depictions in their own conceptualizations of what it means to be a friend. As Alison Alexander notes, "because texts (media content) have lives within larger symbolic and communicative contexts, it is crucial to understand how texts acquire meaning as viewers interact with them during both consumption and communication encounters" (60). It is not only important to examine what messages the media is sending but also how those messages are being interpreted. As an increasing number of American women organize their lives around female friendships rather than traditional marriages, *Playing House* highlights the domestic possibilities of this new reality and presents a timely and unique blending of friendship, kinship, and romance between women.

Works Cited

Abbott, Alysia. "Women without Men." *The Boston Globe* (Boston, MA), 12 Mar. 2017, www.highbeam.com/doc/1P4-1876138021. html?refid=easy_hf. Accessed 27 Aug. 2019.

Albada, Kelly Fudge. "The Public and Private Dialogue about the American Family on Television." *Journal of Communication*, vol. 50, no. 4, 2000, pp. 79-110.

Allan, Graham. "Flexibility, Friendship, and Family." *Personal Relationships*, vol. 15, no. 1, 2008, pp. 1-16.

Alexander, Alison. "Exploring Media in Everyday Life." *Communications Monographs*, vol. 60, no. 1, 1993, pp. 55-61.

Altheide, David L. «Reflections: Ethnographic Content Analysis.» *Qualitative Sociology*, vol. 10, no. 1, 1987, pp. 65-77.

Altman, Irwin, and Dalmas A. Taylor. *Social Penetration: The Development of Interpersonal Relationships*. Holt, Rinehart & Winston, 1973.

Argyle, Michael, and Monika Henderson. "The Rules of Friendship." *Journal of Social and Personal Relationships*, vol. 1, no. 2, 1984, pp. 211-37.

Baxter, Leslie A., and Barbara M. Montgomery. *Relating: Dialogues and dialectics*. Guilford Press, 1996.

Baxter, Leslie A., and Connie Bullis. "Turning Points in Developing Romantic Relationships." *Human Communication Research*, vol. 12, no. 4, 1986, pp. 469-93.

Baxter, Leslie A., and Eric P. Simon. "Relationship Maintenance Strategies and Dialectical Contradictions in Personal Relationships." *Journal of Social and Personal Relationships*, vol. 10, no. 2, 1993, pp. 225-42.

Baxter, Leslie A., and Garth Pittman. "Communicatively Remembering Turning Points of Relational Development in Heterosexual Romantic Relationships." *Communication* Reports, vol. 14, no. 1, 2001, pp. 1-17.

Baxter, Leslie A., and Larry A. Erbert. "Perceptions of Dialectical Contradictions in Turning Points of Development in Heterosexual Romantic Relationships." *Journal of Social and Personal Relationships*, vol. 16, no. 5, 1999, pp. 547-69.

Baxter, Leslie A., et al. "Turning Points in the Development of Blended Families." *Journal of Social and Personal Relationships*, vol. 16, no. 3, 1999, pp. 291-314.

Becker, Jennifer, et al. "Friendships Are Flexible, Not Fragile: Turning Points in Geographically-Close and Long-Distance Friendships." *Journal of Social and Personal Relationships*, vol. 26, no. 4, 2009, pp. 347-69.

Beck, Julie. "Playing House: Finally, a TV Show Gets Female Friendships Right." *The Atlantic*, Atlantic Media Company, 28 Apr. 2014, www.theatlantic.com/entertainment/archive/2014/04/playing-

house-finally-a-tv-show-gets-female-friendships-right/361308/. Accessed 27 Aug. 2019.

Beck, Julie. "How Friendships Change in Adulthood." *The Atlantic,* Atlantic Media Company, 22 Oct. 2015, www.theatlantic.com/ health/archive/2015/10/how-friendships-change-over-time-in-adulthood/411466/. Accessed 27 Aug. 2019.

Behm-Morawitz, Elizabeth, and Dana E. Mastro. "Mean Girls? The Influence of Gender Portrayals in Teen Movies on Emerging Adults' Gender-Based Attitudes and Beliefs." *Journalism & Mass Communication Quarterly,* vol. 85, no. 1, 2008, pp. 131-46.

Boyle, Karen, and Susan Berridge. "'I Love You, Man: Gendered Narratives of Friendship in Contemporary Hollywood Comedies." *Feminist Media Studies,* vol. 14, no. 3, 2014, pp. 353-68.

Brook, Heather. "'Die, Bridezilla, Die!': Bride Wars (2009), Wedding Envy, and Chick Flicks." *Feminism at the Movies: Understanding Gender in Contemporary Popular Cinema.* Routledge, 2011.

Bruess, Carol, and Judy C. Pearson. "Interpersonal Rituals in Marriage and Adult Friendship." *Communications Monographs,* vol. 64, no. 1, 1997, pp. 25-46.

Bullis, Connie, et al. "From Passion to Commitment: Turning Points in Romantic Relationships." *Interpersonal Communication: Evolving Interpersonal Relationships,* 2003, pp. 213-36.

Cate, Rodney M., and Sally A. Lloyd. *Courtship.* Sage Publications, Inc, 1992.

Cross, Susan E., and Laura Madson. "Models of the Self: Self-Construals and Gender." *Psychological Bulletin,* vol. 122, no. 1, 1997, pp. 5.

Downey, Sharon D. "Feminine Empowerment in Disney's Beauty and the Beast." *Women's Studies in* Communication, vol. 19, no. 2, 1996, pp. 185-212.

Erbert, Larry A. "Conflict and Dialectics: Perceptions of Dialectical Contradictions in Marital Conflict." *Journal of Social and Personal Relationships,* vol. 17, no. 4-5, 2000, pp. 638-59.

Fehr, Beverley. "Intimacy Expectations in Same-Sex Friendships: A Prototype Interaction-Pattern Model." *Journal of Personality and Social Psychology,* vol. 86, no. 2, 2004, pp. 265-84.

Fields, Katherine P., and Danette Ifert Johnson. "Negotiation of the Autonomy—Connectedness Dialectic in Adolescent Television Dramas: An Up-Close Look at Everwood, Seventh Heaven, and Veronica Mars." *Communication Quarterly*, vol. 61, no. 3, 2013, pp. 284-300.

Frentz, Thomas, and Janice Hocker Rushing. "Mother Isn't Quite Herself Today": Myth and Spectacle in The Matrix." *Critical Studies in Media Communication*, vol. 19, no. 1, 2002, pp. 64-86.

Gamson, William A., et al. "Media Images and the Social Construction of Reality." *Annual Review of Sociology*, vol. 18, no. 1, 1992, pp. 373-93.

Golish, Tamara D. "Changes in Closeness between Adult Children and Their Parents: A Turning Point Analysis." *Communication Reports*, vol. 13, no. 2, 2000, pp. 79-97.

Hall, Jeffrey A. "Sex Differences in Friendship Expectations: A Meta-Analysis." *Journal of Social and Personal Relationships*, vol. 28, no. 6, 2011, pp. 723-47.

Hess, Amanda. "Playing House Is OK. But Realistic Female Friendships Don't Actually Make for Great TV." *Slate Magazine*, Slate, 1 May 2014, www.slate.com/blogs/xx_factor/2014/05/01/playing_house_and_the_trouble_with_female_friendships_on_tv.html.

Hollinger, Karen. *In the Company of Women: Contemporary Female Friendship Films.* University of Minnesota Press, 1998.

Hsieh, Hsiu-Fang, and Sarah E. Shannon. "Three Approaches to Qualitative Content Analysis." *Qualitative Health Research*, vol. 15, no. 9, 2005, pp. 1277-88.

Johnson, Amy Janan, et al. "Changes in Friendship Commitment: Comparing Geographically Close and Long-Distance Young-Adult Friendships." *Communication Quarterly*, vol. 57, no. 4, 2009, pp. 395-415.

Johnson, Amy Janan, et al. "Relational Progression as a Dialectic: Examining Turning Points in Communication among Friends." *Communication Monographs*, vol. 70, no. 3, 2003, pp. 230-49.

Johnson, Amy Janan, et al. "The Process of Relationship Development and Deterioration: Turning Points in Friendships That Have Terminated." *Communication Quarterly*, vol. 52, no. 1, 2004, pp. 54-67.

Kim, Janna L., et al. "From Sex to Sexuality: Exposing the Heterosexual Script on Primetime Network Television." *Journal of Sex Research*, vol. 44, no. 2, 2007, pp. 145-157.

King, Anthony. "Paging Doctor Yes Please." *Playing House*, season three, episode four, USA Network, 30 Jun. 2017.

Knapp, Mark L. *Social Intercourse: From Greeting to Goodbye*. Allyn & Bacon, Incorporated, 1978.

Leon, Kim, and Erin Angst. "Portrayals of Stepfamilies in Film: Using Media Images in Remarriage Education." *Family Relations*, vol. 54, no. 1, 2005, pp. 3-23.

Livingstone, Sonia. *Making Sense of Television: The Psychology of Audience Interpretation*. Routledge, 2013.

Macnamara, Jim R. "Media Content Analysis: Its Uses, Benefits and Best Practice Methodology." *Asia Pacific Public Relations Journal*, vol. 6, no. 1, 2005, pp. 1-34.

Metts, Sandra. "First Sexual Involvement in Romantic Relationships: An Empirical Investigation of Communicative Framing, Romantic Beliefs and Attachment Orientation in the Passion Turning Point. *The Handbook of Sexuality in Close Relationships*, edited by Amy Wenzel et al., Psychology Press, 2004, pp. 145-68.

Meyer, Michaela. "'It's Me. I'm It': Defining Adolescent Sexual Identity Through Relational Dialectics in Dawson's Creek." *Communication Quarterly*, vol. 51, no. 3, 2003, pp. 262-76.

Moore, Marvin L. "The Family as Portrayed on Prime-Time Television, 1947–1990: Structure and Characteristics." *Sex Roles*, vol. 26, no. 1-2, 1992, pp. 41-61.

Parham, Lennon, and Jessica St. Clair. "Pilot." *Playing House*, season one, episode one, USA Network, 29 Apr. 2014.

Parham, Lennon, and Jessica St. Clair. "Bugs in Your Eyes." *Playing House*, season one, episode ten, USA Network, 17 Jun. 2014.

Parham, Lennon, and Jessica St. Clair. "Employee of the Month." *Playing House*, season two, episode five, USA Network, 25 Aug. 2015.

Parham, Lennon, and Jessica St. Clair. "Let's Have a Baby." *Playing House*, season one, episode nine, USA Network, 17 Jun. 2014.

Parham, Lennon, and Jessica St. Clair. "Kimmewah Kup." *Playing House*, season two, episode six, USA Network, 1 Sep. 2015.

Parham, Lennon, and Jessica St. Clair. "You Wanna Roll with This." *Playing House*, season three, episode five, USA Network, 7 July 2017.

Rawlins, William K., and Dorothy Jerrome. "Friendship Matters: Communication, Dialectics and the Life Course." *Ageing and Society*, vol. 14, no. 1, 1994, pp. 133-134.

Reis, H.T. Gender Differences in Intimacy and Related Behaviors: Context and Process. *LEA's Communication Series. Sex Differences and Similarities in Communication: Critical Essays and Empirical Investigations of Sex and Gender in Interaction*, edited by D.J. Canary and K. Dinida, Lawrence Erlbaum Associates Publishers, 1998, pp. 203-31.

Shapiro, Michael A., and Annie Lang. "Making Television Reality: Unconscious Processes in the Construction of Social Reality." *Communication Research*, vol. 18, no. 5, 1991, pp. 685-705.

Shrum, Larry J. "Media Consumption and Perceptions of Social Reality: Effects and Underlying Processes." *Media Effects*. Routledge, 2009, pp. 66-89.

Spangler, Lynn C. "A Historical Overview of Female Friendships on Prime-Time Television." *The Journal of Popular Culture*, vol. 22, no. 4, 1989, pp. 13-23.

St. Clair, Jessica, and Lennon Parham. "Hello, Old Friend." *Playing House*, season two, episode one, USA Network, 4 Aug. 2015.

St. Clair, Jessica, and Lennon Parham. "Totes Kewl." *Playing House*, season one, episode four, USA Network, 13 May 2014.

Stephens, Vincent. "Odd Family Out: Closely Reading Kate & Allie's 'New Women' Household." *The Journal of Popular Culture*, vol. 46, no. 4, 2013, pp. 886-908.

Stillion Southard, Belinda. "Beyond the Backlash: Sex and the City and Three Feminist Struggles." *Communication Quarterly*, vol. 56, no. 2, 2008, pp. 149-67.

Surra, Catherine. "Reasons for Changes in Commitment: Variations by Courtship Type." *Journal of Social and Personal Relationships*, vol. 4, no. 1, 1987, pp. 17-33.

Suter, Elizabeth A., et al. "Lesbian Couples' Management of Public-Private Dialectical Contradictions." *Journal of Social and Personal Relationships*, vol. 23, no. 3, 2006, pp. 349-65.

Traister, Rebecca. "What Women Find in Friends That They May Not Get from Love." *The New York Times*, 27 Feb. 2016, www.nytimes.com/2016/02/28/opinion/ sunday/ what-women-find-in-friends-that-they-may-not-get-from-love.html?smid=pl-share&_r=0. Accessed 27 Aug. 2019.

Winch, Alison. "We Can Have It All" The Girlfriend Flick." *Feminist Media Studies*, vol. 12, no. 1, 2012, pp. 69-82.

Chapter Seven

Protecting the Public in the Twilight of Trials: Towards Access to Justice in Relational Conflict via the Regulation of Mediators

Rebecca Bromwich and Thomas S. Harrison

Introduction

In the twenty-first century, it is increasingly unlikely that we will end up facing down our friends, family members, or business associates in the context of a formal trial. Most North American litigators know that trials are vanishing from the legal landscape. This is true in both Canada (Winkler) and the U.S. Although it may seem that the reduced reliance on the formal trial process when a relationship breaks down represents a positive change, there are some potential pitfalls with a dependence on formal and public justice. In 2009, American legal scholar R.P. Burns warned of the "death of the trial." He argued for the restoration of trials to a central place in civil justice and that their formal procedures, rules of evidence, and adversarial basis mark the process as a "great cultural achievement." Rather than go gently into the good night of alternative dispute resolution, Burns passionately argued for the protection of formal processes in the face of the declining number of trials. As Judith Resnik has noted, a widespread paradigm shift across

jurisdictions in North America means that fewer and fewer court cases now go to trial and the vast preponderance of them are settled out of court (Farrow; Macfarlane). The twilight of the trial is occurring across civil, family, and criminal matters According to statistics posted online by the Department of Justice, as of 2016, 98 per cent of civil cases initiated across Canada now never make it to trial.[1]

The numbers show that it is likely too late to argue for a new dawn for trials as the dominant mode of dispute resolution. In any event, putting the practical utility of an argument in favour of trials aside, trials do have many downsides. A great deal of evidence indicates that formal civil justice procedures are time consuming, inaccessibly expensive, complex, and subject to backlogs and delays (Statistics Canada).[2] Consequently, it is not entirely surprising that the use of alternative dispute resolution, or ADR, has now become the dominant approach to resolve most civil disputes in the justice system.

According to *Black's Law Dictionary*, ADR refers to a "procedure for settling a dispute by means other than litigation, such as arbitration or mediation. ADR can be defined as encompassing all legally permitted processes of dispute resolution other than litigation" (9). We acknowledge the ascendancy of ADR as a means to settle legal disputes. Indeed, as noted, there are many good reasons to settle disputes outside of the paradigm of trials. However, as with Burns, we are concerned that there is a danger that our most cherished democratic values and protections may be lost in the murky, opaque darkness of mundane processing of alternative dispute resolution to Courts (Fiss; Luban). As Judith Resnik has contended, the changing paradigm of dispute resolution necessitates a change to ethics and regulation in the provision of legal services. Her work is chiefly interested in lawyers' ethics and their regulation when they participate in ADR processes, but the findings relate also to a context in which ADR professionals, including mediators, are serving the public in ways related to what trial lawyers and judges traditionally did. On this point Resnik laments the "privatization and relocation" of the process of resolving disputes out of the public arena constituted by trials into a private, opaque, and poorly regulated space.

We are also particularly interested in one set of cultural achievements that has been written into trials—the public protection of individual rights affected in the professional regulation of those who make their living by practicing law and providing legal services. In particular,

we are concerned about the extent to which the public interest is safeguarded in the alternate resolution of disputes through mediation.

Mediation is one variety of ADR, and it takes place outside the traditional litigation process, without the necessity of a trial. Mediation is a consensual process through which parties who are in dispute are guided to a suggested settlement by a neutral third party individual that they select, who is the mediator (Macfarlane; Menkel-Meadow; Picard et al.; Cappelletti).

Mediation has been celebrated for having many benefits, including reducing costs and increasing the speed of processing matters (Picard et al.). It has also been hailed for reducing the emotional cost and the level of psychological harm caused by conflict. The question we explore in this article is not whether mediation should be employed in dispute resolution but how best to facilitate this process to ensure it is being effectively carried out from a regulatory perspective. Our intention in undertaking this research is to explore how best to encourage mediation while preserving what is best about the formal justice system. Our focus is to highlight gaps in mediator governance; we focus on transparency, accountability and quality of service. Given the fragmentation in regulatory approaches, our goal is to explore different systemic models that may better protect the public, especially from the risk of mediator incompetence or unethical behaviour.[3]

Unfortunately, just as every Ontario litigator knows trials are on the wane, many also have anecdotes about unscrupulous mediators. Among the less salacious of these tales are the well-known, egregious cases of mediators acting badly. For example, in *Maureen Boldt v. Law Society of Upper Canada*, the mediator was found to be engaging in the practice of law without a licence. This case underscores the conflation between general approaches to conflict resolution and elements of traditional legal practice. Conflict resolution is a field that has become more formalized and is increasingly integrated into the traditional justice system across many practice areas, including business law, family law, child protection, and other fields.

This chapter focuses on the slippery distinctions between lawyers and mediators as well as between conflict resolution and the practice of law. It reports on the findings of a limited survey designed to test public perceptions of mediators in Ontario as an additional input in considering possible options. It then situates the findings of that study within

the current state of how mediation is practiced and, relatedly, who has a stake in how it is carried out. This chapter also looks at the extent to which mediation is regulated across Canada, considers the implications of these findings, and recommends that the Ontario government consider a statutory option to permit the Law Society to directly regulate all professionals who engage in mediation.

The chapter proceeds in eight sections. The first section discusses the design of our study, whereas the second section situates our analysis in the contemporary context of mediators in Canada. In the third section, we set out the theoretical justification for considering further regulation of mediation in Ontario, and the fourth section briefly describes changes to the governance of legal services. The fifth section outlines the scope and limits of our survey, followed by an analysis, in the sixth section, of the findings of our empirical research in the subsequent section. Section seven lists the benefits and risks of a range of policy options to better address mediation regulation, and section eight concludes by recommending, given the current policy context, the separate statutory regulation of mediators within the existing jurisdiction of the provincial Law Society.

1. The Study

Our empirical research substantially replicates a similar short survey conducted by a Task Force of the Law Society of British Columbia (BC Task Force) a few years ago. The BC Task Force study questioned whether the Law Society should regulate additional legal service providers other than lawyers. The group reviewed the experience of other jurisdictions, some of which have recently permitted the regulation of legal services by a wide range of groups (BC Task Force 3). The Task Force also examined the current role of statutorily recognized notaries in British Columbia in the more general context of the governance role of the provincial Law Society.

In the course of its study, the BC Task Force made a number of conclusions:

- Legal service providers other than lawyers and notaries should be regulated in some circumstances;
- A single regulator is the preferable model;

- The Law Society is the logical regulator body for legal services;
- Future changes should include some recognition of the role of certified paralegals; and
- It is unclear whether a single regulator of legal services would improve access to justice (BC Task Force 4-5).

Although the BC Task Force acknowledged the need for the recognition of new, additional categories of legal service providers, it did not support the inclusion of such providers within the proposed changes to regulatory framework (20).

The BC Task Force study also considered the inclusion of mediators within the Law Society's regulatory as well as the category of paralegals. In this respect, 63 per cent of respondents to the Law Society survey indicated that they thought mediators should also be regulated, and 60 percent of British Columbians who responded at that time thought there should be a single regulator for all legal service providers (BC Task Force 36).

2. The Study in Context

a) What is mediation in Ontario?

As previously noted, mediation is a form of dispute resolution. It is usually grouped with other approaches, such as arbitration and negotiation,[4] which are considered alternatives to the formal justice system (Menkel-Meadow). Though alternative, mediation is similar to adjudication as an aspect of basic legal governance focused on the social ordering and perception of relationships (Fuller). In particular, the mediation process functions to help parties "not by imposing rules on them, but by helping them to achieve a new and shared perception of their relationship, a perception that will redirect their attitudes and dispositions toward one another" (Fuller, "Mediation" 84).

ADR approaches, such as mediation, have become increasingly prevalent in the administration of justice in the last few years, especially in civil and family proceedings (Meyer). The widespread use of meditation in the justice system in Canada began in the 1970s. Despite some agreement about the general definition of mediation, there remains some dispute as to its precise nature (Menkel-Meadow). At its core, mediation involves a reorientation by disputants to one another so as the

make the legal process of conflict resolution more effective (Fuller, "Mediation" 308-9). The initial introduction of ADR into court procedures also supported wider efforts to improve the qualitative outcomes to the wide range of social disputes that are dealt with through legal procedures in the justice system (Felstiner et al. 613).

The introduction of ADR also had a second explicit purpose and function. From a public administrative perspective, incorporating nontraditional forms of dispute resolution sought to enhance judicial economy. Early intervention with nonadversarial procedures could increase the likelihood that matters would be settled before requiring an expensive hearing in the court system. Mediation also had the capacity to potentially narrow legal issues so that court resources could be more efficiently targeted in cases that went to trial.

Many thought that improving both qualitative outcomes and judicial economy would support increased access to justice.[5] However, at that time, some raised concerns that the utilization of procedures outside the spotlight of the longstanding tradition of open courts challenged the public nature of the court system (Luban 2659-662). More fundamentally, the move towards more collaborative ADR procedures also undermined adversarialism—a basic feature of common law justice systems—at a time when others were highlighting that dichotomous opposition in court was essential to legal governance principles, such as judicial independence (Fuller, "Adjudication").

Despite these concerns, the general trend showed a growing reliance on mediation and other ADR techniques. For example, in Ontario's civil and family justice system, the use of ADR became mandatory in some court proceedings and was combined with judicially overseen caseflow management. In general, recent Canadian studies have confirmed that the use of mediation saves money for courts, families, and businesses, and it results in better psychosocial outcomes for everybody. Though not without some continued debate as to its effectiveness, ADR and mediation have become important modern features of Ontario's justice system (McKiernan).[6]

b) Current Governance of Mediators in Ontario

Despite the ubiquity of mediation, the overall governance of mediators is fragmented in Ontario. For example, mediators, who are also lawyers and paralegals, are subject to the authority of the provincial Law Society—the statutorily authorized body that oversees the legal profession. However, there is no requirement that anyone receive any formal legal training as a lawyer or paralegal in order to act as a mediator.

In addition, the provincial civil mandatory mediation program, under its Civil Rules, establishes a list of those who wish to be identified on a governmental roster as mediators. However, the criteria for designation on the list encourages, but does not require, actual training in mediation. Under these lists, local mediation committees in Toronto, Windsor and Ottawa, also have some authority to consider complaints against mediators.

There are also two substantial organizations of mediators, as well as several smaller, more local ones, that operate in the province of Ontario. The province-wide, large mediator organizations are the ADR Institute and the Ontario Association of Family Mediators (OAFM). These bodies provide training to prospective mediators as a precondition to membership; they have also established a disciplinary regime with professional behavioural codes to address mediator conduct, which also includes a complaints enforcement process. As noted by Julia Macfarlane, the establishment of conduct codes and a discipline process by these groups can provide the "trappings" of professionalism by a new group of legal practitioners (55), who seek some of the traditional benefits and autonomy inherent within legal self-regulation (Schneider), as it has developed in Canada.[7]

However, both professional mediator bodies in Ontario are private organizations. Neither the ADR Institute nor the Association of Family Law Mediators is under any obligation to publically report on such issues as records of complaint proceedings or disciplinary measures taken against their membership. These mediator professional bodies are wholly self-regulating in the sense that they are not subject to any direct government oversight in the same way law societies are.

Ultimately, governance mechanisms for mediators are split between the Law Society, some governmental bodies, and private organizations in Ontario. In addition, given the lack of central and standardized licensing and accreditation, it is possible for someone to act as a

mediator in Ontario without being subject to any of these governance regimes. It is also possible for a mediator to run afoul of regulations in one or more organizations and to continue working, with the public not advised about any of the difficulties that might have arisen. Although there are a number of governance bodies and mechanisms in place, there remains no formal requirements or qualifications for someone to call themselves a mediator or to act in this capacity to resolve disputes, many of which have legal dimensions.

3. Purpose and Function of Further Regulation of Mediators

In some sense, the broader court system is an institution that operates to provide public goods (Stilwel). In this respect, the fairness of the legal system is also subject to the principles of transparency and public accountability, and it builds on the traditional concept of open courts. Individuals who represent parties in legal disputes or adjudicate within this system are in this sense are independent public officials, who have duties and obligations in the public interest.

Similarly, many professional mediators also act to provide legal services in the justice system in Ontario. More specifically, to the extent that mediators operate within the public court and tribunal system, the regulation and oversight of individual mediator behaviour should be subject to standardized scrutiny to ensure it upholds and protects the public interest. Such public interest values include consumer protection in the creation of consistent and open standards for aspects of professional mediator behaviour.

These standards should also include recognized rules of entry to be a professional mediator and conduct assurance rules (Semple 42). Rules of entry include standardized training and accreditation. By comparison, conduct assurance relates to standards of consumer protection, such as individual competency, confidentiality, and conflict of interest rules.

Additional regulatory techniques serve to ensure individual conduct but also to control legal entities and businesses within the marketplace.[8] Such guidelines focus not only on the transparency and accountability of the disciplinary process for professionals but also on legal marketplace considerations, such as advertising and solicitation restrictions, business structure, and professional insurance requirements.

Ultimately, these features of legal professional regulation serve to protect individuals as well as the wider social interest to ensure the provision of legal services (Mcfarlane 55). The most important way in which regulation advances public purposes is by supporting the value underlying one of the goals of legal services regulation, which is to enhance access to justice by making the process of mediation consistent, reliable, and as available as possible to members of the public (Mcfarlane 55).

For example, ADRIO, the Alternative Dispute Resolution Institute of Ontario, which is essentially a club, is one of the private organizations overseeing some mediators in Ontario, provides varying levels of designation. These include a "chartered mediator" designation, for which ADRIO sets forth criteria, including eighty hours of mediation and skills training. For those mediators who enlist as members, the organization also provides accreditation for qualified mediators, with somewhat less training. ADRIO also provides its own training, including online and in-person options. However, consistent, transparent, and accountable approaches to mediation governance are thwarted within the extant regime, since it is fragmented between this private and voluntary body and several other entities (Mcfarlane 55). Moreover, within the broader governance regime in law, there have also been a number of ongoing and related changes to legal services regulation, which is described in the next section.

4. Current Situation

Potential modification to the regulation of mediation services in Ontario should take into account the general trend towards change in legal services regulation (Semple 42). Throughout the world, there has been a move away from the organization of legal professionals as a single hegemonic profession. Even though the differentiation among legal professionals may be more obvious internationally, evidence of a broader approach to the provision legal services is also apparent in Canada.

Major changes to legal services regulation have been occurring globally for a number of years. For example, as a group lawyers have almost always been treated as a unified profession in Canada, with a monopoly on the provision of legal services. To the extent that the Canadian Bar has been self-regulating, its organizational independence has historically

been recognized and supported by statute.[9] In other countries however, there is a more pluralistic approach to the regulation and provision of legal services.

In England and Wales, for example, the tradition of statutory oversight has been more limited in the legal profession. Recent legislation in those countries has also placed substantial authority to oversee all legal professional designations into the hands of a government established Legal Services Board (Legal Services Act). Apart from the traditional barrister, additional legal professional designations include advocates, solicitors, and conveyancers. In England, regulatory changes authorized by the Legal Services Act 2007 have created a range of eight designations, or groups of legal professionals, who may now all provide identified legal services. [10]

Similar, though less extensive, changes have occurred elsewhere and in Canada. For example, Washington, New York and California all now recognized additional classes of legal professionals. In Canada, Quebec also has a recognized additional class of legal professionals.[11] In British Columbia, there are also several hundred notaries, who have a separate statutory grant of authority to perform some legal services. In Ontario, the Law Society also now regulates and licences paralegals, a recognized class of legal advocates, which now shares many of the institutional features of traditional lawyer self-regulation (Woolley et al.). The recognition of additional classes of legal professions as well as changes to legal regulation abroad and in Canada suggest that the time is ripe for reconsidering the regulatory approach to mediators in Ontario.

5. Ontario Mediator Regulation Survey

The BC Task Force included in-person consultations, which were held publicly on four dates at various urban locations in the province. The BC study also received and included several written submissions (BC Task Force 33). By comparison, the reach of the Ontario survey was limited to an online survey, hosted by the Carlton University website; it was further distributed through notifications by the researchers on various social media networks, such as LinkedIn, Twitter and Facebook. The survey was active from July 1 to September 1, 2017.

The Ontario survey's limitations were based in part on the prescribed purpose of the study. Our intent was not to seek a comprehensive

assessment of preferences in legal services regulation in Ontario. Instead, our survey design took into account the future need for further empirical work in this area. The inclusion of this empirical component in this policy options paper also addresses a perceived gap in studies of the administration of justice—that is, they do not adequately incorporate empirical considerations. Our study presents an initial set of comparative data to delineate potential attitudinal differences between jurisdictions. Though limited in reach, the results of this Ontario survey may also serve as a benchmark for further studies of this sort.

Though modelled on the 2013 BC Task Force survey, our empirical approach to the question of legal services regulation in Ontario also differed in several respects. The Ontario survey first sought to distinguish the sources of response through the inclusion of additional options for respondents to identify themselves as law students and as a member of the public. Unlike the BC Task Force survey, ours did not include an explicit category for notary public or distinguish between lawyers and other service providers, such as paralegals.

Similarly, the Ontario survey also set out a wider range of twelve potential providers of legal services for respondents to identify who should be regulated. The purpose of the wider range was to acknowledge changes in other jurisdictions, such as England and Wales, where such providers are distinct, and also to provide some comparative information in relation to other possible groups, such as immigration consultants or arbitrators.[12]

The Ontario survey additionally sought to further distinguish between the possible public policy options for legal services regulation. In British Columbia, the Task Force survey only sought views about the possibility of a single regulator versus a distinct regulator for each (or some) providers. Our questions highlighted these possible preferences but also included an explicit option of the "law society as sole regulator," an option to choose "government," and a further additional "other" category. Our Ontario survey excluded questions related to British Columbia's experience with the regulation of notaries, but it also included a similar question asking if respondents would support co-regulation between government and an independent regulator.

6. Survey Results and Analysis

Our survey was completed by fifty-one respondents from July 1 to September 2, 2017. Respondents self-identified as lawyers (42 per cent), members of the public (28 per cent), law students (16 per cent), and mediators (4 percent); some chose not to identify with any of those categories and selected "other." Out of these 10 percent of respondents, all but one were students or faculty in legal education programs. No respondents identified as paralegals.

The clearest finding from our study was that a strong majority (88 per cent) of respondents thought that legal service providers, other than lawyers, should be regulated. This finding is perhaps unsurprising in Ontario where the current *status quo* is that paralegals and lawyers are both regulated by the Law Society of Ontario and are considered to be providing legal services. This result may, therefore, simply reflect some level of support for that current situation. Another clear finding from the study was that a strong majority (70 per cent of respondents) felt that everyone who provides legal services should be regulated.

Interestingly, however, only 46.81 percent of respondents specifically indicated that mediators should be regulated. Given that this response seems inconsistent with the other answer on the part of 70 per cent of respondents that all legal services providers should be regulated, it is possible that this question may have been confusingly framed. It may also be that respondents do not consider mediation to be a legal service. The discrepancy between the numbers on this answer and the numbers for the answer about everyone who provides legal services speaks to a need for more detailed research with interviews asking more nuanced questions.

There was also no clear majority response to the question about whether each legal services sector should have its own regulator. The largest percentage (42.86 per cent) of respondents indicated that each legal services provider should have its own regulator, but a large number (26.53 per cent) instead answered that they felt the law society should act as the sole regulator for all providers of legal services. Again, apparently inconsistently with this, a large majority of respondents (87.5 per cent) indicated that they would support co-regulation between government and an independent regulator, which suggests that perhaps public support is lacking for the current approach to lawyer self-regulation found across Canadian jurisdictions (with limited exceptions in Quebec).

The scope and small sample size of our survey provides only a preliminary snapshot of attitudes about the regulation of mediation in Ontario. However, if it reflects more widespread beliefs—this limited data suggest there is significant public support for public regulation of legal services providers in addition to lawyers and that some respondents include mediators within that group. At a minimum, the survey points to the lack of empirical metrics in assessing features of the legal system and speaks to how it would be beneficial to conduct more detailed in-depth and in-person research (Ramsay).

7. Possible Paths Forwards: Policy Options

Our examination did not presume that the traditional framework of legal self-regulation in Canada is necessarily the most effective approach to this issue. However, given the legal regulator's current and traditional situation as a governance model, alternatives set out below are assessed in relation to the predominant model found in Canada of law society regulation. In this respect, although there may be a number of additional theoretical considerations, our approach is rooted in a pragmatic consideration of likely alternatives based on current experience. Our review of the current situation pertaining to professional regulatory practices in law in Canada and abroad suggests there are five possible policy options, which are set out in the list below. The simplified list of options for mediation regulation are followed by brief descriptions and a short assessment of the policy risk of adopting each policy approach, based on the description and analysis above; "pros" and "cons" are used to identify policy risks. These five identified options for addressing governance in relation to meditators considered are as follows:

A. Status quo

B. Independent self-regulation

C. Independent, statutorily authorized self-regulation

D. Government co-regulation

E. Direct governmental regulation

7.1 Policy and Legal Options: Pros and Cons

A. Status Quo

Pros

- Mediation approaches appear reasonably functional within current system.[13]

- Mediator bodies, such as ADR Institute and OAFM, have evolved naturally within Ontario's legal culture.[14]

- Mediator bodies have already adopted several indicia of professionalism, such as mandatory training and accreditation, ethics codes, and complaints procedures (Mcfarlane 55).

Cons

- Meditation governance in Ontario is fragmented between private and government bodies (Mcfarlane 55).

- Mediation may be facilitated by mediators who have little or no ADR training or experience (Mcfarlane 55).

- Inconsistency in mediator regulator arising from fragmented governance may raise consumer concerns about mediators (Semple 42).

- Fragmented governance regime presents assessment challenges in determining how mediation practically functions in the public interest (Mcfarlane 55).

- Fragmented governance also challenges the transparency of remedies for mediator incompetency, misconduct, or quality of service concerns.

B. Independent Self-Regulation (e.g., British Columbia Notaries)

Pros

- The recognition of mediators as a professional group through a separate grant of statutory authority, as in British Columbia, would unite the current fragmented approach to mediation governance.

- Statutory recognition could but utilized to also incorporate standardized entry requirements, and other institutional issues with respect to regulation of mediators as a group (Sempel).

Cons

- The prospective statutory regime's recognizing mediators separately could result in tension between recognized legal professional mediators, such as lawyers and paralegals.[15]

- The rationalization of current mediator governance approaches by existing stakeholders, such as private mediator bodies like ADR Institute and OAFM, could present challenges.

- The creation of a separate statutory regime for mediator regulation could also appear redundant in light of the similar regulatory framework established by the provincial law society for other legal professionals.

C. Independent Statutorily Authorized Self-Regulation (Ontario's Paralegals)

Pros

- The British Columbia survey suggests public preference for legal services regulation through one body (BC Task Force 4-5).

- The categories of legal services providers will be expanded to include mediators consistent with scope of regulators expansions in other jurisdictions.[16]

- The Law Society of Ontario already has oversight of both lawyer mediators and of paralegal mediators.

- Given its historical role and experience, the Law Society may currently be in best position to manage tensions in overlaps between the mediator role and provision of other legal services.

Cons

- Potential conflicts and tensions could arise between traditional self-regulation, which is limited to lawyers and paralegals in Ontario, and potential oversight of a wider body of legal professionals

- Current stakeholders such as existing mediator professional bodies may object and wish to retain status quo.

- The Law Society may require further legislative, financial, or other supports to take on oversights of thousands of new legal professionals.

D. Co-regulation
(e.g., Quebec Notaries)

Pros

- Co-regulation provides a framework for separate categories of legal professionals to maintain distinction as autonomous self-regulatory identities.

- The creation of additional classes of legal service providers, with their own professional bodies overseen by a central Office of Professions, as in Quebec, could increase the availability of legal services to the public.

- The increased scope of legal services through multiple categories of legal service providers could reduce the cost of legal services to the public.

- Distinct legal service professional bodies may better address differences in the range of legal roles, as first level oversight would be among peer-level legal professionals.

- Co-regulation more closely connects the statutory authorization of an oversight professional body with the government's role to act in the public interest.

Cons

- The co-regulation of mediators and other additional classes of legal service providers could have a disruptive effective on the current legal services marketplace.

- Co-regulation may require additional resources and legislative support to develop and implement potentially expansive framework of new self-regulatory bodies for possible additional classes of legal service providers.

- Co-regulation may also diminish the perception of the independence of legal advocates, given a closer connection between statutory authorizations and governmental oversight.

E. Governmental Regulation
(e.g., Elimination of Professional Self-Regulation)

Pros

- The government would have direct oversight and control of legal service professionals to ensure regulation in the public interest.[17]

Cons

- Regulation may set a precedent allowing for the eventual erosion of autonomous advocacy.

- Current professional legal service provider organizations, including the Law Society, may oppose direct government intervention.

- Direct government oversight is inconsistent with the historical tradition of legal service regulation in Ontario and across Canada.

8. Analysis, Recommendations, and Rationale

Based on a consideration of policy risk and in light of the important public goals outlined below, we conclude that the Government of Ontario should consider further regulation of mediation by statutorily recognizing mediators and establishing a consistent and public governance regime. Several interrelated arguments support further regulation, which are set out below. Based on these considerations, we argue that the most effective policy proposal is for mediators to have a separate grant of statutory authority, which is overseen by the existing legal regulator in the province of Ontario, which now occurs with other legal professionals. The arguments to support the additional regulation of meditators through the Law Society of Ontario based on a separate grant of statutory authority include the following.

i. Prioritization of the Public Interest

At the individual and institutional level, public interest has become an important value in legal professionalism. For example, lawyers have long been required to act individually in the public interest as officers of the court. At the institutional level in Ontario in 2006, the *LSA* was altered to make the public interest a statutory obligation for regulation of lawyers and later paralegals. Given the increasingly prominent contribution that mediation plays within the formal justice system,

mediators should similarly be statutorily obliged to act in the public interest within the existing framework of legal governance.

ii. Ensures Entry Level Consistency in Professional Competencies

There is currently a high degree of regulatory fragmentation in the regulation of mediators in Ontario. Under the current governance regime, there is no generally recognized standard of certification. At present, a person could claim the title of mediator and purport to resolve legal conflicts with little or no training or assessment of their competency to perform these tasks. Further regulation of mediation should seek to ensure a common level of entry level professional competencies. The governance of mediators in the public interest can build on the work of such private mediation organizations as ADRIO, which has developed identifiable competencies for mediations in their voluntary Competency Assessment Program. These include the following:

1. Ability to set forth ground rules for mediation.

2. Ability to work strongly with felt ideas of the disputants.

3. Ability to separate the mediator's personal values from issues under consideration.

4. Ability to work with the parties effectively to get the facts, issues, and perceptions clearly on the table.

5. Ability to conduct the mediation process in a fair, impartial, dignified, and respectful manner.

6. Ability to ensure that all parties have the ability to participate in the process.

7. Ability to preserve the parties' autonomy in decision making.

8. Ability to uncover parties' needs and interests.

9. Ability to address ethical issues in mediation in a manner consistent with the Code of Conduct ("ADRIO Competencies").

iii. Individual Conduct and Practice Assurance

Further regulation of mediators would establish a common approach to address ongoing individual mediator practice matters in relation to clients, such as confidentiality and conflicts of interest. Such regulation would also highlight when duties of loyalty to clients were superseded by duties to the administration of justice to require things like disclosure, withdrawal, or termination of the professional relationship. As a matter of assuring continuing high standards of practice, additional regulation would also address such issues as initial mediator training and competency, continuing professional development, as well as ongoing skills and knowledge maintenance through training.[18]

iv. Common Standard of Recognized Institutional Professional Practices

Additional regulation would also recognize and make consistent institutional professional practices for mediators as a group. This may include institutional regulatory mechanisms such as the following: filing annual professional reports for review by a common professional body; oversight of complaints investigations; adjudicative procedures to ensure fair and open professional discipline; the imposition of sanctions; public reporting of disciplinary decisions; and review and appeals mechanisms consistent with administrative law principles, such as fairness.

v. Provides Consumer Market Protections to Address Quality of Service

In legal regulation generally, consumer complaints generally comprise a significant portion of public complaints about the legal profession (Woolley et al.). In the specific case of mediators, further regulation through a central body would address common consumer concerns, such as those raised by the issues of professional fees, advertising of services; it would also impose mediator obligations to maintain appropriate levels of professional insurance. These consumer market protections would be more regularized by setting a common standard subject to review by one oversight body. Given the current range of governance models, the experience of the Law Society as a legal regulator, and the important role of mediation the justice system, the current legal regulator seems to be best suited to ensure the protection of the consumer and to address the quality of mediation services.

Conclusion

Although conflicts between friends, family members, and business associates are frequently being resolved through ADR processes such as mediation, the legal regulation of mediators is not an issue dominating the headlines at present. Gaps in access to justice, however, remain perpetually in the news cycle ("Canada's Top Judge"). The recognition of mediators as an additional class of legal service providers has the potential to enhance access to justice in Ontario. Given trends towards the recognition of additional legal service providers, more attention should be paid to how conflict resolution professionals are trained and held accountable. There are numerous conscientious and hard-working individuals with significant experience and expertise working as mediators in the province. It is also a disservice to those people who have taken the time to become properly trained and experienced in order to serve the public good to allow unregulated individuals whose competence and professional behaviour are not subject to scrutiny to perform the same services.

One option for further research would be to consider how best to benefit from and incorporate the experience and authority of current nonstatutory but professional mediator governance bodies in the further regulation of the mediator profession. We also acknowledge the need and recommend additional research and extended empirical study about the feasibility of recognizing further categories of legal service providers, in addition to the lawyers and paralegals, currently regulated in Ontario.

In the end, the regulation of legal services should be consistent with the public purposes of the broader justice system. In many ways, Canada has led the world in its approach to governance of the legal profession. However, if Canadian jurisdictions are to remain at the forefront of regulatory approaches to legal services, then the governance framework in this area must continue to adapt to changes occurring in the marketplace and throughout legal culture more generally. Such adaptations should continue to prioritize the public interest in transparent, reliable processes to resolve relational conflicts with their friends, family members, and business associates by maintaining the institutional independence of legal services, but they should also further expand to include a wider range of providers, which includes mediators.

Endnotes

1. Some of these developments may be contributing to a widespread and growing popular perception in Canada that the civil justice "system is broken" (Speigel).

2. There is some evidence that there is a related declining trend in the use of civil courts utilization overall (Canadian Forum on Civil Justice).

3. As discussed, fragmented approaches to mediator governance and a lack of transparency in mediator discipline relative to other justice system officials means this final challenge is difficult to quantify. However, there is some evidence of current public concerns about mediator behaviour (Bruineman; Diebel).

4. There are also further hybrid models that combine different aspects of these ADR approaches (Zweibel).

5. This meant both substantively in the sense that the overall systemic outcomes would improve and procedurally in the sense that improved qualitative outcomes and judicial economy enable actual and more effective utilization of the court system (Rankin).

6. In civil proceedings in Ontario, there is mandatory mediation, geographically restricted to Toronto, Ottawa and Essex County. Although resort to mediation is often voluntary, courts generally encourage settlement both informally and through the imposition of mandatory conferences that may employ ADR procedures. As Trevor Farrow notes, the scope of mediation is also important within the public administrative law regime and also within private dispute settlement, the latter of which is largely' outside the scope of this chapter.

7. Legal self-regulation by statutorily authorized but independent bodies led by lawyers elected by the Bar is fairly distinct to Canada, whereas the practice of self-regulation of the legal profession globally is becoming increasingly. The Canadian regime being described as its "last bastion" by some (Woolley et al. 4).

8. The four regulatory techniques identified by Noel Semple are entry rules, conduct assurance rules, conduct insurance rules, and business structure rules (42).

9. In Ontario, the first statutorily recognized law society in the world for both barristers and solicitors, this recognition occurred with the passage of *An Act for Better Regulating the Practice of Law* (1797).

10. These include the traditional distinction between barristers and solicitors, but also legal executives, licensed conveyancers, patent and trade mark attorneys, costs lawyers, and notaries.

11. Some four thousand notaries in Quebec maintain their own distinct professional standing, overseen by the government's Office of Professions.

12. Our survey excluded the BC Task Force inclusion of native court workers but included court workers, commissioners, mediators, mortgage brokers, realtors, accountants, title insurers, trust companies, and a catchall of "everyone who provides legal services."

13. Though fragmented and lacking in both transparency and accountability, there is only limited public concerns apparent about mediator regulation at this time.

14. Though as an aspect of public administration the current model appears flawed, it may also be effectively responsive in some respects and, from a social systems perspective, fit within the natural environment of Ontario's justice system. For a recent examination of the place of social systems theory on the Canadian justice system, see Martine Valois.

15. This could include exacerbating competitive challenges between different legal service providers, which has reportedly resulted in some past tensions (Taddese).

16. In addition to additional classes of individual legal service providers, this also includes the possible inclusion other entities, such as law firms, as the appropriate subject of regulation (Dodek).

17. Though some argue that professional self-regulation is the most efficient form, since only members of the recognized professional group have the skills to assess professional behaviour (Gorman and Sandefur).

18. By comparison, the mandatory imposition of education requirements has been a current issue for both lawyers and judges in Canada.

Works Cited

ADR Institute of Ontario, adr-ontario.ca/. Accessed 28 Aug. 2019.

"Alternative Dispute Resolution." *Black's Law Dictionary 91*, 9th ed., 2009.

British Columbia. Law Society of British Columbia: Legal Service Providers Task Force. *Report of the Legal Service Providers Task Force.* 2013, www.lawsociety.bc.ca/docs/publications/reports/LegalServicesProvidersTF_final_2013.pdf. Accessed 28 Aug. 2019.

Bruineman, Marg. "Focus: Mediators Largely Unregulated in Canada." *Law Times*, 17 Apr. 2017, www.lawtimesnews.com/author/na/focus-mediators-largelyunregulated-in-canada-13294/. Accessed 28 Aug 2019.

Burns, Robert P.. "The Death of the American Trial." *Northwestern Law School: Faculty Working Papers*, Paper 176, 2009, scholarlycommons. law.northwestern.edu/facultyworkingpapers/176. Accessed 31 Aug. 2019.

Canada. Statistics Canada. *Civil Court Survey 2014/2015 and 2015/2016.*

Statistics Canada, www23.statcan.gc.ca/imdb/p2SV.pl?Function=get-Survey&SDDS=5052. Accessed 28 Aug. 2019.

Canadian Forum on Civil Justice. "What's Happening in Canada's Civil Courts?" *SLAW*, 23. Jan. 2018, www.slaw.ca/2017/01/23/whats-happening-in-canadas-civil-courts/. Accessed 28 Aug. 2019.

"Canada's Top Judge Calls for Fair Access to Justice for All." *CTV News*, 20 Oct. 2017, www.ctvnews.ca/canada/canada-s-top-judge-calls-for-fair-access-to-justice-for-all-1.3640939. Accessed 28 Aug. 2019.

Cappelletti, Mauro. "Alternative Dispute Resolution Processes within the Framework of the World-Wide Access-to-Justice Movement." *Modern Law Review*, vol. 56, no. 3, 1993, pp. 282-96.

Diebel, Linda. "Unqualified Mediators Prey on Broken Famlies." *Toronto Star*, 14 Jan. 2008, www.thestar.com/news/ontario/2008/01/14/unqualified_mediators_prey_on_broken_families.html. Accessed 28 Aug. 2019.

Dodek, Adam. *Law Firms in Canada. Canadian Bar Review*, vol. 90, no. 383, 2011, pp. 383-440.

Dunn, William. *Public Policy Analysis*. Routledge, 2015.

Farrow, Trevor. *Civil Justice, Privatization, and Democracy*. University of Toronto Press, 2014.

Felstiner, R.L."The Emergence and Transformation of Disputes: Naming, Blaming and Claiming." *Law and Society Review*, vol. 15, pp. 631-54.

Fiss, Owen. "Against Settlement." *Yale Law Journal*, vol. 93, no. 1073, 1984, pp. 1073-90.

Fuller, Lon. "Mediation-Its Forms and Functions." *California Law Review*, vol. 44, no. 305, 1971, pp. 305-39

Fuller, Lon L. "The Forms and Limits of Adjudication." *Harvard Law Review*, vol. 92, no. 353, 1978, pp. 353-409.

Gorman, Elizabeth H., and Rebecca L Sandefur, "Golden Age, Quiescence, and Revival: How the Sociology of Professions Became the Study of Knowledge-Based Work." *Work and Occupations*, vol. 38, 2011, pp. 275-302.

Goss, J. "A Spectrum of ADR Processes." *Alta Law Review*, vol. 34, no. 1, 1995, pp. 1.

Luban, David. "Settlements and the Erosion of the Public Realm." *Georgetown Law Journal*, vol. 95, no. 261, 1995, pp. 2619-662.

Macfarlane, Julie. "Mediating Ethically: The Limits of Codes of Conduct and the Potential of a Reflective Practice Model." *Osgoode Hall Law Journal*, vol. 40, no. 1, 2002, pp. 40-87.

Maureen Boldt v. Law Society of Upper Canada. ONSC 3568. Ontario Superior Court of Justice. *Superior Court of Justice*, 2010.

McKiernan, Michael. "Winkler Calls for 'Fresh' Approach with Expanded Mandatory Mediation." *Law Times,* Sept.2010, www.lawtimesnews.com/20100920899/headline-news winkler-calls-for-fresh-approach-with-expanded-mandatory-mediation. Accessed 28 Aug. 2019.

Menkel-Meadow, Carrie. "The Case for Mediation: The Things that Mediators Should be Learning and Doing." *International Journal of Arbitration, Mediation and Dispute,* vol. 82, no. 2, 2016, pp. 22-33.

Meyer, Alfred W. "To Adjudicate or Mediate: That is the Question." *Valparaiso University Law Review*, vol. 27, no. 2, 1993, pp. 357-84.

Perrin, Benjamin, et al. "Bridging Canada's Justice Deficit Gap." *Macdonald-Laurier Institute,* 16 May 2016, www.macdonaldlaurier. ca/bridging-canadas-justice-deficit-gap-mli-paper-. Accessed 28 Aug. 2019.

Picard, Cheryl, et al. *The Art and Science of Mediation.* Emond Montgomery Ltd., 2004.

Ramsay, I. "Small Claims Courts: A Review." *Rethinking Civil Justice: Research Studies for the Civil Justice Review,* Ontario Law Reform Commission, 1996, pp. 491-541.

Rankin, Micah. "Access to Justice and the Institutional Limits of Independent Courts." *Windsor Yearbook of Access to Justice,* vol. 101, 2012, pp. 101-38.

Resnik, Judith. "Lawyers' Ethics Beyond the Vanishing Trial: Unrepresented Claimants, De Facto Aggregations, Arbitration Mandates, and Privatized Processes." *Fordham Law Review,* vol. 85, no. 101.

Schneider, C.D. "A Commentary on the Activity of Writing Codes of Ethics." *Making Ethical Decisions,* edited by J. Lemmon, Jossey-Bass, 1985, pp. 83-84.

Semple, Noel. *Legal Services Regulation at the Crossroads.* Edward Elgar, 2015.

Speigel, Allison. "Why You Should Care That Our Civil-Justice System Is Broken." *Globe and Mail,* 8 Sept., 2017, www.theglobe-andmail.com/report-on-business/small-business/sb-managing/why-you-should-care-that-our-civil-justice-system-is-broken/article36112054/ Accessed 30 Aug. 2019.

Stilwell, Frank. *Political Economy: The Contest of Economic Ideas.* Oxford University Press, 2001.

Taddese, Yamri. "Time to Expand Paralegal Rights?" *Law Times,* 29 Apr. 2013, www.lawtimesnews.com/author/yamri-taddese/time-to-expand-paralegal-rights-9530/. Accessed 28 Aug. 2019.

The Association of Family Mediators,www.oafm.on.ca/. Accessed 28 Aug. 2019.

Valois, Martine. *Judicial Independence: Keeping Law at a Distance from Politics.* LexisNexis Canada Inc., 2013.

Winkler, Warren. "The Vanishing Trial." *Advocates' Society Journal,* vol. 27, no. 3, 2008, pp. 3-5.

Woolley, Alice et al., editors. *Understanding Lawyers' Ethics in Canada.* LexisNexis, 2011.

Zweibel, Ellen. "Hybrid Processes: Using Evaluation to Build Consensus." *Dispute Resolution: Readings and Case Studies,* edited by Julie Macfarlane, Emond Montgomery Publications, 1999, pp. 463-522.

Chapter Eight

Friendship

Myrina Bromwich

Friendship is a really good experience and a really meaningful thing. Although friends can be selfish, bratty, mean, annoying, and a lot of other bad things, friends can also be generous, funny, kind, interesting, and much much more. That's why friendship is important because it prepares you for real life when you get older for the good times, the bad times, the sad times, and the happy times. Friends also encourage you and make you laugh when you are sad.

Friendship can also be really annoying because you don't want to make your friends feel bad at any point, and sometimes you do it by accident and they still get mad at you. In some cases, there can also be bullying, which is a negative thing, but as soon as you make friends, the period of bullying will be over. I think that friendship is very important. It involves your whole life: when you are a child, when you are an adult, and when you are an older person.

Chapter Nine

Polygamy and Human Rights in Canada and France

Jens Urban

"Oppression of women—the reason often given for continuing
to prohibit plural unions—can also be found in
monogamous marriages"—(Bailey and Kaufman 165)

In 2005, Canada changed in a significant way the traditional defini-
tion of marriage, which was a voluntary union of one man and one
woman to the exclusion of all others. That year, the Supreme Court
of Canada (*Reference re Same-Sex Marriage*) legalized same-sex marriage,
which has been codified by the Civil Marriage Act. Eight years later,
France followed in legalizing same-sex marriage with its Act No 2013-
404, adopted on May 17, 2013 (Gouvernement de la France). It was only
after a lengthy debate that both countries authorized homosexual
marriages.

The fundamental nature of marriage has undergone important
changes during the last few years in France and in Canada. The contem-
porary definition of marriage, which is often referred to as traditional in
both of these countries and in most Western countries, essentially
amounts to a prohibition of polygamous marriages—a provision consol-
idated in the *Criminal Code of Canada* article 293 and in the *Code Pénal* of
France, article 433-20. As a result of the acknowledgment of lawmakers
of the need for a change, all other provisions, with the exception mainly
of the prohibition of underage marriage, have been mitigated, removed,
or the prohibition can be bypassed by the application of other laws.

As French and Canadian legislators and courts often acknowledge the negative paradoxical economic and distributive effects of the prohibition of polygamy, they are sometimes corrected by accepting polygamous relationships in certain situations. The impacts that the prohibition of polygamy causes on human rights are much more difficult to detect. Violations are clearly detectable when it relates to freedom of speech, religion, and association, and to the principle of equality, which are often discussed by critics. The indirect paradoxical consequences are subtler and affect not only polygamous families but also other groups in society.

Part I: The Direct Paradoxical Effects of the Prohibition of Polygamy

In Canada, the court appointed to the *Blackmore* case (Reference re: Section 293 of the Criminal Code of Canada) was well aware of the juxtaposing effects that the prohibition of polygamy had on many human rights. The judge also stated that the classic analyses were insufficient to determine the potential impediment on fundamental rights for the people involved that could result from prohibiting polygamy. Certainly, the courts have access to an extensive amount of case laws that were settled according to the Charter in Canada, and to the Constitution, the Declaration of the Rights of Man and of the Citizen of 1789, the Preamble of the Constitution of 1946 (restated by the one in 1958) in France, as well as international laws and treaties. Nevertheless, the judge was required to consider the applicability of the two conditions found in the Oakes test (*R. v. Oakes*)—a legal test used by Canadian jurists that sets the threshold on whether or not a limitation on basic rights is justified. The principle underlying this test provides for an analytical framework to establish if, first, the measures that limit the fundamental rights harm as little as possible the right in question and, second, if there is a proportionality between the restriction and the objective.

In France, there are unfortunately no case laws that explored the question of polygamy in any comparable way. Legislators, judges, and the majority of jurists generally assume its prohibition, with monogamous marriage being regarded as the "backbone of European legal civilisation" (Carbonnier 81). Very few jurists will be against the

generally accepted norm that entails that "intolerance for polygamous marriage draws the line of unity for civilisation" (Carbonnier 341). This is certainly a direct result of the tradition of Roman law in France, a more or less closed system of codification that does not result in the same continuous debate, as well as the continual reassessment of common law as Canada's judicial doctrine and other countries with this legal system. In any case, according to French legislators, polygamy is unquestionably at odds with gender equality, one of the Republic's core values. Though having followed its own separate path, Canadian legislators have nonetheless reached more or less the same conclusion.

Legislators and courts in both France and Canada agree that polygamy interferes with fundamental rights, especially those of polygamous women. Yet does that result in an indisputable conclusion? As mentioned previously in terms of individual rights, other rights of polygamous people were so deeply affected that the courts and legislators have softened the public order and prohibition of polygamy in order to protect the fundamental rights of the people involved. Furthermore, assuming that the prohibition of polygamy prevails over foreign rights, although generally tolerated, the prohibition of polygamy creates without a doubt an impediment on the rights of foreigners.

How could it then be verified whether the findings of jurists in France and in Canada are correct? This chapter argues that legislators and judges have neglected to consider many effects on rather secondary, but no less important, fundamental rights. Without focusing the analysis on the facts of the case, this chapter suggests that the court in the *Blackmore* case neglected to address the full consequences resulting from a prohibition of polygamy, which consequently promoted monogamous relationships. In other words, the court neglected to consider the paradoxical effects on fundamental rights, something that must be done in order to properly compare protected fundamental rights and those that are violated by such a prohibition. This approach is also applicable to the case of France, assuming that both countries share the same commitment towards the protection of fundamental rights. The following section attempts to list the fundamental rights that could be infringed by prohibiting polygamy and by limiting legally protected relationships to monogamous ones.

1. Violation of the Principle of Equality

a) Gender Equality

With respect to gender equality, the official perspective of France, Canada, and the European Union is clear: polygamy goes against the principle of equality between men and women. However, the foundations supporting this argument are unclear. In France, it is evident that the courts and legislators commonly accept without question the fact that polygamy goes against gender equality. If they do, the courts will usually refer to principles of civil law outlined in the doctrine. However, they also draw from international conventions, such as the CEDAW, which states that "polygamous marriage contravenes a woman's right to equality with men, and can have such serious emotional and financial consequences for her and her dependents that such marriages ought to be discouraged and prohibited" (General Recommendation No. 21).

The interpretation of the Canadian tribunals is not any clearer, except that they seem to be in agreement with the analysis of the CEDAW by stating that polygamy causes prejudices for the persons involved. With respect to *amicus curiae*—which examines why and how polygamy alone violates the principle of equality to an extent that would justify its prohibition, whereas polyamory is not subject to any equivalent prohibition—the judge from the *Blackmore* case expressed his surprise in a circular argument:

> There is an argument that Parliament has also drawn a distinction on the basis of marital status by criminalizing only polygamists even though polyamorists (or others in multi-party unions who do not come within the ambit of s. 293 as I have interpreted it) engage in similar conduct. Again, the distinction between the two groups are not one based on stereotypes but, rather, on harm, in particular in this scenario, harm to the institution of monogamous marriage. (Reference re: Section 293 para 1266)

Contrary to French judges and legislators, Judge Bauman—as do many advocators of the prohibition of polygamy—cited studies that supposedly prove that polygamy is the cause of inequality between women and men in polygamous families. This chapter shows that these rare studies do not often apply to polygamous families who live in France and in Canada.

It is easy to maintain that polygamy causes gender inequality, but only stating this does not prove it. Is polygamy rather a symptom of and not the cause of inequality? If polygamy were to be permitted, would it still be considered as conflicting with gender equality, bearing in mind that polygyny, as well as polyandry, are both considered as acceptable?

Since distinguishing the potential human rights violations is difficult, it may be easier to recognize instead that it is the prohibition of polygamy that causes gender inequalities. For example, given what was established concerning the rights of foreigners, it is plausible that the application of existing laws causes considerable prejudices for women who partake in polygamous relationships and are seeking to immigrate. According to Beverly Baines, a polygamous man who wants to immigrate, can do so without too much trouble, as long as he chooses only one of his spouses. The other spouse or spouses do not enjoy any protection. Thus, these immigration laws not only violate the principle of equality, but their application also constitutes, in some way, a violation of universal human rights (Baines, "Polygamy's Challenge 26-27).

French professor of public law, Danièle Lochak, brings further precisions by using immigrant rights as an example:

The prohibition of polygamous familial reunification was not in itself questionable: it was in fact called for by numerous associations for immigrant women, being the most affected by this issue ... if we truly had a concern of protecting these women, it would have been logical to regulate the situation for those who were there prior the voting of the law, instead of leaving them in secrecy and precariousness. Even when concerning men, polygamy may be hated (at least where it is officially devoted to marriage, because as it is well known there is a great acceptance for double de facto unions), but how can it be that people have lived in France for years—sometimes several tens of years— with two spouses, without having been criticized, are suddenly refused the renewing of their residency permit and are then obliged to leave France? Is it really acceptable? As far as anyone knows, polygamists are not dangerous criminals. (Lochak 52)

The international dimension of the prohibition of polygamy must be considered, particularly in the case of immigrant rights. As previously mentioned, international conventions forbid or disadvantage polygamy.

However, the Constitutional Council and the courts in Canada often reject to address these conventions as constitutional norms. As opposed to the existing decision about polygamy in Canada, the Courts in France and in Europe have not determined whether the European Convention for the Protection of Human Rights and Fundamental Freedoms of November 4, 1950—which requires in section 8 that privacy and family life, and in section 14 that nondiscrimination be respected—condemns or not the restrictions of polygamy.

It seems impossible to say unequivocally that polygamy violates gender equality. These statements appear to have been formed by legislators and courts without being supported by recent studies or that are applicable to polygamous families in France and in Canada. On the contrary, the strict application of immigration rights seems to cause an infringement to gender equality rights for polygamous women who would like to immigrate to France or obtain French citizenship.

Finally, even if polygamy was the cause of gender inequality, the same goes for practices which are widely accepted in French and Canadian societies. According to the American philosopher Susan Moller Okin, marriage and family life, as practiced in our society, are "unjust institutions" who favour gender inequalities. In her magnum opus *Justice, Gender and the Family*, she analyses John Rawls's theory of justice by inquiring "can justice co-exist with gender?" (Moller Okin 90). Moller Okin proposes that, inter alia, we should prohibit not only polygamy but also monogamous marriages, as they result in material, psychological, and political inequalities between men and women. If it seems illogical that many feminist philosophers do not necessarily object to polygamy, it is important to remember another element related to the topic of polygamy: one of the first feminist movements was organized by women from Utah who were for the most part polygamous (Iversen 504-24).

b) **Equality between Polygamist and Monogamist**

As previously explained, the prohibition of polygamy can have a paradoxical effect on gender equality, even more so regarding immigrant rights. Some authors support that the institution of monogamous marriage (or common law relationships, civil solidarity pact, etc.) is not neutral and violates the liberal principal of equality. More specifically, by protecting and giving advantages solely to monogamous conjugal

relationships, it creates inequalities for those who partake in relationships with more than one partner. In other words, researchers such as Susan Moller Okin and Tamara Metz suggest that the state should not have the authority to define conjugal relationships and marriages between adults, as every individual has a different interpretation resulting from various cultural backgrounds, religions, and life experiences. It is safe to say that citizens from both Canada and France have many different opinions as to what a conjugal relationship represents or should represent and about whether its regulation violates formal equality before the law and substantive equality between families and various cultures (Metz 7).

The question of prohibition relates to formal equality because individuals in polygamous relationships are completely excluded from some legal protections that those in monogamous relationships enjoy. It relates to substantive equality because, especially in the case of Canada and France, globalization and the immigration of individuals coming from different cultures result in discretely changing the nature of a state's institutions, such as marriage, common law relationships, and civil solidarity pacts. The advantages given to monogamous relationships constitute not only a danger to violate gender equality, but ultimately also to monogamous and polygamous relationships themselves. Again, the courts and the legislators are certainly aware of this, but they are not willing to accept that the prohibition of polygamy and the recognition of only monogamous relationships create paradoxical effects of inequality for the members of polygamous families.

Many of those who are against polygamy neglect to acknowledge that the role of modern polygamy may have changed, particularly in countries such as France and Canada, where women are protected by other laws. It is important to remember that these women, coming from countries where polygamy is legal, are not necessarily treated like objects in their culture, but instead polygamous marriage gives them protection and status, an invaluable advantage for new immigrants: "Legalized polygamy contributes to gender inequality, but, paradoxically, may be a refuge for women with limited options, who obtain at least some rights and protections within that form of marriage. Plural unions, on the other hand, do not provide any such refuge to women" (Bailey and Kaufman 5).

To give privileges exclusively to monogamous relationships, paradoxically, jeopardizes the rights for other groups of people who are not in polygamous relationships. In fact, this impacts every person that partakes in interpersonal relationships that do not fall within the categories permitted by the state. These individuals who do not partake in one of the permitted categories do not enjoy the same protection by the state. Metz points out that the preferred status that the state gives to monogamous relationships endangers freedoms and equality rights. Furthermore, states do not sufficiently protect care-giving relationships, which is the main reason why legislators want to maintain conjugal relationships (114). Metz further argues that the state in general is not well equipped to be the moral authority that decides who can and who cannot get married and that in Western societies, the majority of the population would rather the state not perform any moral role. Yet with aging populations, Western states rely heavily on the close or personal relationships between its citizens to provide care. But these states do not understand that caregiving relationships do not only exist within a monogamous couple, but they also emerge in many different forms. These caregiving relationships are outside of the state's influence and are characterized by strong emotional relations that can be spiritual or physical, or founded on friendship or love (Metz 115). By giving economic advantages solely to monogamous relationships, the state impedes to a certain degree the rights of people who do not participate in such relations but are involved in relationships of which the state and society are taking advantage.

Nowadays, many individuals are giving care to other members of society outside of monogamous marriage relations, without receiving any definite protections from legislators. It is true that caregiving or mutual help is only one of the multiple reasons for which individuals settle in monogamous relationships in Western countries (MacLean and Eekelaar 379-98; Eekelaar 413-31). However, as seen previously, this caregiving relationship is the main interest for the state to get involved in the regulation of conjugal relations. The prohibition of polygamous marriage coupled with the exclusive protection of monogamous relations weaken equality rights for every individual involved in a nonmonogamous relationship but who nevertheless experiences a good caregiving relationship in polygamous or polyamorous relationship. During the public debate on polygamy in Canada, as part of the

Blackmore case, this issue of inequality was extensively examined by jurists and many researchers who all reached a similar conclusion, namely that the prohibition of polygamy and the protection of monogamy has adverse effects on all nonmonogamous relationships (Sheff 251-283; Tweedy).

In summary, the types of relations and co-habitation between adults in France and in Canada have become so complex and individualized since the 1950s, that the prohibition of polygamy has had a negative impact on the rights of those who partake in other forms of relationships. Inversely, the favouritism the monogamists enjoy—such as marriage, civil solidarity pacts, or common law relationship—excludes many individuals of a protection, which results in the mishandling of equality rights between polygamists and monogamists. Additionally, the expansion of such protections would be in the interest of the French and Canadian government, since caregiving relationships between individuals without the state's involvement are advantageous for a society as a whole from an organizational and financial stand point.

2) Violation of Freedom of Speech, Religion, and Association

The prohibition of polygamy is certainly an infringement to freedom of speech, freedom of religion, and to freedom of association, which was acknowledged by the judge in the *Blackmore* case. For this reason, Section 1 of the Charter is applied in Canada, which is known as the "reasonable limits clause," since the government can refer to this provision to justify the imposition of a limitation on the rights guaranteed by the Charter. Thus, rights that are stated in the charter are not absolute and can be infringed upon if the courts determine that the infringement is reasonably justified. Therefore, this section of the Charter protects rights by ensuring that the government cannot limit rights without justification; consequently, it results in both limiting and guaranteeing the rights stated in the Charter. As previously mentioned, the criteria found in the *Oakes* judgement determine if the application is justified. First, there must be a pressing and substantial objective that legitimates the use of the law or government action. Second, the means chosen to achieve the objective must be proportional to the burden on the rights of the claimant. To establish if the objective is proportionate,

it must be rationally connected to the limit on the Charter right; the limit must minimally impair the Charter right, and there should be an overall balance or proportionality between the benefits of the limit and its deleterious effects (*R. v. Oakes*). According to the judge, all the conditions have been met in order to justify the restriction on certain fundamental rights by prohibiting polygamy (Reference re: Section 293).

Similar reasoning can certainly be applied regarding the prohibition of polygamy in France, where the limitation on fundamental rights can be justified according to section 4 of the Declaration of the Rights of Man and of the Citizen of 1789. This section states that the exercise of fundamental rights and freedoms has no limits except those which assure to the other members of society the enjoyment of the same rights. This being said, the analysis of the impact on fundamental rights is incomplete, since legislators and courts neglect to study how monogamous relations, as the exclusive conjugal relationships that are sanctioned by law, can violate certain fundamental rights—more specifically, freedom of religion.

a) Negative Freedom of Religion

Positive freedom of religion always involves negative freedom of religion (Robert; Cabrillac). This fundamental right guarantees not only the practice of religion, but also the right to not profess any religion. As previously mentioned, by examining fundamental rights regarding marriages, quite often the debate revolves around the fact that the right to freedom of religion is in direct potential conflict with equality rights and maybe even the right of association (Baines, "Equality's Nemesis?" 57-80). In reality, the major religions of Christianity have influenced the establishment of monogamous marriages. To this day, unlike secular France, churches in Canada even have the authority to conduct wedding ceremonies on behalf of the state, and this procedure stabilizes individual freedom of major religions with the freedom of different beliefs.

However, if one does not wish to be in a monogamous marriage as prescribed by law, which has been vastly influenced by religious interpretations specific to marriage, this is in conflict with the right to religious freedom. In fact, it can be argued that the strict application of marriage rules punishes certain ways of living, which do not necessarily

go against the role of the state as being a tool for national identification or a tool for the distribution of care, as supposed by legislators (Metz 7). How could a violation of the right to freedom of religion be justified to a polygamous family without being prejudiced?

b) Positive Freedom of Religion

The prohibition of polygamy can indirectly infringe on fundamental rights of religious freedom. For example, canon law of the Catholic Church forbids divorces, since according to article 1141 of the *Codex Iuris Canonici* "a marriage that is ratum et consummaum can be dissolved by no human power and by no cause, except death." However, the Divorce Act of Canada clearly permits divorces as does *the Civil Code in France*. A divorce granted by the law is valid in all of Canada and it dissolves the marriage of the spouses (Drummond 341), just as the ruling that grants a divorce in France "dissolves the marriage at the date at which it acquires force of res judicata" (article 260 C civ.).

Yet section 293 of the Criminal Code states that "every one who ... practises or enters into ... any kind of conjugal union with more than one person at the same time ... is guilty of an indictable offence and liable to imprisonment for a term not exceeding five years" (section 293). In France, section 433-21 of the Civil Code says that "any minister of religion who habitually conducts religious ceremonies of marriages without being presented beforehand with the marriage certificate received by officials responsible for civil status is punished by six months' imprisonment and a fine of €7,500" (article 433-21 C civ.). The difference between both countries is evident: in theory, Canada tolerates informal bigamy, as it enables the coexistence of a civil marriage to one and a religious marriage to another. Unlike in France, where it is unambiguous when it comes to religious ceremonies, the solemn celebration of marriage in Canada without a civil marriage is not prohibited by provincial or federal legislation or by jurisprudence. In Canada, the state has no authority to define what constitutes a religious marriage to a nonreligious one. But since the Criminal Code of Canada refers to one "type of conjugal union" without specifying exactly what type of union and without application of that part of the law to religious ceremonies, Canada implicitly permits bigamy and even polygamy by tolerating a civil marriage with one person and a civil marriage with one person or more at the same time. It would be difficult to think that

so-called multicultural Canada would start to reinforce this part of section 293 by prohibiting religious ceremonies. However, what would then be the value of such a stipulation if it were not reinforced (Drummond 342)? Would its reinforcement be in conflict with the right to freedom of religion?

The prohibition of polygamy, as well as monogamous unions being the exclusive conjugal option in Canada and in France, clearly infringes the right to equality and the right to freedom of religion. Both of these violations have not been sufficiently justified by legislators and Courts in these two countries. In addition, these two judicial realities violate the right to freedom of religion by permitting a type of conjugal union that has clearly been influenced by the Christian religion—the monogamous union. Finally, in theory, marital law existing in France and in Canada violates canon law, which does not permit divorce, as well as criminal law in Canada, which technically allows polygamy by accepting simultaneously a religious marriage and a civil marriage.

Part II: The Indirect Paradoxical Outcomes

It is important to not overlook the other paradoxical effects caused by the prohibition of polygamy as well as the prioritization of monogamous unions by the French and Canadian governments. These effects, which lead to a quasi-tacit violation of certain rights, can be divided into two categories. First, many of these violations emerge when observing facts and events surrounding families who continue to partake in a polygamous lifestyle regardless of the formal prohibition. Second, other effects can be deduced when comparisons are made with other minority groups in society. These effects impact not only members of polygamous families but also other minorities in Canadian and French society.

1. The Impacts on Polygamous Families

a) Lack of Sufficient Legal Protection in the Case of a Divorce

One of the main effects resulting from prohibiting polygamy is that women in polygamous relationships who are seeking a divorce do not enjoy the same legal protections as monogamous women (Baines, "Polygamy's Challenge" 26-27). First, polygamous women do not have any access to the laws legislating divorce, which excludes them from

multiple protections granted by these laws in Canada and in France. Second, its criminalization promotes a political environment that enables governments to exclude polygamous families regarding the right of inheritance and the matrimonial regime. Despite the progress achieved in the judicial precedent and legislation in some Canadian provinces and in France, these are not yet universally accepted judicial principles (Baines, "Polygamy's Challenge" 26-27). The protections for divorced polygamous women in Canada and in France often exemplify specific or rare cases, voluntary guidelines, or, as in Canada, of practices that are not applied in every region of the country due to provincial jurisdiction.

In addition, the courts, especially in Canada, do not have much experience with polygamous divorce cases, and judges often have a significant discretionary power, mainly due to the lack of judicial precedent. It is important to note that these legislative stipulations, which exemplify mainly the exception to the rule, apply mostly to polygamous relationships that were concluded outside of Canada and France, since a polygamous marriage taking place in these countries would not be legally recognized. Finally, the cultural aspect should not be underestimated when it comes to access to justice for polygamous women. By being almost entirely members of cultural minorities and by often living in parallel societies, ambiguous legislation and a general prohibition of polygamy do not motivate more women to reveal themselves as being polygamists and risk criminal prosecution.

b) Possible Increase in Domestic Violence

The following two probable outcomes are connected; however, it is relevant to make the distinction between the outcome that could result in an increase of domestic violence and the outcome that contributes solely to be disadvantaged, without necessarily being abused. As mentioned previously, few studies have been conducted, mostly due to the fact that polygamous families often live in seclusion. Nevertheless, the works of jurist Angela Campbell, and especially those of the anthropologist Janet Bennion, help to uncover the effects of the prohibition of polygamy on polygamous families. Bennion's work shows that domestic violence occurring in polygamous relations becomes increasingly pronounced when polygamy is prohibited because it forces polygamous families to live more or less in secrecy.

Bennion studied Mormon fundamentalist communities in Montana, Mexico, and Utah. The anthropologist found that there were three contributing factors to child sexual abuse and domestic violence against women. First, the ideology of male supremacy perpetuated by biblical texts and economic circumstances is a major factor. Second, the geographical and social isolation of women and children make abuse far more possible. Third, economic deprivation results in an increase of male unemployment, which results in their general dissatisfaction with their role as men. Bennion believes these three factors trigger domestic violence, not polygamy per se. The stigma associated with polygamy as a result of its prohibition could promote these three factors instead of eliminating them. Polygamy keeps being practiced behind closed doors, which could possibly facilitate abuse. Bennion believes the real problem lies in the performance of fundamentalism by these communities, which are forced into hiding, and not the practice of polygamy:

> Culture contributes directly to violence against females by treating it as expected, normal, or deserved. The police contribute to abuse by calling rape a simple domestic dispute; the courts contribute to abuse by reducing sentences of perpetrators, and the community contributes to abuse by hiding abusers within its homes, churches, and schools. (Bennion 18)

Jurist Emily Duncan highlights the possible outcomes of forcing polygamous communities to practice in hiding and partake in polygamy surreptitiously (315-58). According to her, underage marriage would be the main problem that would result from forbidding polygamy. In Utah, for example, underage marriage is still performed, even though the legal age to marry went from being fourteen to sixteen (326). Another repercussion of the prohibition of polygamy and of its clandestine practice is that physical punishment, domestic violence, and religious, verbal, or emotional abuse against children and women are not being reported to the authorities (328). On top of that, children of polygamous families are often homeschooled, which isolates them even more from the outside world (329).

Thus, the ban and the stigmatization of polygamy have opposite effects to the rights that this prohibition seeks to protect, according to legislators. By forcing polygamous families to hide and practice their lifestyle secretly, the government minimizes or eradicates its control over domestic violence in these families.

c) Exclusion of Particularly Vulnerable Persons

Nancy Polikoff claims that limiting the institution of marriage to monogamous relationships will always exclude people that are particularly in need of specific protections (7-8). The author highlights that all persons in nonmonogamous relationships suffer economic disadvantage and lack medical or emotional care; for instance, children of socially unacceptable relationships are not able to be proud of their parents (7-8). She asserts that even when same-sex marriage was legalized, "all whose family form, for whatever reason, is not marriage, will still be without those supports that every family deserves" (9).

The impact of the prohibition of polygamy can also be seen in Russia and in Central Asia. The English anthropologist Caroline Humphrey studies the Buryats, who live in northern Mongolia in Siberia. She shows that in this region, many women encourage and request polygamy for economic reasons, since the Buryat population is in decline of about three percent per year and that the surplus amount of Buryats women who chose to partake in informal polygamy does not enjoy any governmental protection (qtd. in Katbamna).

The prohibition of polygamy does not only affect wives. In France, for example, reunification rights can also be applied with regards to children and pursuant to article 14 of the European Convention on Human Rights. French law does not prohibit familial reunification per se, but it grants this fundamental right guaranteed by the Constitution exclusively on behalf of one spouse and her underage children. The Council Directive 2003/86/EC on the right to family reunification legitimizes the limited measures directed against polygamous households by the "proper compliance with the values and principles recognized by the Member States, in particular with respect to the rights of women and of children" (0012-0018).

It is also true that the European Court of Human Rights has sanctioned discrimination on the basis of the nature of the filiation (*Vermeire v. Belgium*). However, invoking the denial of reunification of the excluded children with their mother seems inconsistent with the Convention's objectives, since the text does not take into account the potential agreement of the nonresidential spouse, parental authority, or even the best interest of the child. Finally, the current text of article 411-7 of CESEDA provides the following:

When a polygamous foreigner resides in France with a first spouse, familial reunification cannot be granted to another spouse. Unless the other spouse is deceased or deprived of their parental right, the children will not benefit from familial reunification either. The residence permit applied for or obtained by another spouse will be refused or withdrawn. The residence permit of a polygamous foreign national residing in France who brought along more than one spouse, or children other than those of the first spouse or of another spouse which is deceased or deprived of their parental rights, will be withdrawn.

The above provision could be inconsistent with section 14 of the European Convention on Human Rights, since it excludes the children of the spouse that is living abroad from familial reunification. Thus, a prohibition of polygamy causes negative impacts for children of polygamous relationships, who are usually already at a disadvantage because of their status as immigrants.

2. Impacts on Other Groups of Society

a) Effects of Legitimization of Rights

Two further paradoxical effects that could result from prohibiting polygamy are now addressed. The first effect is the legitimization of rights, which has been explained in-depth by the law professor Duncan Kennedy (236-63). This effect can be observed in conjunction with securing the rights of other groups, for example same-sex couples. Without going too much in detail of Kennedy's work, this effect can be summarized as follows: when a specific right is granted to a group, denying this same right to another group seems even more justified than before. As previously mentioned, this outcome has been observed by many more authors with the adoption of same-sex marriage (Stacey; Bernard). For example, the sociologist Judith Stacey affirms the following:

However, unless legal recognition of same-sex marriage is accompanied with social recognition and material support for the broad array of contemporary family forms which children and adults of all genders and sexual orientations now inhabit, their gain might prove to be a loss for vast numbers of other children and families. (532)

Journalist Tara Siegel Bernard of the *New York Times* has noticed a similar phenomenon in the United States. Since the legalization of same-sex marriage, same-sex couples certainly have more privileges and benefits, yet there is still no protection for families that do not form a monogamous couple. In the Canadian context, jurist Gillian Calder argues that the "challenges to a 'traditional' notion of 'the family' in Canada have cemented, in the process, a more rigid boundary around a monogamous, conjugal understanding of the family form" (55). An example of the tension that is created by this paradox can be formulated as follows: a homosexual marriage does not adequately reflect the patriarchal tradition of a marriage, but a polygamous marriage is too patriarchal (Handley 85-109).

In sum, some authors maintain that to eliminate these paradoxical effects, multipartner unions also need to be accepted (Chambers). This argument will be used later to offer alternative regulations to marriages.

b) The Impacts of the Subordination of Rights

Finally, the prohibition of polygamous marriage could result in creating the paradoxical effect of the subordination of rights, which is connected to the fact that another group in society was already granted similar rights. Wendy Brown describes this consequence as follows: as soon as the rights of a subordinated group have been acknowledged, they can change their nature and tacitly become tools for dominant groups over subgroups. In her book *States of Injury*, which touches on the general relation between freedom and equality, Brown focuses on this question: when does legal recognition become an instrument for regulation or even discrimination? She focuses on the paradox that exists once the rights of a minority group have been accepted and recognized. Brown maintains that the nature of these rights can change and become an instrument for the previous minority group, which is now part of the majority, to leave the other minority groups behind and increase their isolation. Indeed, "rights are more likely to become sites of the production and regulation of identity as injury than vehicles of emancipation" (134).

Thus, some authors think that the expansion of the definition of marriage to other groups, such as same-sex couples, has had a negative and paradoxical impact for other groups in society. For Polikoff, the legalization of same-sex marriage has done nothing more than include a specific group in the realm of monogamous marriage by increasing the exclusion of many other marriage groups, like polygamous families:

"When advocates for gay and lesbian couples exclude from the definition of the problem others who are affected by marriage's special treatment, they leave behind allies and a huge proportion of gay men and lesbians in pursuit of the solution of marriage for same-sex couples" (107).

Moller Okin also emphasizes that marriage inadvertently discriminates against couples outside of the realm of marriage, since it perpetuates traditional roles for men and women in a couple (139). Any deviation from this traditional dynamic, even by accepting the equality of both parties of that marriage, must be subordinated to the existing concept of marriage. Once again, the types of families outside of the monogamous realm are not readily accepted.

Lastly, it was demonstrated that the state advantages monogamous marriage for all kinds of reasons except for the protection of the traditional monogamous couple (Metz 3). The institution of marriage has indeed been used to control and exclude from power and benefits African Americans (Franke), Mormons, and Indigenous people (Carter), and a prohibition of different forms of conjugal unions potentially can discriminate against those who practice them, especially immigrants (Rude-Antoine 93-103).

Conclusion

The prohibition of polygamy, despite being done in the name of the wellbeing of women and children can have paradoxical effects on the rights of those individuals involved in nonmonogamous relationships. As demonstrated, legislators and courts often acknowledge the negative paradoxical economic and distributional impacts, and sometimes contradict the general prohibition of polygamy when it comes to rights regarding succession, marital regime, and social rights. On the issue of nationality and status of immigrants, and notwithstanding the inflexible situation of the Canadian and French governments, the situation is less clear, but it may be that the governments accept these circumstances for political reasons.

These paradoxical effects on the rights of polygamous families, but also other groups affected by the prohibition of polygamy, have been less studied. Research on polygamous families living in France and in Canada is almost nonexistent. Of course, many of the paradoxical

effects identified here are initially theoretical in nature, but previous experiences regarding the question of same-sex marriage may provide some guidance to the question of polygamy.

In any case, it is evident that the prohibition of polygamy creates detrimental effects that cannot be rectified justly by the law or previous court decisions in Canada or France. Legislators in both countries prioritize the wellbeing and security of their citizens when prohibiting polygamy, even though this is explained differently. The recent legalization of same-sex marriage proves that it is not necessarily about protecting 'traditional marriage', which has never truly existed in Canada or France.

It is almost impossible to overcome all the effects that matrimonial law, even if comprised of many types of marriages, could have on members of society. The issue is not polygamous marriage but the nature and concept of marriage itself. Other than age, the sole marriage restriction in Canada and France is the number of people a person can marry. Nonetheless, more and more types of different families have emerged in Western countries, and the law can no longer guarantee just and equal treatment for all people in these families in the same way it can for people in a monogamous marriage. The institution of marriage or marriage contract is no longer an ideal judicial vehicle to protect the rights of families, and it must be replaced by another legal framework, as it has already been established to some degree by nonmarried couples.

If marriage and other related laws, such as civil solidarity pacts and common law relationships, signify more than a set of laws and court decisions that regulate fiscal issues in couples, the state should completely withdraw from regulating marriages and establish laws that can accommodate all types of relationships. In other words, the state has many incentives to completely withdraw from regulating conjugal relationships and achieve its goals by other judicial means.

Works Cited

Bailey, Martha, and Kaufman, Amy J., *Polygamy in the Monogamous World*. Praeger, 2010.

Baines, Beverley. "Equality's Nemesis?" *Journal of Law and Equality*, vol. 5, no. 1, 2006, pp. 57-80.

Baines, Beverley. "Polygamy's Challenge: Women, Religion and the Post-Liberal State." *Les ateliers de l'éthique*, vol. 2, no. 1, 2007, www. erudit.org/en/journals/ateliers/2007-v2-n1-ateliers03575/1044656 ar.pdf. Accessed 31 Aug. 2019.

Bennion, Janet. "Abbas Raptus : Exploring Factors that Contribute to the Sexual Abuse of Females in Rural Mormon Fundamentalist Communities." *Forum on Public Policy*, 2006, forumonpublicpolicy. com/archive06/bennion.pdf. Accessed 29 Aug. 2019.

Brown, Wendy. *States of Injury: Power and Freedom in Late Modernity.* Princeton University Press, 1995.

Calder, Gillian. "Penguins and Polyamory: Using Law and Film to Explore the Essence of Marriage in Canadian Family Law." *Canadian Journal of Women and the Law*, vol. 21, no. 1, 2009, pp. 55-89.

Carbonnier, Jean, *Droit civil: La famille*, Presses Univ. de France, 1979.

Carter, Sarah, *The Importance of Being Monogamous*, The University of Alberta Press, 2008.

Council *Directive 2003/86/CE du Conseil du 22 septembre 2003 relative au droit au regroupement familial*, 2003, JO, L 251, pp. 0012-0018.

Chambers, David L., "Polygamy and Same-Sex Marriage." *Hofstra L Rev*, vol. 26, no. 1, 1997, scholarlycommons.law.hofstra.edu/hlr/ vol26/iss1/2. Accessed 29 Aug. 2019.

Codex Iuris Canonici. 1983, Code c 1141.

Drummond, Susan G. "Polygamy's Inscrutable Criminal Mischief." *Osgoode Hall Law Journal*, vol. 47, no. 2, 2009, pp. 317-69.

Duncan, Emily J. "The Positive Effects of Legalizing Polygamy: Love Is a Many Splendored Thing." *Duke Journal of Gender Law & Policy*, vol. 15, no. 1, 2008, pp. 315-338.

Eekelaar, John. "Why People Marry: The Many Faces of an Institution." *Family Law Quarterly*, vol. 41, no. 3, 2007, pp. 413-31.

Franke, Katherine M., "Becoming a Citizen: Reconstruction Era Regulation of African American Marriages." Yale Journal of Law and the Humanities, vol. 11, no. 2, 1999, digitalcommons.law.yale.edu/yjlh/ vol11/iss2/2. Accessed 29 Aug. 2019.

Handley, William R. "Belonging(s): Plural Marriage, Gay Marriage and the Subversion of 'Good Order'" *Discourse*, vol. 26, no. 3, 2004, pp. 85-109.

Iversen, Joan. "Feminist Implications of Mormon Polygyny." *Feminist Studies*, vol. 10, no. 3, 1984, pp. 504-24.

Katbamna, Mira. "Half a Good Man Is Better than None at All." *The Guardian*, 27 Oct. 2009, www.theguardian.com/education/2009/oct/27/polygamy-study-russia-central-asia. Accessed 29 Aug. 2019.

Kennedy, Duncan. *A Critique of Adjudication: fin de siècle*. Harvard University Press, 1998.

Lochak, Danièle. "Polygamie: ne pas se tromper de combat!" *Plein Droit*, vol. 52, 1998, pp. 36-37.

MacLean, Mavis, and John Eekelaar. "The Significance of Marriage: Contrasts between White British and Ethnic Minority Groups in England." *Law & Policy* vol. 27, no. 3, 2005, pp. 379-98.

Metz, Tamara, *Untying the Knot: Marriage, the State, and the Case for Their Divorce*. Princeton University Press, 2010.

Okin, Susan Moller, *Justice, Gender, and the Family*. Basic Books, 1991.

Polikoff, Nancy D., *Beyond straight and gay marriage: valuing all families under the law*, Boston, Beacon Press, 2008.

R. v. Oakes. 1 RCS 103, 1986.

Reference re: Section 293 of the Criminal Code of Canada. BCSC 1588. British Columbia Supreme Court, 2011.

Robert, Jacques. "La liberté de religion, de pensée et de croyance." *Libertés et Droits fondamentaux*, edited by Rémy Cabrillac, Dalloz, 2016, pp. 411-36.

Rude-Antoine, Edwige, "Muslim Maghrebian Marriage in France: A Problem for Legal Pluralism" *International Journal of Law and the Family*, vol. 5, no. 2, 1991, pp. 93-103.

Siegel Bernard, Tara. "As Same-Sex Marriage Becomes Legal, Some Choices May Be Lost." *The New York Times*, 8 July 2011, www.nytimes.com/2011/07/09/business/some-companies-want-gays-to-wed-to-get-health-benefits.html. Accessed 29 Aug. 2019.

Sheff, Elisabeth. "Polyamorous Women, Sexual Subjectivity and Power." *Journal of Contemporary Ethnography*, vol. 34, no. 3, 2005, pp. 251-83.

Stacey, Judith, "Marriage in the U.S.: Unequal Opportunity—Room for Debate." *The New York Times*, 3 July 2011, www.nytimes.

com/roomfordebate/2011/07/03/marriage-the-next-chapter/
marriage-in-the-us-unequal-opportunity. Accessed 31 Aug. 2019.

Stacey, Judith. "Legal Recognition of Same-Sex Couples: The Impact on Children and Families." *QLR*, vol. 23, 2004, pp. 529-34.

Tweedy, Ann E. "Polyamory as a Sexual Orientation." University of Cincinnati Law Review, vol. 79, no. 4, 2011, scholarship.law.uc.edu/uclr/vol79/iss4/5. Accessed 29 Aug. 2019.

Vermeire c. Belgique. 87 CEDH (Sér A) 799, 1991.

Notes on Contributors

Myrina Bromwich is a ten-year-old-girl who loves gymnastics, scouting, singing, her family, her dog, her friends, and her pet turtles.

Rebecca Bromwich, PhD, LLM, LLB, is a lawyer, legal scholar, and mother of four. She teaches at the Department of Law and Legal Studies at Carleton University in Ottawa, Ontario, Canada, as well as works in a management role with a large international law firm. Before that, she was a practicing lawyer working in litigation, including in the fields of criminal and family law.

Eileen Doherty, PhD, is an assistant professor of communication and media arts at Marymount Manhattan College.

Sheila Alease Ferguson, PhD, LPCC, is the director of family-to-family child welfare services for the Fatima Family Center of the Diocese of Cleveland's Catholic Charities Corporation. Over the course of her career, she has served as a therapist, a social services program administrator, an evaluation researcher, an organizational change consultant, an adjunct faculty, a curriculum designer, and a subject matter expert.

Thomas Harrison, PhD, LLM, LLB, is a postdoctoral fellow, assistant professor (adjunct,) and director of the Legal Ethics and Professionalism Program in the Faculty of Law, Queen's University. He is also a director at the Canadian Association of Legal Ethics. His PhD was on the independent role of lawyers and judges in Canada's court system.

Toni C. King, PhD, is the director of the Center for Black Studies and an associate professor at Denison University, where she holds a joint appointment in Black studies and Women's and Gender Studies. Toni's publications appear in a wide range of books, journals, and anthologies,

including the *National Women's Studies Association Journal* and the *Journal of Women and Therapy*.

Sally Param, PhD, recently finished her PhD at the University of Malaya, Malaysia, in 2016. Her research passions are in the fields of gender and generations, particularly along ethnic lines. She has recently given presentations the Asian Research Institute (ARI) in Singapore (June 2015), the Inter-Disciplinary Net in the Czech Republic (May 2016), and in University of Science, Malaysia (October 2017).

Noémie Richard is currently completing her undergraduate degree in the Bachelors of Global and International Studies at Carleton University, specializing in Global Law and Social Justice.

Josephine L. Savarese, PhD, is an assistant professor at St. Thomas University with research interests in criminology and women's studies.

Meredith Stevens, PhD, teaches in the Department of International Liberal Arts at Tokushima University in Japan.

Olivia Ungar is a fourth year law and legal studies honours student at Carleton University.

Jens Urban, PhD, is a legal scholar and policy analyst. He has more than twenty-five years of experience in legal research and analysis, management and coordination, teaching, and business. His experience includes work in the private, public, non-profit and academic sectors.

Kari Wilson, PhD, is an assistant professor of communication studies at Indiana University South Bend.

Deepest appreciation to
Demeter's monthly Donors

DEMETER

Daughters
Linda Hunter
Muna Saleh
Summer Cunningham
Rebecca Bromwich
Tatjana Takseva
Kerri Kearney
Debbie Byrd
Laurie Kruk
Fionna Green
Tanya Cassidy
Vicki Noble
Bridget Boland

Sisters
Kirsten Goa
Amber Kinser
Nicole Willey
Regina Edwards